The 1900s

New beginnings, new machines

The opening decade of the 20th Century was a quiet period in the United States. The automobile was just coming into the life of Americans.

Sports, especially baseball, were big, and Orville Wright in 1903 made the first successful airplane flight at Kitty Hawk, N.C.

A record 12,285,349 immigrants landed on America's shores in 1907.

Some other highlights were:

❑ President William McKinley was shot Sept. 6, 1901, at the Pan-American Exposition in Buffalo, N.Y., by anarchist Leon Czogosz. Following McKinley's death Sept. 12, Vice President Theodore Roosevelt became the 26th president of the United States.

❑ Also in 1901, pitcher Cy Young led the Boston Pilgrims of the rookie American League to baseball's first World Series, defeating the National League Pittsburgh Pirates.

❑ Minnesota's exhibits at the Pan-American Exposition in 1901 identified the state as the "Bread and Butter State."

❑ Fort Lincoln, located south of Bismarck, N.D., was completed and garrisoned in 1903. The military base became a training center for the state militia and was used as a detention camp for enemy aliens during World War II.

❑ A fire in Chicago's Iroquois Theater on Dec. 30, 1903, resulted in 602 deaths. Many of those killed were trampled to death.

❑ Crowds were out in full force when President Roosevelt, a former rancher in

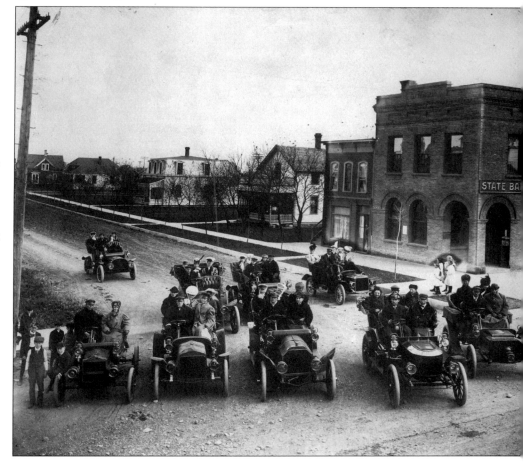

ROAD RALLY

The turn of the century brought many changes to America, including the introduction of the automobile. Here, motorists show off their cars in October 1906 in downtown Cooperstown, N.D.

MYRTLE PORTERVILLE PHOTOGRAPH COLLECTION, INSTITUTE FOR REGIONAL STUDIES-NDSU LIBRARIES

North Dakota's Badlands, visited Fargo April 7, 1903.

❑ Jon Rooney was executed at the North Dakota Penitentiary in Bismarck on Oct. 17, 1905. It was last legal hanging in North Dakota.

❑ A killer earthquake and fire hit San Francisco April 18-19, 1906, leaving 452 dead and a loss of $350 million.

❑ The famous horse, "Dan Patch," paced the mile in 1 minute, 55 seconds at

the Minnesota State Fair in 1906, setting a world record.

❑ Minnesota levied a statewide tax for support of highways in 1907.

❑ The 50th anniversary of Minnesota's admission to statehood was celebrated at the 1908 State Fair, with an attendance of 326,753 for the week.

❑ President Roosevelt issued a proclamation in 1909 establishing Minnesota's Superior National Forest.

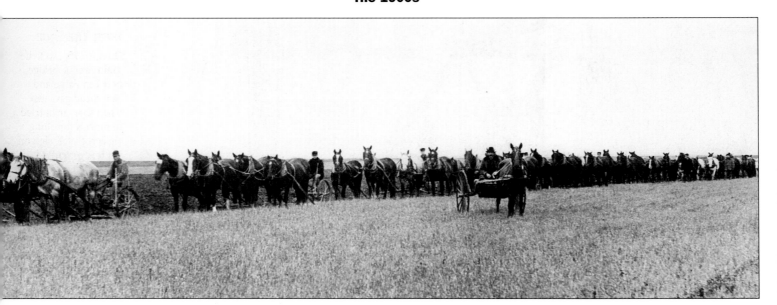

DOWN ON THE FARM

Huge bonanza farms, created by railroad investors, flourished in the early 1900s, proved the viability of wheat farming in North Dakota. This paved the way for homesteading and settlement. The large-scale farms went out of existence after the 1920s due to land-price inflation and tax changes. It took quite a crew to get the work done, as seen in this plowing photo on the Kingman farm near Hillsboro, N.D.

FRED HULTSTRAND HISTORY IN PICTURES COLLECTION, INSTITUTE FOR REGIONAL STUDIES-NDSU LIBRARIES

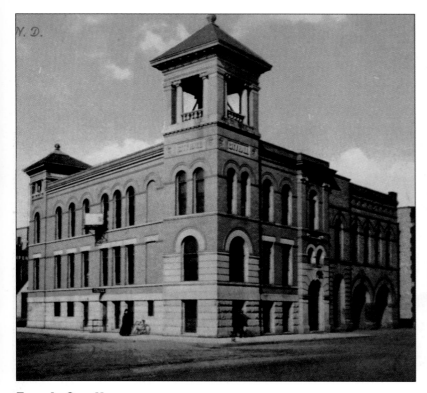

FARGO'S CITY HALL

Fargo's former City Hall was built in 1905-06 for $19,194 at the corner of NP Avenue and Roberts Street. It contained a fire hall (at right), the police department (ground level at left) and other city offices, including the City Commission chambers. It was replaced in December 1959 by the current City Hall and Civic Auditorium complex. The Fargo Fire Department's main station occupies the old City Hall site.

INSTITUTE FOR REGIONAL STUDIES, NDSU LIBRARIES

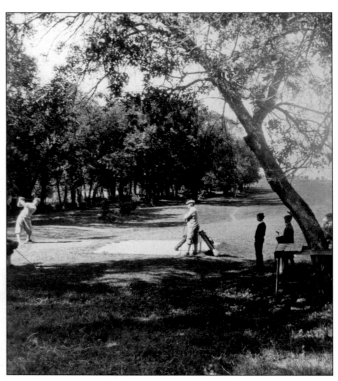

A NEW GAME IN TOWN

As the calendar moved from the 1800s to the 1900s, folks in the Fargo-Moorhead area began making plans to bring the game of golf to town. The first course, Fargo Country Club, was built at Eighth Street and 13th Avenue South. It was so far out of town in those days, according to member J.A. Montgomery, clerk of the federal court, "that we never thought of walking out there, but hitched the horse to the buggy and drove out." The club eventually moved the course further south to its current location along the Red River, where this photo was taken.

THE FORUM / FILE PHOTO

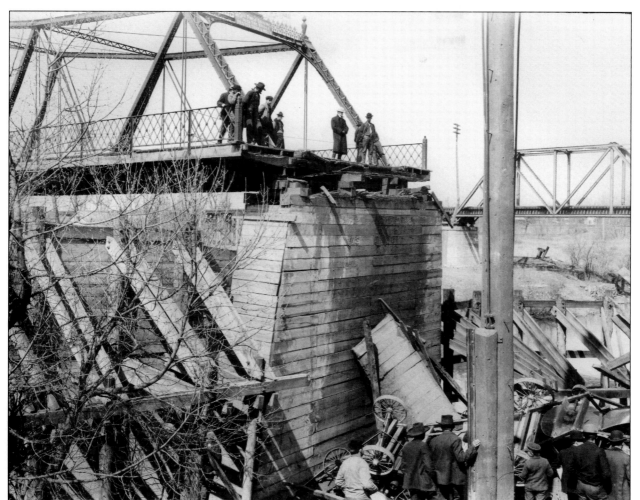

OVER THE EDGE

On April 15, 1902, the Main Avenue bridge between Fargo and Moorhead gave way when three men tried to move a threshing rig across it. A sign on the bridge warned: "$10.00 fine for driving over this bridge faster than a walk." Amazingly, the three men survived. One of them, George "Rat House" Miller, was found beneath the thresher in one piece. He had landed in a slight depression in the ground and the rise on either side was just enough to spare him from being crushed. He suffered only a broken leg and unspecified head injuries. Later, Miller sued the city of Moorhead and was awarded $8,700 in damages.

CLAY COUNTY HISTORICAL SOCIETY ARCHIVES

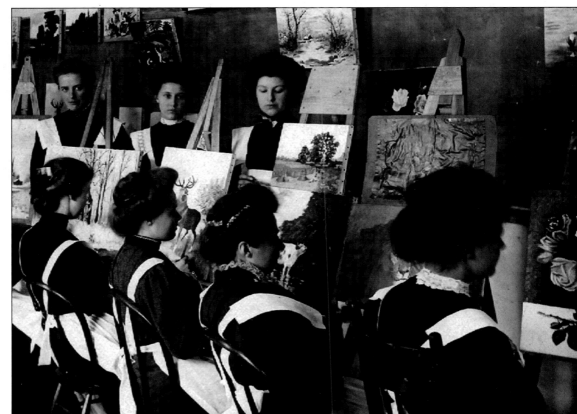

ARTISTIC EXPRESSION

Young women studied art, domestic sciences, Norwegian, music and the Bible at Fargo's Oak Grove Lutheran High School when it was known as the Oak Grove Lutheran Ladies' Seminary in 1909.

COURTESY OF OAK GROVE LUTHERAN SCHOOL

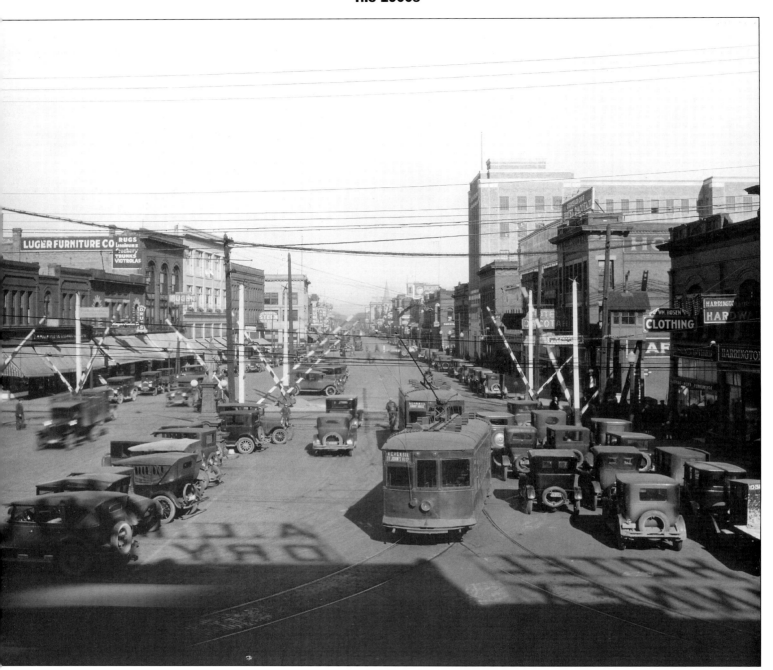

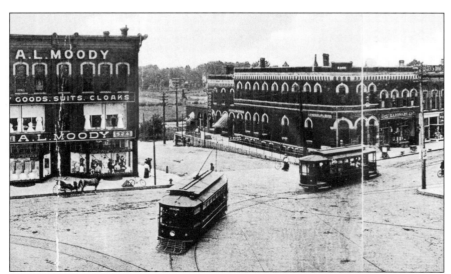

EARLY-DAY MASS TRANSIT

Streetcars and automobiles crowd a bustling Broadway after the turn of the century in downtown Fargo looking north from present-day Main Avenue, known as Front Street until the 1960s. Downtown Fargo businesses attracted shoppers from throughout the region. At left, streetcars turn onto Broadway from Main Avenue. Fargo's streetcars stopped running in 1937.

TOP: INSTITUTE FOR REGIONAL STUDIES, NDSU LIBRARIES
LEFT: COURTESY OF WIMMER'S JEWELRY, FARGO

The 1910s

Taking flight, going to war

As the United States and the world moved through the decade, war clouds began to gather in Europe and in 1917 the United States entered World War I.

During the decade, the first transcontinental airplane flight was made from New York to Pasadena by C. P. Rodgers. It took 82 hours and 4 minutes. The new luxury liner, the Titanic, hit an iceberg April 16, 1912, and 1,345 passengers and crew members lost their lives.

World War I ended with the treaty signing Nov. 11, 1918. More than 123,325 Minnesota troops took part in the war. It was also during this decade that the Constitution was amended to allow Congress to levy and collect taxes.

Some other highlights were:

❑ The Boy Scouts of America were incorporated Feb. 8, 1910.

❑ In 1910, the first airplane flight in North Dakota took place at an exhibition in Grand Forks.

❑ The first airmail flight was completed from Minneapolis Oct. 17, 1911. Hugh Robinson completed a portion of the journey to New Orleans by flying from Minneapolis to Rock Island, Ill., a distance of 371 miles. The plane carried 25 pounds of mail.

❑ The North Dakota Legislature in 1913 passed a law making bootlegging illegal and punishable by imprisonment.

❑ Ford Motor Co. raised basic wage rates from $2.40 for a nine-hour workday to $4 for an eight-hour workday Dec. 23, 1913.

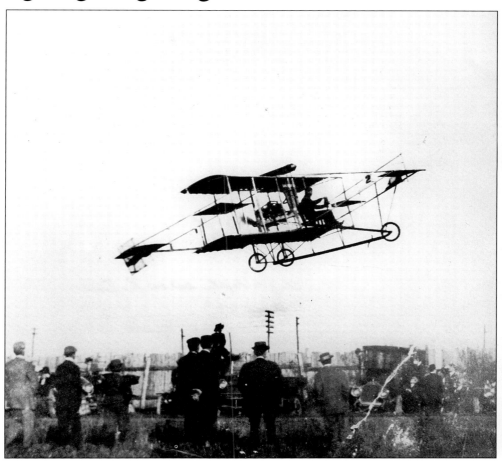

FARGO'S FIRST FLIGHT
"Lucky Bob" St. Henry makes what is considered to be Fargo's first successful flight June 9, 1911.
COURTESY OF HECTOR INTERNATIONAL AIRPORT

❑ Fargo residents turned out in force to welcome the 1st North Dakota Infantry July 26, 1916, when it returned from Mexico.

❑ President Woodrow Wilson was re-elected in 1916 with the slogan: "He kept us out of the war." Six months later, American doughboys were on their way to Europe.

❑ An influenza epidemic in 1918 killed 20 million people throughout the world, including 548,000 in the United States and its armed forces. It was estimated that 2,700 North Dakotans died.

❑ Forest fires swept large areas of Minnesota's Carlton and St. Louis counties in 1918, leaving 432 dead.

❑ The Nonpartisan League tried to take over North Dakota's public schools Feb. 3, 1919.

❑ In 1919, the State Industrial Commission was created to manage the Bank of North Dakota and the state Mill and Elevator at Grand Forks.

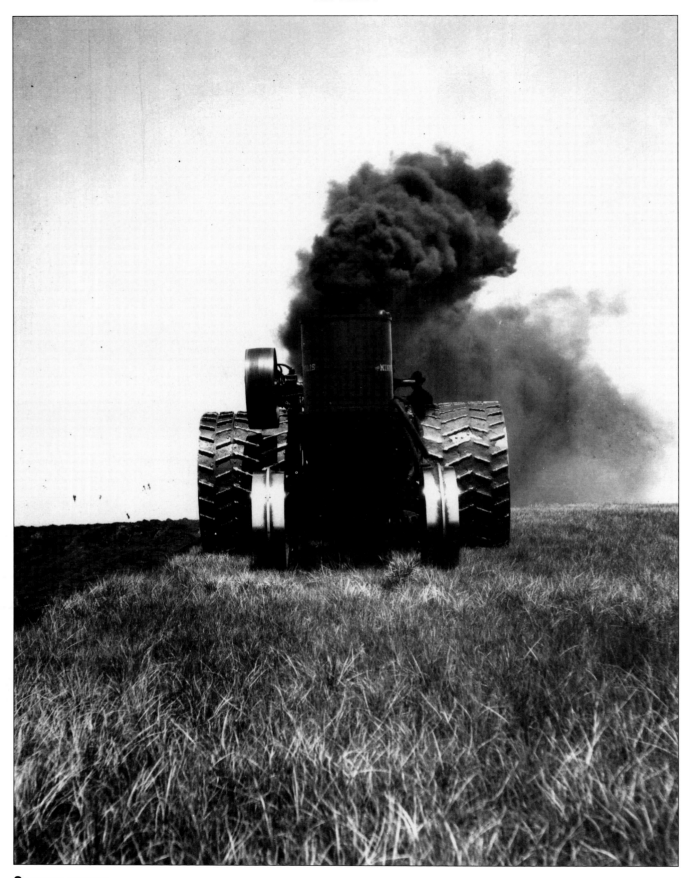

GROUNDBREAKING

A 45-horsepower Minneapolis double-tandem compound-steam tractor breaks sod northwest of Fullerton, N.D., circa 1910. Steam power replaced horsepower for some sod breaking in the region. Gas power took its place in the 1930s and '40s.

F.A. PAZANDAK COLLECTION, INSTITUTE FOR REGIONAL STUDIES, NDSU LIBRARIES

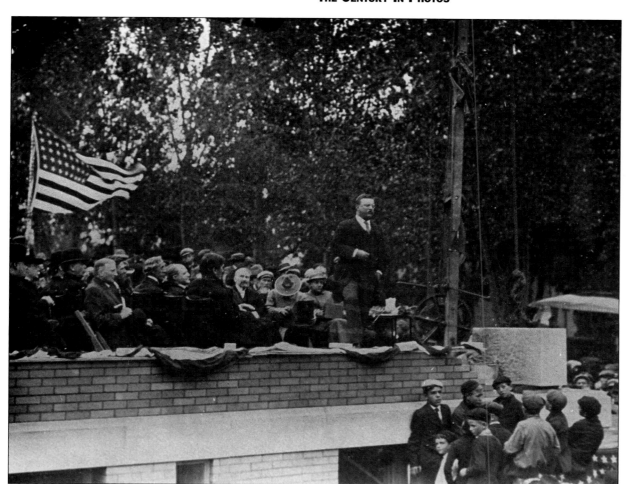

PRESIDENTIAL VISIT

U.S. President Theodore Roosevelt speaks to a crowd estimated at 30,000 during a Sept. 5, 1910, dedication ceremony for the library at Fargo College. The college, located just south of Island Park, was in operation from 1897 until 1922. Its peak enrollment was 700 and it produced four Rhodes Scholars. The library building was donated by Andrew Carnegie. It was torn down in 1964 after serving as the home office for Western States Life Insurance Co. It was not Roosevelt's first trip to the state. Theodore Roosevelt National Park in western North Dakota includes one of the ranches Roosevelt operated during the 1880s.

A CENTURY TOGETHER PHOTOGRAPH COLLECTION, INSTITUTE FOR REGIONAL STUDIES, NDSU LIBRARIES

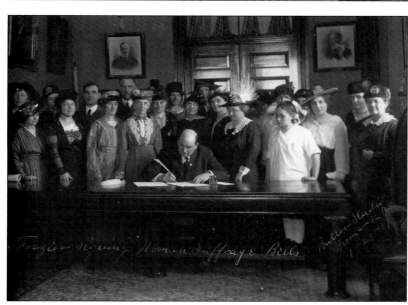

SIGNING FOR THEIR RIGHTS

North Dakota Gov. Lynn G. Frazier signs the Women's Suffrage Bill Jan. 23, 1917. Included in the photo are governor's wife and their twin daughters, Uni and Versity. The 19th Amendment, which gave women the right to vote, became part of the U.S. Constitution Aug. 26, 1920, when Tennessee became the 36th state to ratify it. North Dakota ratified the 19th Amendment Dec. 2, 1919. The 1923 Legislature was the first to include women.

NORTH DAKOTA MASONIC GRAND LODGE PHOTOGRAPH COLLECTION, INSTITUTE FOR REGIONAL STUDIES, NDSU LIBRARIES

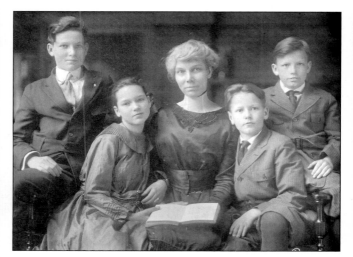

SOCIALIST 'RED KATE' JAILED

Kate Richards O'Hare, shown with her children, was sentenced to five years of hard labor at a federal penitentiary in Missouri for a seditious speech she delivered July 17, 1917, at Bowman, in the southwestern corner of North Dakota. The conviction closed a spectacular trial in Bismarck. She was charged with saying "any person who enlisted in the army of the United States for service in France would be used for fertilizer and that is all that he was good for, and that the women of the United States were nothing more or less than brood sows to raise children to get into the army and be made into fertilizer." She served as international secretary for the Socialist Party of America. She died in comparative obscurity in 1948 at age 70.

THE FORUM / FILE PHOTO

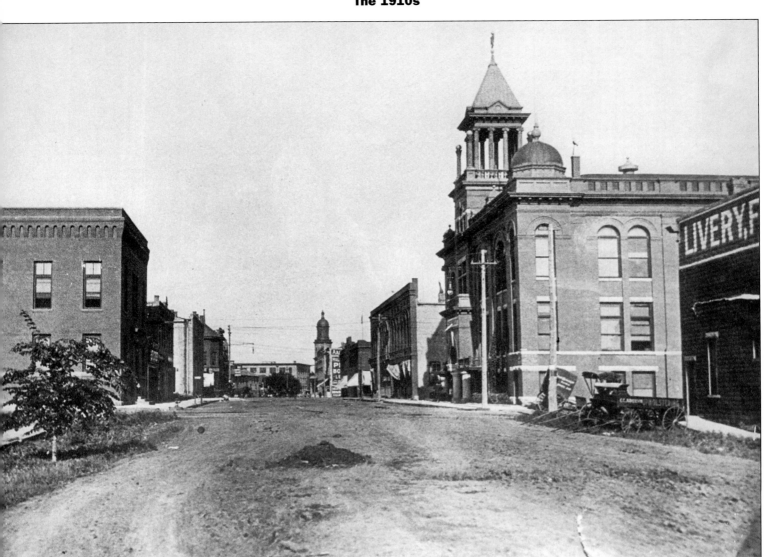

My, How Things Change

This is what Fargo's First Avenue North looked like in 1910. The old Masonic Lodge is pictured at right on the corner of First Avenue and Fifth Street. At the extreme right, the livery building was located on the corner where The Forum building stands today

The Forum / File Photo

Just A Stream

It's difficult to recognize this as the Red River in a 1910 photograph near the Northern Pacific bridge (with the old south bridge behind it). The river was at its lowest stage in Fargo-Moorhead history.

O.E. Flaten

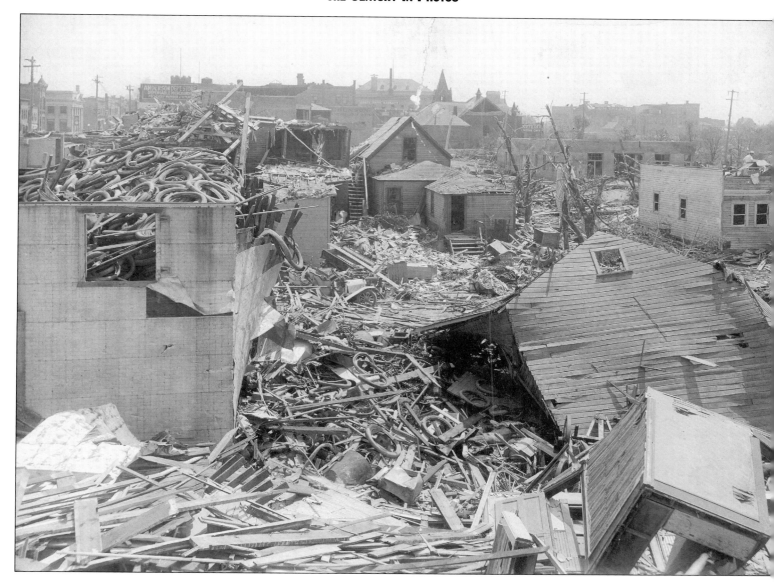

FERGUS FALLS KILLER TORNADO

Two-thirds of Fergus Falls, Minn., was destroyed June 22, 1919 when a double tornado churned through the city, killing 62 and injuring about 200. It was a disaster that made headlines around the world.

THE FORUM / FILE PHOTO

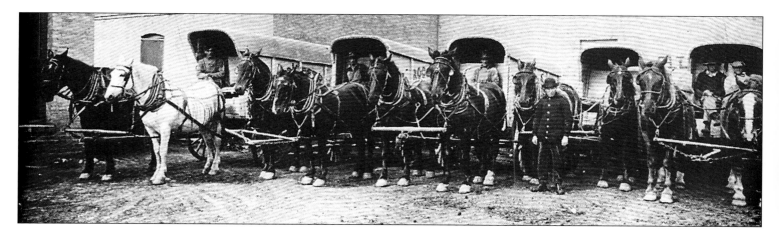

GOT ICE?

Delivery wagons line up at the Fargo Detroit Ice Co. headquarters on Front Street (now Main Avenue) in Fargo in 1916.

THE FORUM / FILE PHOTO

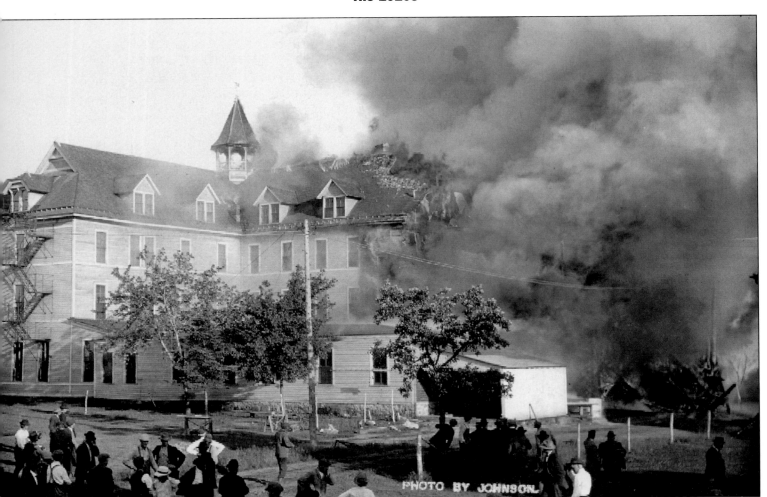

LANDMARK GOES UP IN FLAMES

The famous Hotel Minnesota, one of Detroit Lakes' landmark buildings, goes up in flames in 1915. In the photo at right, the hotel's ornate architecture stands out. It originally opened under the name Lakeside. When sold a year later, it was renamed. It was located at the corner of Washington Avenue and Frazee Street, where the Becker County Jail and a sporting goods store are now located.

TOP AND RIGHT: THE FORUM / FILE PHOTOS

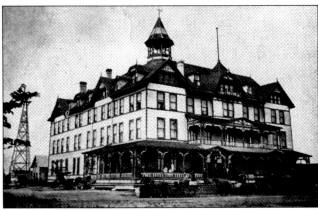

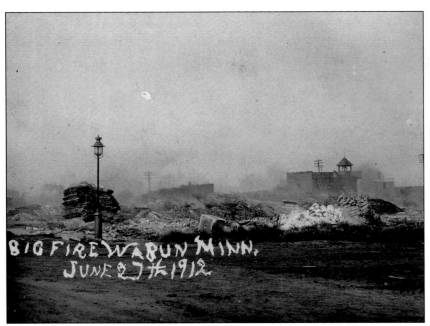

PRAIRIE BLAZE

It was windy and dry June 27, 1912, when fire destroyed Williamson's restaurant and Chondonnet Lumberyard in Waubun, Minn. A Soo Line Railroad agent called Thief River Falls, Minn., to dispatch a train pulling tanks of water. The arrival of the train and the agent's quick actions are credited with saving the town from being destroyed.

COURTESY OF CLIFF OFTELIE

12

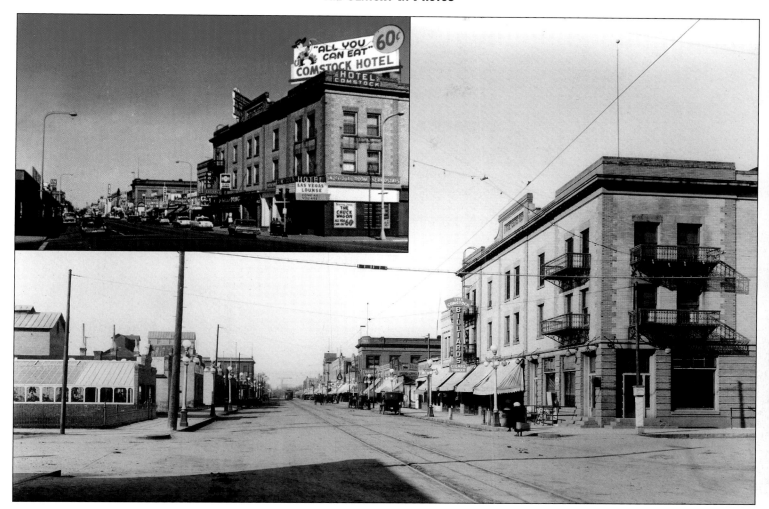

MOORHEAD REVISITED

This is what downtown Moorhead looked like in 1915 and in the 1960s (inset). It's a view down what once was called Front Street and what later became Center Avenue. The buildings were demolished as part of the city's urban renewal project.

TOP: CLAY COUNTY HISTORICAL SOCIETY
INSET: CLAY COUNTY HISTORICAL SOCIETY

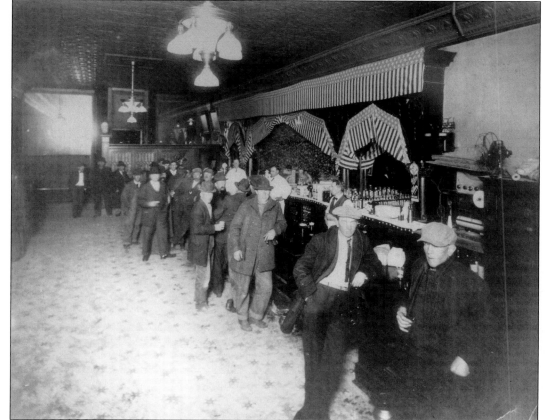

THE SALOON YEARS

Business is brewing at Kiefer's saloon, 406 Front St. (now Center Avenue) in Moorhead in this 1914 photo. Moorhead's liquor trade flourished because North Dakota did not allow the sale of alcohol when it became a state in 1889, There were 44 saloons in Moorhead at the turn of the century.

COURTESY OF CHARLIE F. JOHNSON

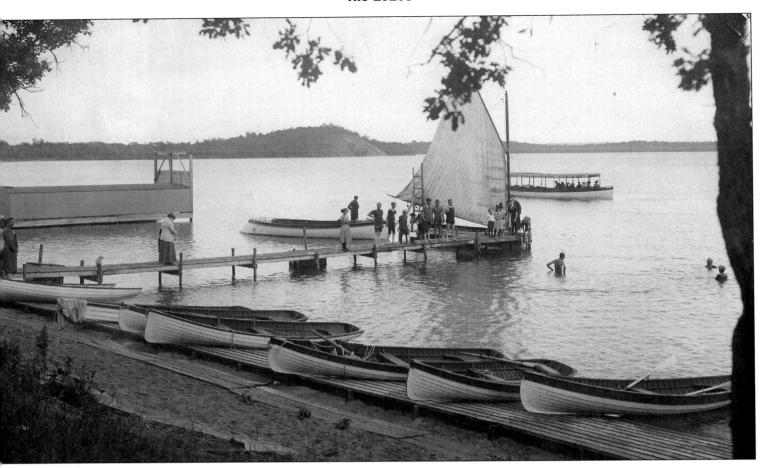

FAIR HILLS VACATION

Fair Hills Resort on Pelican Lake near Pelican Rapids, Minn., circa 1912. Recreation always has been an important part of people's lives in the region. The Kaldahl family has run Fair Hills since 1926 when Ed Kaldahl and son Chet purchased what was then a small fishing camp. David and Barb Kaldahl, the third generation, run the resort today, along with their sons, Dan and Steve. The resort is among the 10 largest in Minnesota.

BECKER COUNTY HISTORICAL SOCIETY

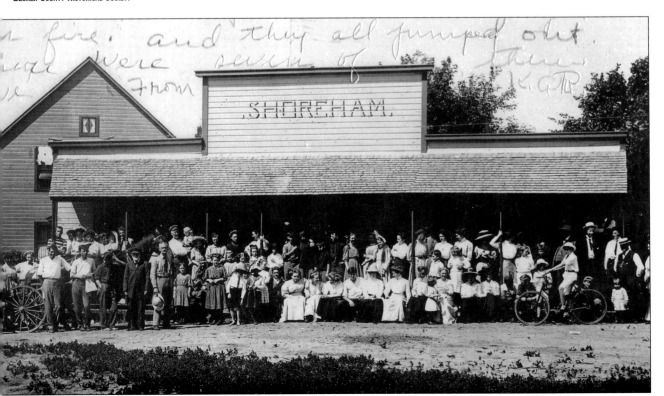

MAIL TIME

A large crowd gathers while waiting for mail to be delivered at Shoreham village between lakes Melissa and Sallie, southwest of Detroit Lakes, Minn., circa 1912.

BECKER COUNTY HISTORICAL SOCIETY

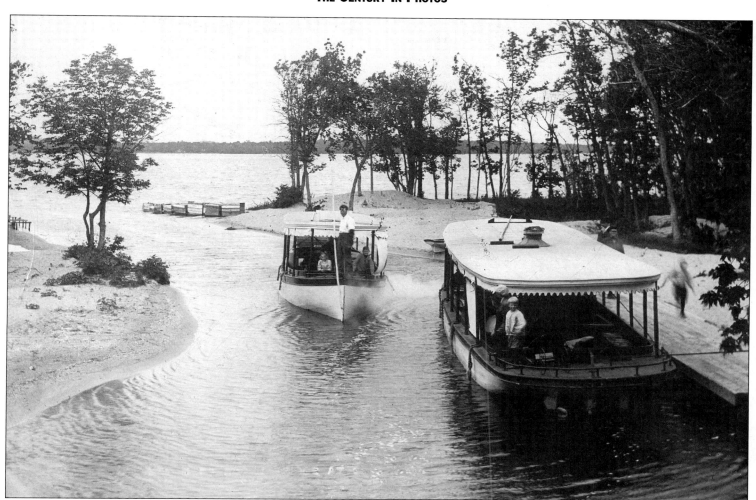

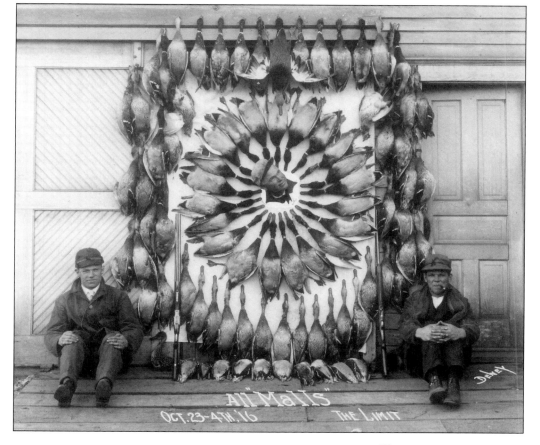

LAKE TRANSIT

A passenger boat plies the Pelican River between lakes Sallie and Melissa southwest of Detroit Lakes, Minn., near the village of Shoreham, circa 1910. The other boat is docked. During the late 1800s and early 1900s, passenger boats could sail from Detroit Lakes through Sallie and Melissa to Little Pelican Lake northwest of Pelican Rapids.

BECKER COUNTY HISTORICAL SOCIETY

WHAT A HUNT!

Hunting was good in October 1916 when three Fargoans shot 90 mallards in the Wyndmere-DeLamere area in southeastern North Dakota. Hunters, left to right, are R.E. Cole, C.E. Manning and C.W. Hauser. They bagged a rare black duck, shown top center.

THE FORUM / FILE PHOTO

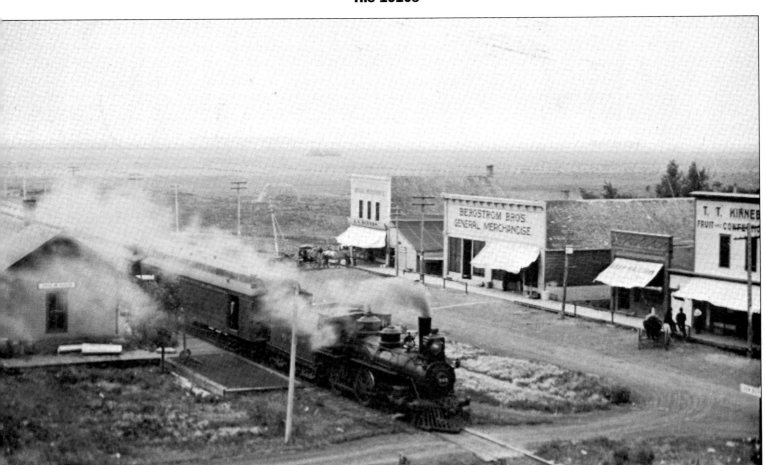

COMING THROUGH

A Chicago-Milwaukee train momentarily breaks the peace and quiet of Hickson, N.D., as it rolls through town, circa 1910. Hickson is a small community about 15 miles south of Fargo.

THE FORUM / FILE PHOTO

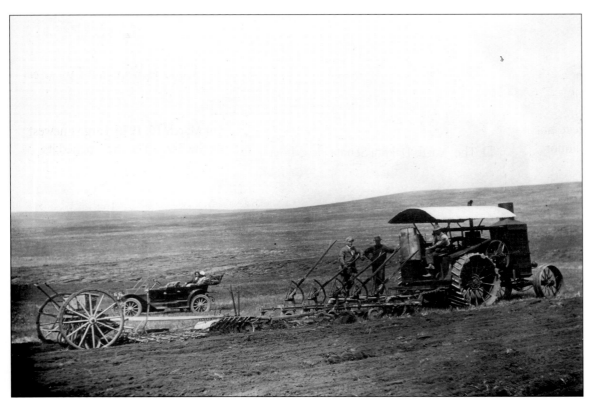

TWO BIRDS WITH ONE MACHINE

A steam tractor handles plowing and seeding in one operation, pulling a plow, disc, drag and drill through a field near Dickinson, N.D., circa 1912.

INSTITUTE FOR REGIONAL STUDIES, NDSU LIBRARIES

The 1920s

Roaring forward, plunging deep

The "Roaring '20s" marked the point at which the United States began developing into a modern society. During and after World War I, people continued to move from the farm to the cities in record numbers. The 1920 census found that for the first time the majority of Americans lived in urban areas.

By decade's end, automobiles, telephones, radios and electric washing machines had become fixtures in American households. The Oct. 29, 1929, stock market crash brought the decade to an end, and plunged the nation into a deep depression.

Some other highlights were:

❏ Eight people were killed in 1920 on a farm near Turtle Lake in one of North Dakota's worst mass murders.

❏ The 19th Amendment to the U.S. Constitution became law on Aug. 26, 1920, giving women the right to vote in all elections.

❏ The 18th Amendment to the Constitution, called the Prohibition Amendment, became law, causing unforeseen problems. Taking effect Jan. 16, 1920, it outlawed the sale of liquor throughout the United States. As bootlegging of liquor became lucrative, gang wars erupted.

❏ A bomb explosion Sept. 16, 1920, on Wall Street in New York City killed 30, injured 100 and did $2 million in damages.

❏ North Dakota Gov. Lynn J. Frazier, Atty. Gen. William Lemke and Agricultural and Labor Commissioner John N. Hagen, all Nonpartisan League

FROM STRASBURG TO BRIGHT LIGHTS

Lawrence Welk was one of the many people who left the farm for the big city during the 1920s. Welk spent his childhood at his home near Strasburg in south-central North Dakota. He went on to international fame and fortune as a band leader. Welk's television show was popular worldwide.

THE FORUM / FILE PHOTO

members, were recalled by voters in 1921 in the first successful gubernatorial recall in the nation.

❏ The North Dakota Senate closed the legislative session on March 5, 1921, with fist fights, brawls and arrests at the state Capitol in Bismarck.

❏ The first radio station in Minnesota to begin broadcasting was WLAG in Minneapolis, which today is known as WCCO.

❏ The University of Minnesota, on Nov. 15, 1924, dedicated its new stadium "in remembrance of the thousands of Gopher soldiers who answered the Great Call in 1917."

❏ On March 15, 1926, Fargo's newest theater, the Fargo Theatre, opened its doors on Broadway.

❏ Charles A. Lindbergh, Little Falls, Minn., flew his Spirit of St. Louis solo across the Atlantic Ocean from New York City to Paris May 20, 1927.

❏ On Oct. 1, 1927, New York Yankee Babe Ruth shattered the major league home run record with his 60th homer.

❏ The first all-talking movie was shown in New York City Aug. 24, 1928.

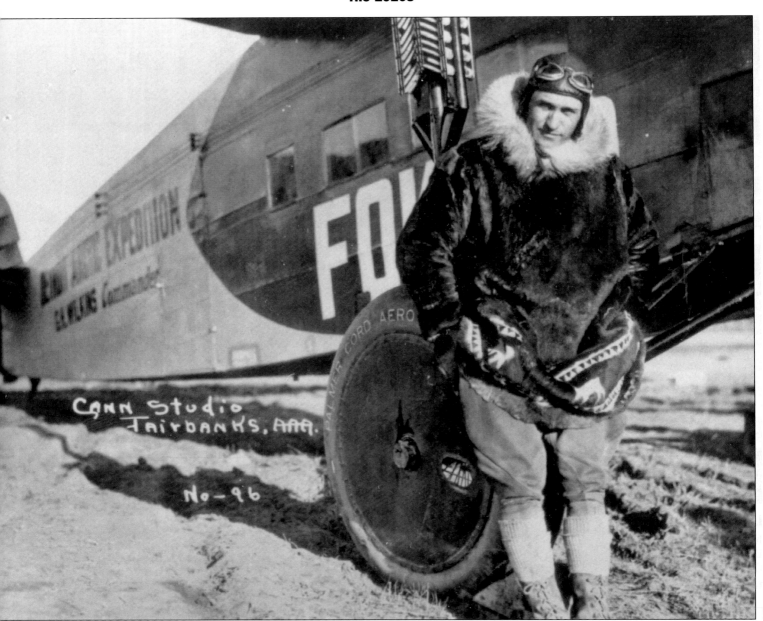

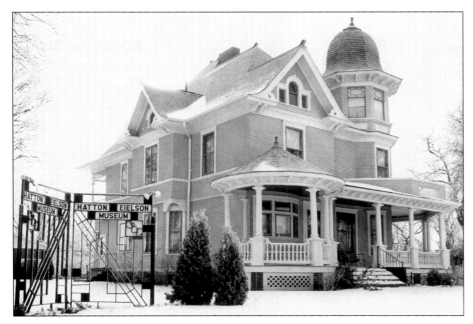

NORTH DAKOTA'S POLAR PILOT

In 1928, Hatton, N.D., native Carl Ben Eielson made the first successful non-stop flight over the North Pole with English explorer Hubert Wilkins. Eielson received world acclaim and many awards as an aviation pioneer. On Nov. 9, 1929, Eielson died when his plane went down in bad weather during an Arctic rescue mission. About 15,000 people attended his funeral in Hatton.

THE FORUM / FILE PHOTO

KEEPING MEMORIES ALIVE

The house that Carl Ben Eielson grew up in now is the site of the Hatton Eielson Museum. It was purchased in 1981 by the Hatton Eielson Museum and Historical Association. Prior to that, the museum was located in another house in Hatton.

THE FORUM / FILE PHOTO

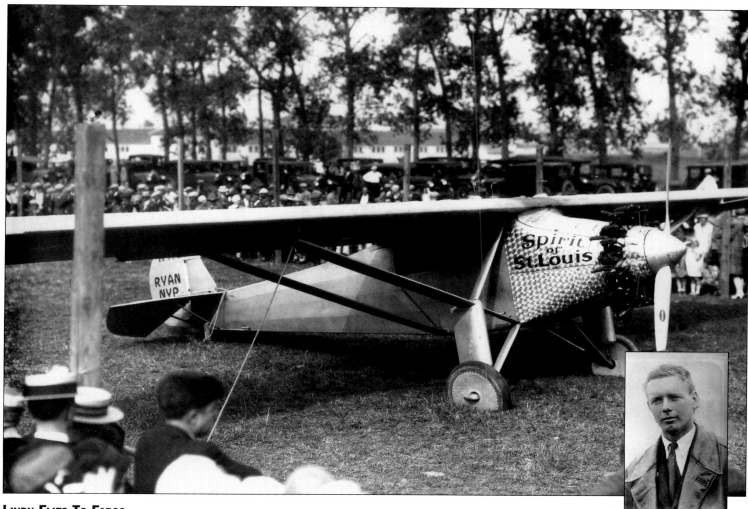

LINDY FLIES TO FARGO

It was a day of great celebration Aug. 26, 1927 when Charles A. Lindbergh (inset) flew his Spirit of St. Louis to Fargo. It was part of an 82-city tour across the United States after Lindbergh became the first person to fly solo across the Atlantic Ocean. Two weeks after the visit by "Lucky Lindy," the Fargo City Commission appropriated the first funds for improvements at Hector Field, now Hector International Airport.

TOP AND INSET: DAVID ANDERSON PHOTOGRAPH COLLECTION, INSTITUTE FOR REGIONAL STUDIES, NDSU LIBRARIES

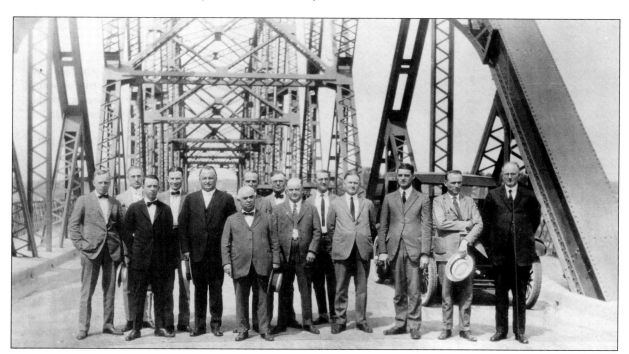

BRIDGING THE GAP

Dignitaries gather for the Sept. 18, 1922 dedication of the Missouri River highway bridge linking Bismarck and Mandan, N.D. "It is the climax of a marvelous progress and is prophetic of the still greater progress that this territory shall make," said Gov. R. A. Nestos. It became the fourth common method of crossing the wide Missouri – following the canoe, the ferry boat and the railroad.

THE FORUM / FILE PHOTO

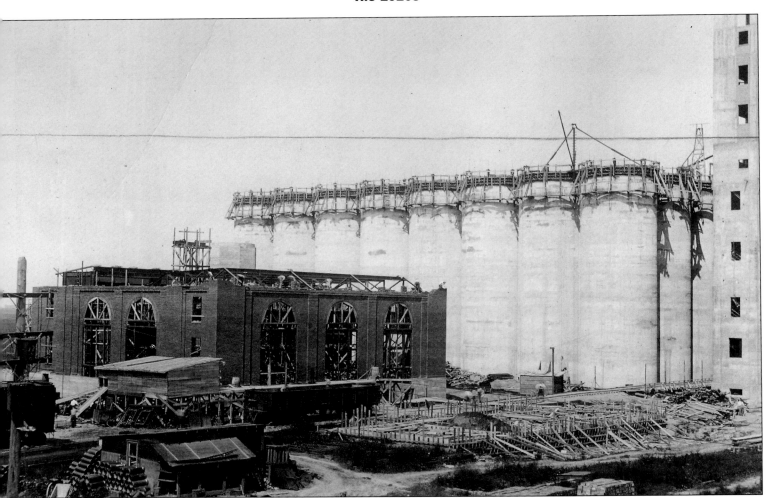

PROCESSING WHEAT

The tanks and walls of North Dakota's State Mill and Elevator rise in Grand Forks. The state-owned Mill and Elevator began operating Oct. 30, 1922. The 1919 Legislature organized the State Mill and Elevator Commission to build a facility to process wheat from North Dakota farmers. It was part of an effort to break the monopoly held by Twin Cities millers. Still in operation today, it is the only state-owned elevator in the nation.

THE FORUM / FILE PHOTO

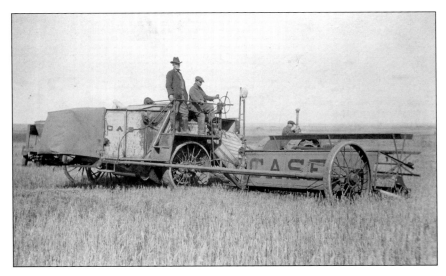

NEW CONTRAPTION

Experimental combines appeared on the farm scene in the 1920s. There were 39 combines successfully used in North Dakota in 1926, two of them in the Red River Valley. The new machines helped farmers harvest grains faster and with less manpower.

THE FORUM / FILE PHOTO

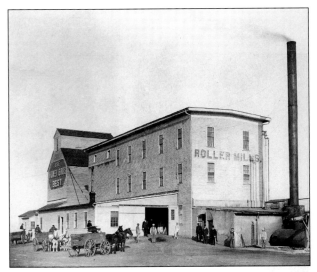

DELIVERING THE GOODS

The growth of farms in the 1920s led to the development of agricultural processing, like this mill in Park River, N.D.

FRED HULTSTRAND HISTORY IN PICTURES COLLECTION, INSTITUTE FOR REGIONAL STUDIES, NDSU LIBRARIES

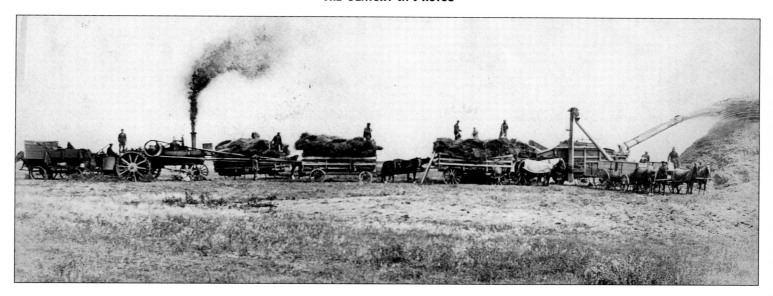

PULLING TOGETHER

Farmer cooperatives cropped up in the Red River Valley in the 1920s. By 1937, there were nearly 600 farmer-owned co-ops in North Dakota, half of them grain related. Above, farmers work together threshing grain in the 1920s near Kloten, N.D., 45 miles southwest of Grand Forks. In a 1988 photo at right, steam rises from the Minn-Dak Farmers Cooperative sugar refinery north of Wahpeton, N.D.

TOP: THE FORUM / FILE PHOTO
RIGHT: THE FORUM / FILE PHOTO

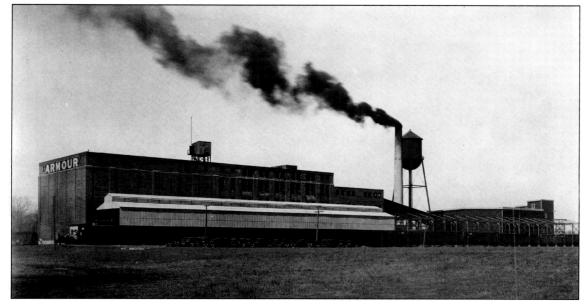

PACKERS

Armour & Co. opened a large meatpacking plant in West Fargo Nov. 7, 1925. Company-owned houses associated with the plant still stand today. The plant operated until 1959. It employed 500 people at its peak. Remnants of the plant still stand.

THE FORUM / FILE PHOTO

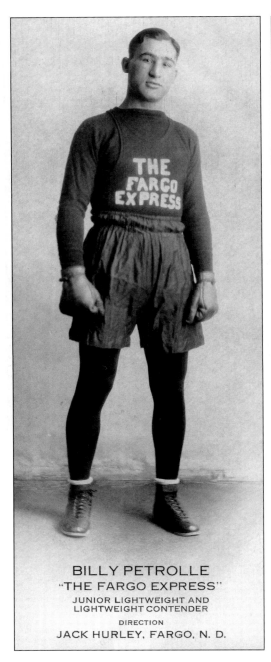

BILLY PETROLLE
"THE FARGO EXPRESS"
JUNIOR LIGHTWEIGHT AND
LIGHTWEIGHT CONTENDER
DIRECTION
JACK HURLEY, FARGO, N. D.

FARGO EXPRESS ROLLS ON

Dilworth native Billy Petrolle began his 11-year professional boxing career in 1922. Nicknamed "The Fargo Express," Petrolle entered the ring with a colorful Indian blanket over his shoulders rather than a robe. Petrolle beat champions in the lightweight and welterweight classes, but had only one title fight. That was a losing effort to lightweight champion Tony Canzonerie in 1932. Two of Petrolle's most notable fights were at New York's Madison Square Garden in the early 1930s. His last bout was Jan. 24, 1934, against Barney Ross, who had beaten him nine months earlier and did it again that day. Petrolle was named to the International Boxing Hall of Fame in 1962. He died in 1983.

COURTESY OF JOANNE STACK

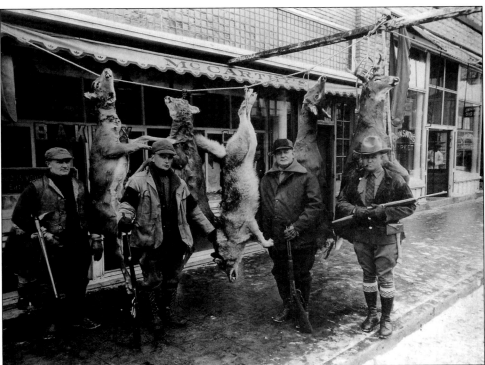

END OF A LEGEND

Time ran out for a legendary wolf known throughout the Detroit Lakes, Minn., area as Ol' Three Legs during the 1926 deer season when crack shot Fred Darkow of Detroit Lakes shot the animal near Bad Medicine Lake. The wolf (center) was hung on display with four deer in downtown Detroit Lakes. From left, hunters are George McCarthy, Darkow, Jack Robbins and conservation officer Harry LaDue.

BECKER COUNTY HISTORICAL SOCIETY

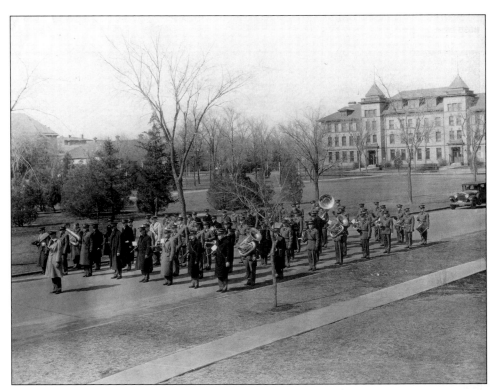

MARCHING DOWN UNIVERSITY

Director Clarence S. Putnam leads the North Dakota Agricultural College Gold Star Band down University Drive on a chilly day, circa 1920s. In the background is Ceres Hall.

NDSU ARCHIVES

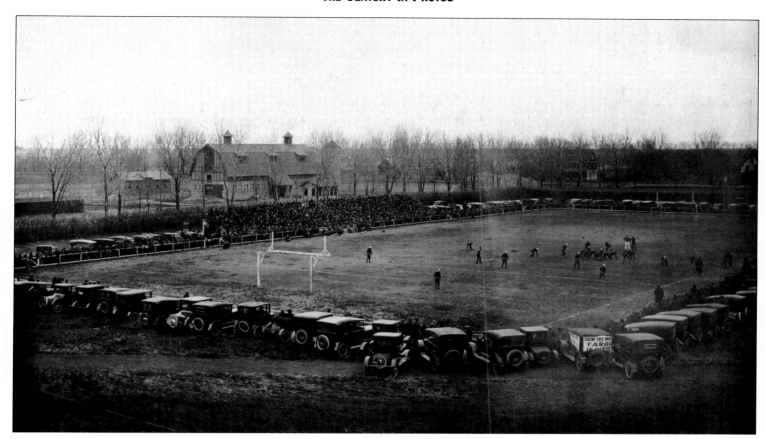

LUXURY SEATS

North Dakota Agricultural College and the University of North Dakota square off in a football battle Oct. 30, 1920 in Fargo. The Bison are punting from midfield. The field was located in what is now the mall area east of the NDSU Memorial Union. The field was later moved north. The barn in the photo was located just west of where the Bentson-Bunker Fieldhouse now stands.

NDSU ARCHIVES

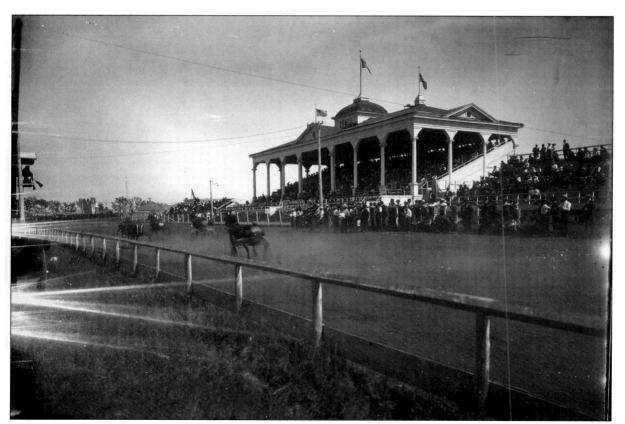

KICKING IT UP

Harness racers trot past the grandstand at the North Dakota State Fairgrounds in north Fargo, circa 1920. The name of the fair was changed to the Red River Valley Fair in 1938. The fair moved to its West Fargo location in 1966. The fairgrounds, located between Broadway and University and 17th and 19th avenues, were sold to the Fargo Public Schools and North Dakota State University.

INSTITUTE FOR REGIONAL STUDIES, NDSU LIBRARIES

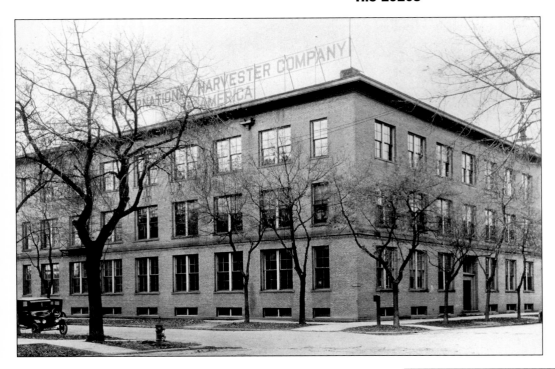

From Parts To Arts

The International Harvester Co. parts distribution center, shown at left circa 1920, was built in 1910. The Plains Art Museum (below) acquired the building in 1993 and opened after extensive renovation.

Top: The Forum / File Photo
Below: The Forum / File Photo

To Your Health

MeritCare Hospital in Fargo, formerly St. Luke's, was founded in 1908. Located in the 700 block of Broadway, it was a small complex in the 1920s compared to the sprawling facilities today. At right, the hospital as it appeared in the 1920s. The Fargo Clinic, also today a part of MeritCare, is located to the north of the original hospital.

Top: The Forum / File Photo
Right: The Forum / File Photo

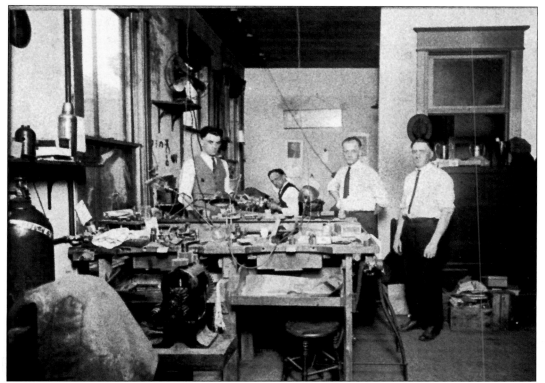

GEM OF A BUSINESS

Fred Wimmer (seated) and fellow jewelers at Wimmer's Jewelry worked in a shop above Woolworth's on Broadway in Fargo during the 1920s. Fred, an immigrant from Hungary, started the business in 1919. It is now run by two grandsons.

COURTESY OF WIMMER FAMILY

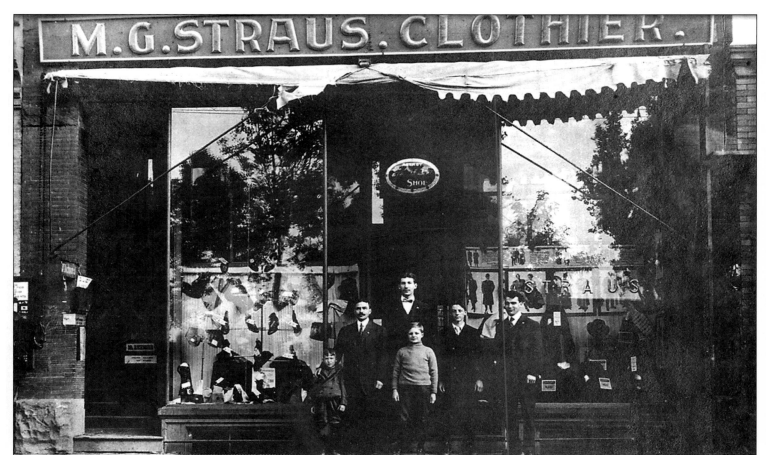

CLOTHES MAKE THE MAN

M.G. Straus (second from left) operated clothing stores in the area until 1920 when he retired and moved to California. He opened his first store before the turn of the century. This photo was taken in front of the Casselton, N.D., store in 1907. Straus also had North Dakota stores in Valley City, Grand Forks, LaMoure, Carrington, Cooperstown and Devils Lake and one in Moorhead.

COURTESY OF STERN FAMILY

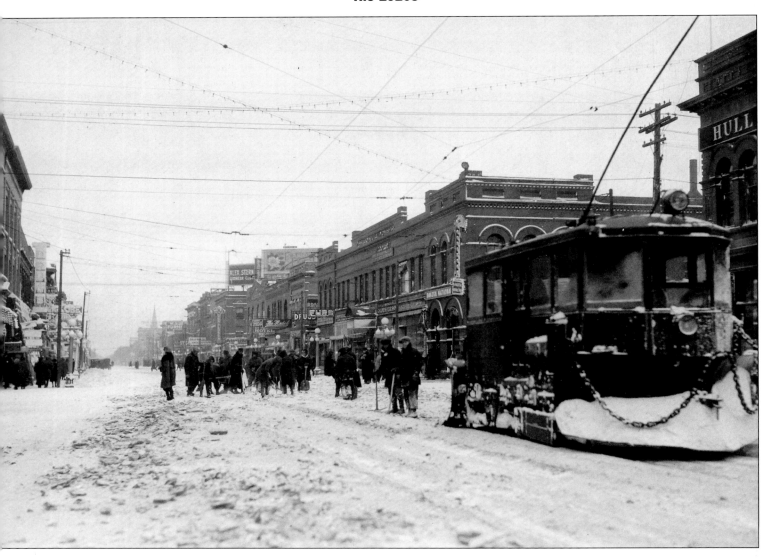

DIGGING OUT

Workers help a Fargo streetcar crew clear the tracks on Broadway Feb. 13, 1923, following a blizzard that claimed 27 lives as it swept across the Dakotas, Minnesota and southern Canada. This scene looks north from NP Avenue.

THE FORUM / FILE PHOTO

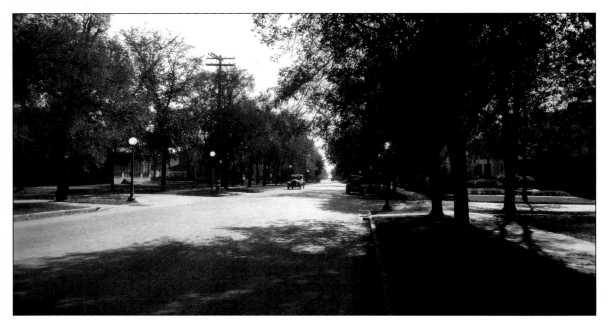

THE SUNNY SIDE OF THE STREET

Eighth Street South has long been one of Fargo's elite home districts. Many of the mansions are still standing. The ornate street lamps and cobblestone streets added to the prestige of the area in the early days.

INSTITUTE FOR REGIONAL STUDIES, NDSU LIBRARIES

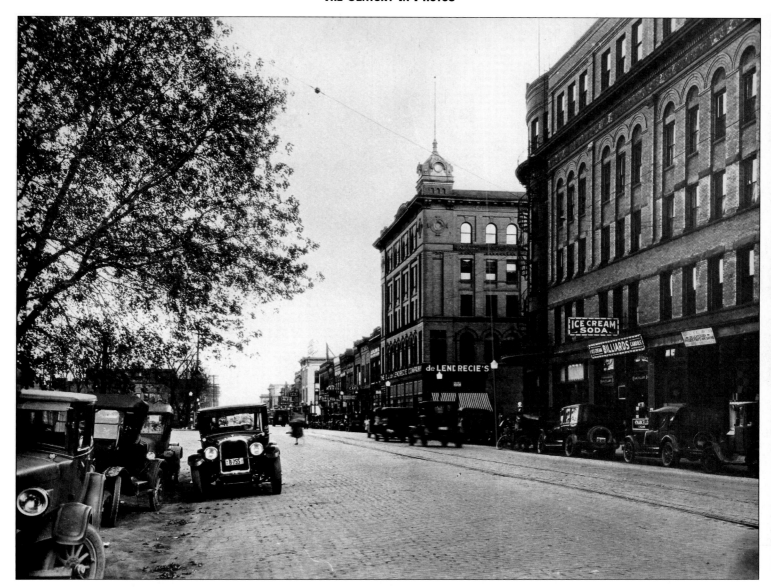

DOWNTOWN ANCHOR

DeLendrecie's, at the corner of Fargo's 7th Street and Main Avenue was a downtown business anchor for 70 years. The department store moved to West Acres shopping center when the mall opened in 1972. The deLendrecie's building today is known as Block 6, which houses commercial businesses and 130 apartments. The building at right housed a hotel, lounge and other businesses. It was destroyed by a fire in the 1950s.

THE FORUM / FILE PHOTO

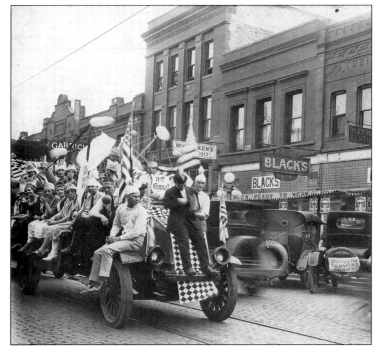

EVERYONE LOVES A PARADE

The Inter-State Fair Parade moves down Broadway between 1st and 2nd Avenues North in July 1923. Black's Ready To Wear store eventually became the Black Building, then the tallest structure in downtown Fargo.

COURTESY OF SCHLOSSMAN FAMILY

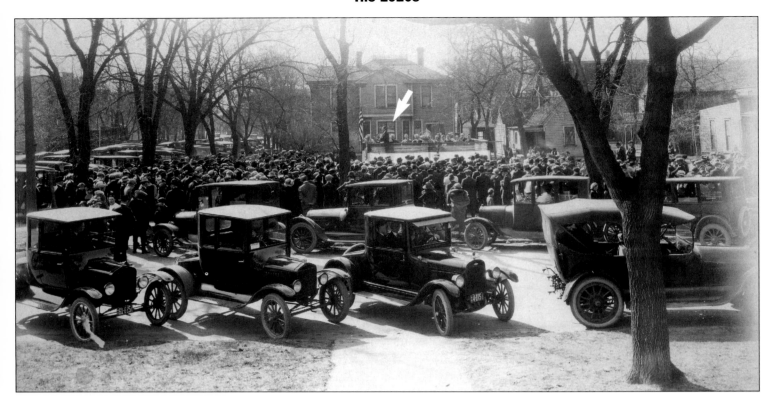

WHAT GOES UP...

On Sept. 23, 1923, John Burke (arrow), former governor of North Dakota and former treasurer of the United States, laid the cornerstone for Fargo's Elks Lodge at 1st Avenue and 8th Street North. The lodge had more than 1,300 members at the time.

THE FORUM / FILE PHOTO

...MUST COME DOWN

In September 1995 the Fargo Elks Lodge building was demolished. It was sold to the federal government to provide the site for the expanded federal court building named in honor of the late U.S. Sen. Quentin Burdick. Because of declining membership, the Elks could not maintain the large building.

THE FORUM / BRUCE CRUMMY

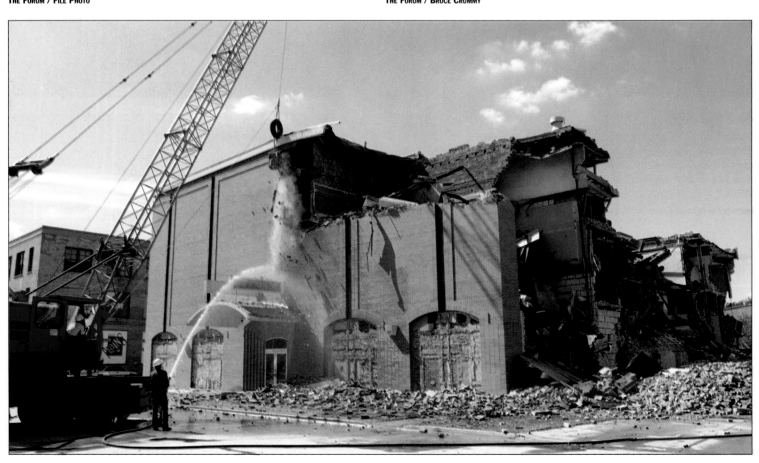

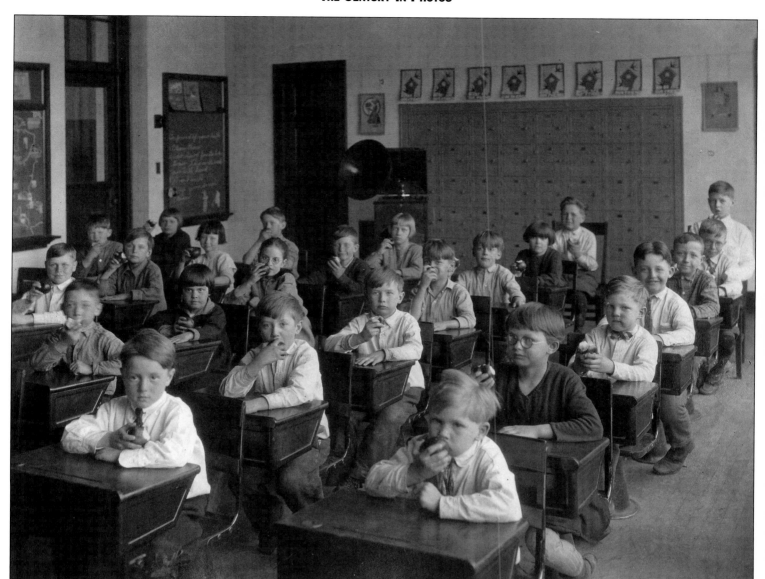

AN APPLE A DAY

Students at Ben Franklin Elementary School in north Fargo enjoy an apple break as part of their health lesson in the mid-1920s.

INSTITUTE FOR REGIONAL STUDIES, NDSU LIBRARIES

MAKING SCHOOL CALLS

A dentist checks the teeth of a young girl while others wait in line at a Fargo elementary school in the 1920s.

INSTITUTE FOR REGIONAL STUDIES, NDSU LIBRARIES

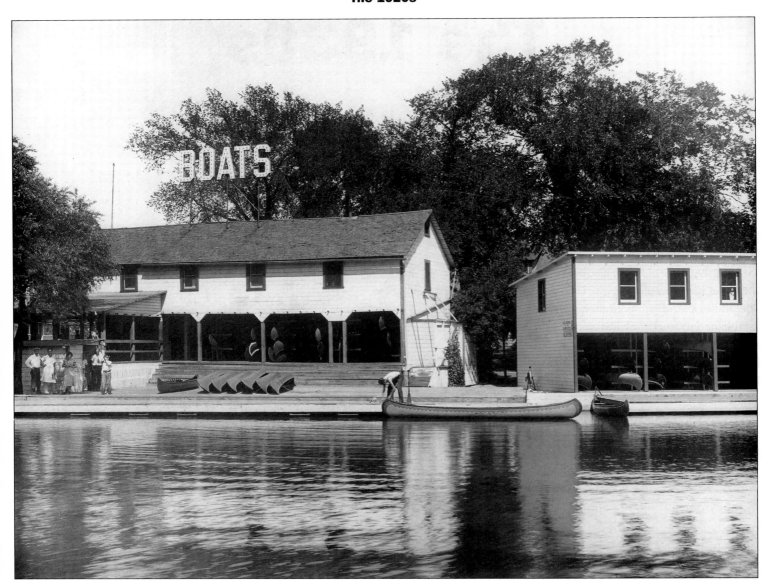

CRUISIN' DOWN THE RED

Dommer's was a popular recreation site on the Red River in downtown Fargo during the first half of the century. A footbridge just above the mid-town dam made Dommer's accessible to people from Fargo and Moorhead. The business closed in 1959.

THE FORUM / FILE PHOTO

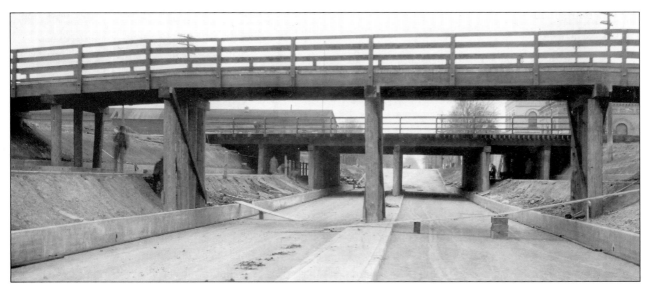

DOWN UNDER

In 1923, the North 10th Street underpass was constructed to ease travel to and from north Fargo. It was built in two parts to facilitate travel for Great Northern trains. The GN roundhouse was located southwest of North Dakota Agricultural College.

THE FORUM / FILE PHOTO

The 1930s

Dry and depressing: A trying time

Drought and the "Great Depression" followed the "Roaring '20s." More than 13 million Americans were out of work by 1933, and more than 750,000 farmers lost their land. Hundreds of thousands of people lost their life savings as banks failed.

The drought created a "Dust Bowl" on the Great Plains, including the Dakotas. "Bread lines" and "soup kitchens" were established to feed homeless people. President Franklin D. Roosevelt and a Democratic Congress passed the "New Deal" in an effort to end the depression.

Some other highlights were:

❑ Floyd B. Olson, Minnesota's first Farmer-Laborite governor, takes office in 1931.

❑ In 1931, the site of the International Peace Garden on the North Dakota-Manitoba border was selected.

❑ Fifty to 70 men broke into a jail at Schafer in North Dakota's McKenzie County Jan. 21, 1931, and seized prisoner Charles Bannon. The mob hung Bannon from a nearby bridge in the last recorded lynching in the state. He was being held for trial in the deaths of the A.F. Haven family of six.

❑ Sinclair Lewis from Sauk Centre, Minn., won the Nobel Prize for literature in 1931.

❑ Minnesotans, in 1932, cast their first Democratic majority in a national election.

❑ Bank robbers John Dillinger, Charles Makley, Russell Clark and Harry Pierpoint were captured in Tucson, Ariz.,

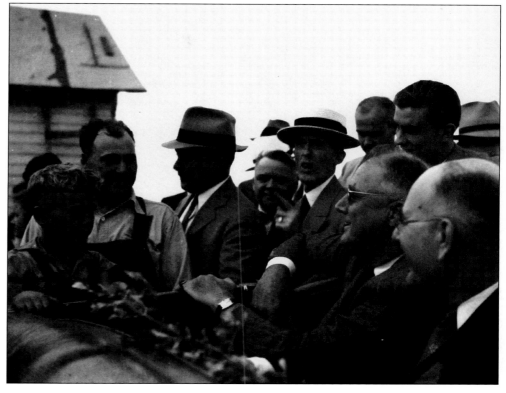

PRESIDENTIAL VISIT

President Franklin D. Roosevelt (seated second from right) visits a farm grant recipient near Mandan, N.D., in August 1936 during the height of drought and depression that plagued the United States.

THE FORUM / FILE PHOTO

Jan. 25, 1934, with $38,000. Dillinger and Herbert Youngblood, Port Huron, Mich., escaped from jail at Crown Point, Ind., and were shot to death July 22 by FBI agents outside a movie house in Chicago.

❑ North Dakota Gov. William L. Langer was sentenced to 18 months in prison and fined $10,000 on federal extortion charges on June 29, 1934. Later that year, on July 18, the state Supreme Court ousted Langer from governor and the National Guard was called out to protect his successor.

❑ On May 28, 1935, the Dionne sisters were the first quintuplets to survive beyond infancy. The were born to Elzire and Oliva Dionne of Callander, Ontario.

❑ The Social Security Act was adopted by Congress in 1935.

❑ Will Rogers, 56, and Wiley Post, 36, were killed Aug. 15, 1935 when Post's plane crashed in the fog near Point Barrow, Alaska.

❑ Still deep in drought in 1936, North Dakota recorded its highest and lowest temperatures ever. It was 120 above at Steele and 60 below at Parshall.

❑ North Dakota Agriculture College in Fargo, now North Dakota State University, lost its accreditation and 1,200 students staged a mass protest April 8, 1938.

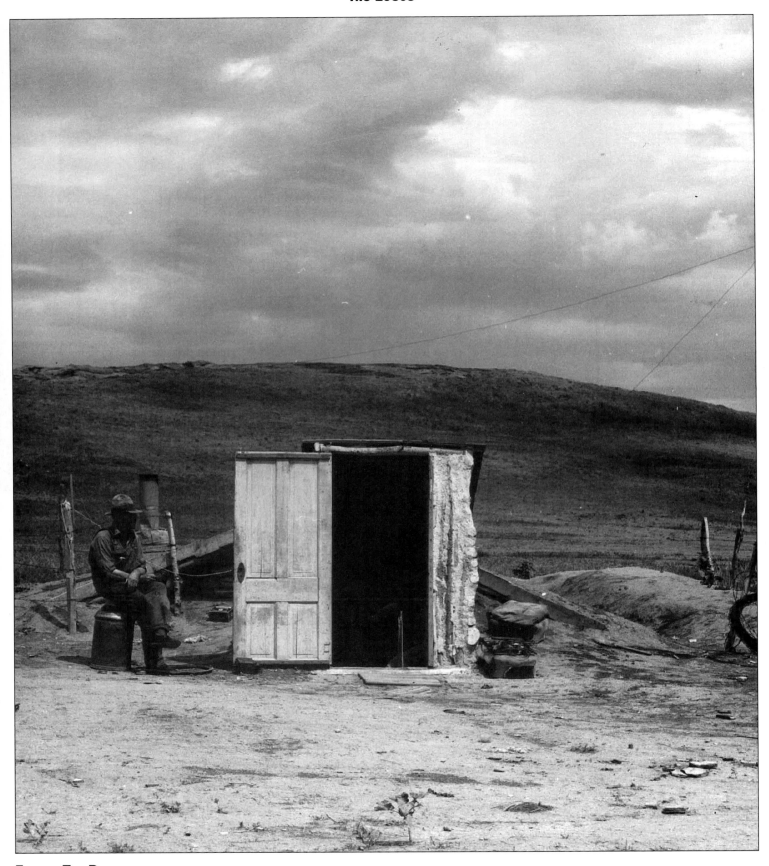

FEELING THE PAIN

The "Dust Bowl" of the 1930s took its toll on farmers and ranchers in the Dakotas. A farmer sits on a milk can outside his humble underground home near Grassy Butte about 40 miles northwest of Dickinson in the North Dakota Badlands. That part of the state lost more than half of its farmers and ranchers during that time and much of the land was purchased by the federal government and turned into grasslands.

THE FORUM / FILE PHOTO

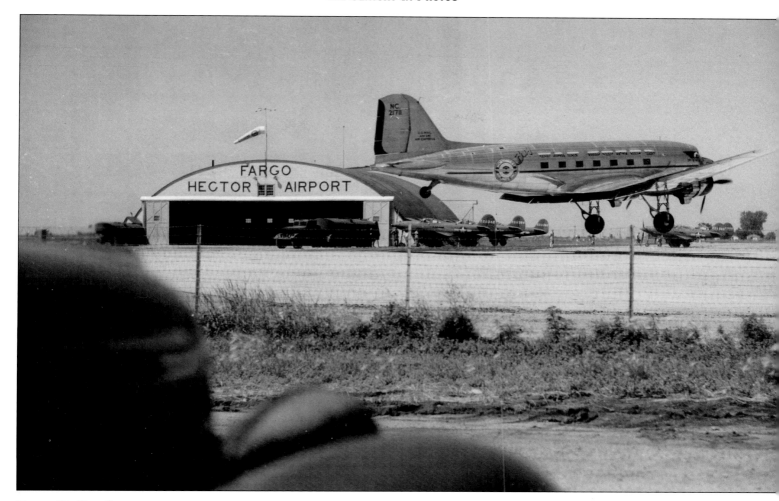

TAKING TO THE SKIES

An early-day airliner lands at Fargo's Hector Airport in the 1940s. Development of the airport began in the 1930s after Fargoan Martin Hector donated a quarter section of land to the city.

HECTOR INTERNATIONAL AIRPORT

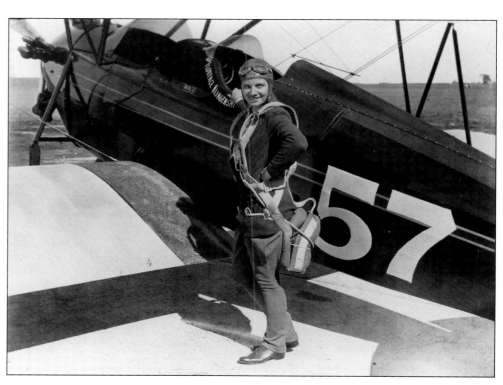

RECORD SETTER

Florence Klingensmith, a daring young woman from rural Moorhead, followed her dream to her death when the souped-up racer she was flying crashed during a 1933 Chicago International Air Show. Klingensmith twice set the women's national loop flying record. She sweet-talked six Fargo businessmen into helping her buy her first plane – "Miss Fargo" – for $3,000. She was 29 when she died.

MINNESOTA HISTORICAL SOCIETY

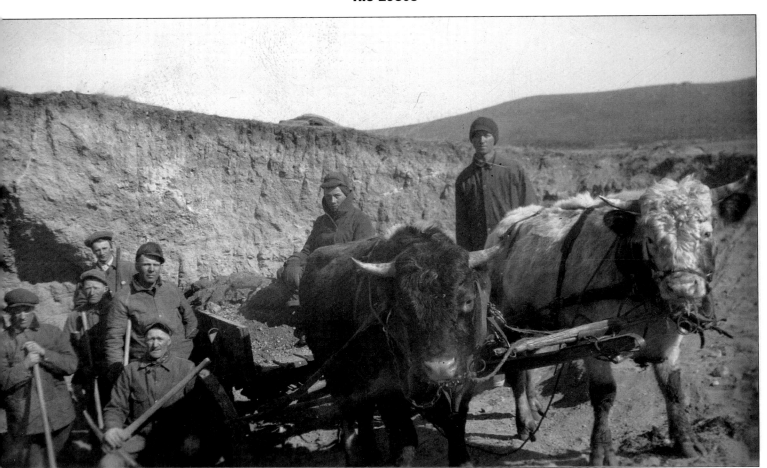

GOING BACK TO WORK

During the drought and depression of the 1930s, a group of laborers loads a wagon with dirt as part of a Work Projects Administration project in Griggs County near Cooperstown, N.D. The WPA was a federal program aimed at helping people who did not have jobs.

INSTITUTE FOR REGIONAL STUDIES, NDSU LIBRARIES

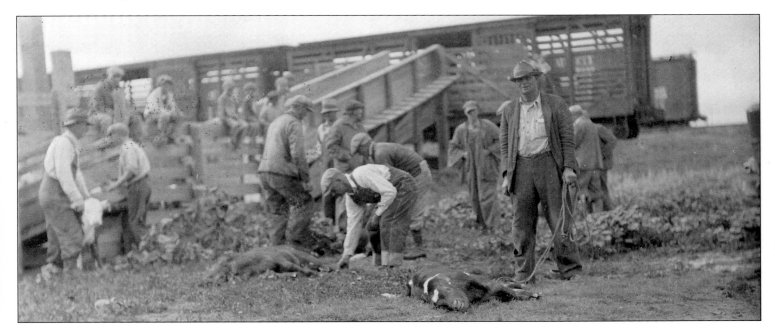

DROUGHT TAKES TOLL

The 1930s drought forced ranchers in Adams County near Hettinger in southwestern North Dakota to reduce their cattle herds. Calves are being butchered so that veal can be made available to the needy. Many farmers and ranchers had to leave the land because of the drought.

INSTITUTE FOR REGIONAL STUDIES, NDSU LIBRARIES

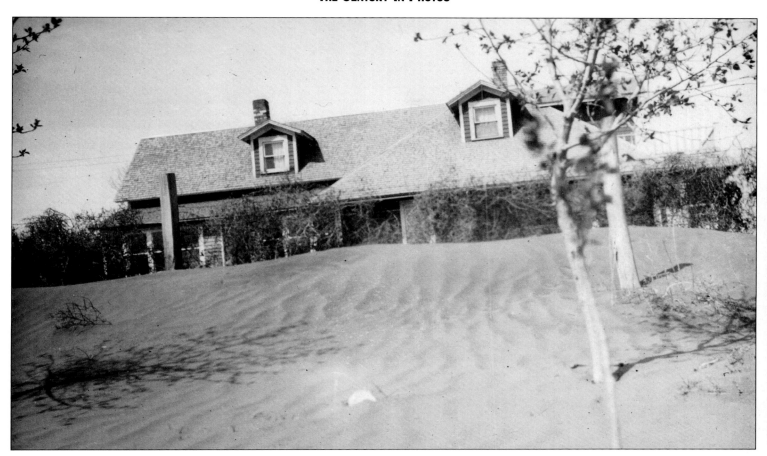

SAND BLIZZARD

The widespread drought of the 1930s doomed many farmers in the Dakotas, leaving sand and dirt drifts in place of fertile farmland.
NDSU ARCHIVES

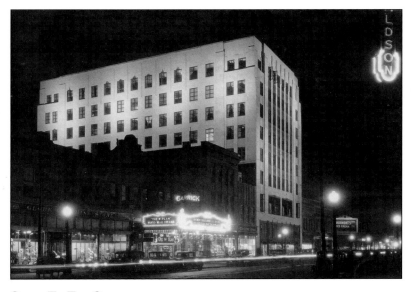

GOING TO THE SHOW

The Garrick Theatre on Broadway in Fargo operated from sometime around 1916 until the early 1930s. It was just south of the Black Building, which at the time was the tallest building in Fargo. Another early day theater was the Orpheum, which was located at 611 NP Ave., the site of a parking lot today. The Orpheum was destroyed by fire, but Forum files do not indicate the fate of the Garrick. At their beginnings, the two theaters offered live performances, the Orpheum later becoming a movie theater before being destroyed by fire.

COURTESY OF SCHLOSSMAN FAMILY

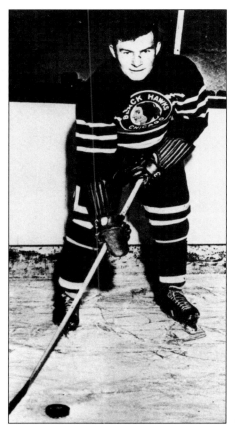

'MR. HOCKEY'

Cliff "Fido" Purpur, recognized as North Dakota's greatest hockey player of all time, began his career at the University of North Dakota and then went on to spend 14 seasons in the National Hockey League in the 1930s and '40s. At 5-foot, 5-inches and 145 pounds, he was the only American in the NHL at the time. He has been inducted into the North Dakota Sports Hall of Fame in Jamestown and the U.S. Hockey Hall of Fame.

INSTITUTE FOR REGIONAL STUDIES, NDSU LIBRARIES

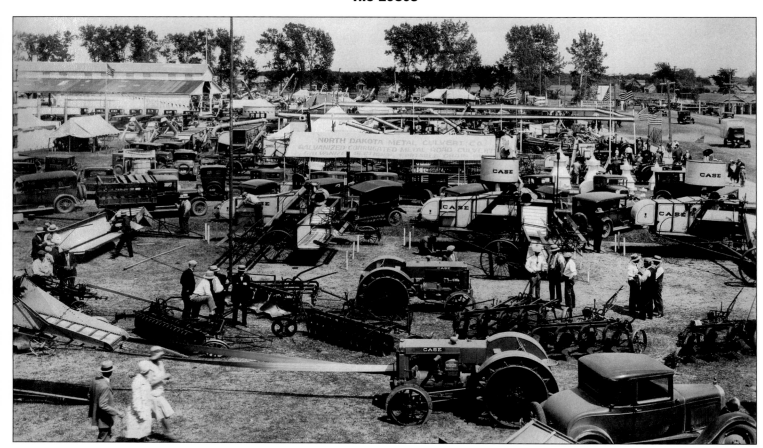

LET'S GO TO THE FAIR

Tractors, threshing machines, plows, automobiles, trucks and other farm goods are on display in the 1930s at the North Dakota State Fair in Fargo. The site, later known as the Red River Valley Fairgrounds, was in north Fargo between Broadway and University Drive and 17th and 19th Avenues.

DAVID ANDERSON PHOTOGRAPH COLLECTION, INSTITUTE FOR REGIONAL STUDIES, NDSU LIBRARIES

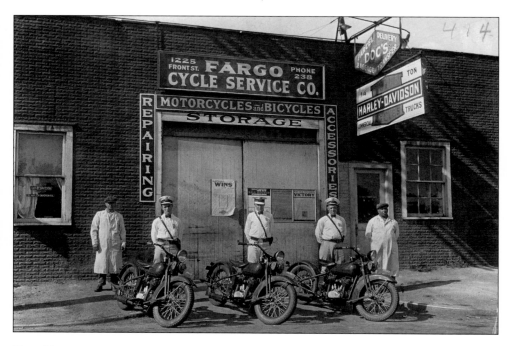

EASY RIDERS

Three Fargo policemen stand by their motorcycles with mechanics in the early 1930s at Fargo Cycle Service Co., 1225 Front St. (now Main Avenue).

INSTITUTE FOR REGIONAL STUDIES, NDSU LIBRARIES

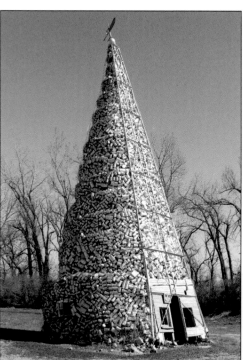

LEANING TOWER OF CANS

A 55-foot pile of empty lube cans has long been a landmark in Casselton, N.D. Max Taubert, who operated a Sinclair station, conceived the idea as an advertisement in 1932 and threw in the first can. The pile was moved in 1973 because of the expansion of the Loegering Manufacturing plant.

THE FORUM / NICK CARLSON

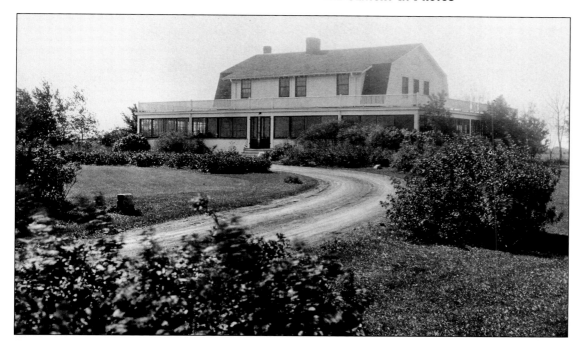

OLD AND NEW

The original Fargo Country Club building was destroyed by fire in 1930. The current facility (below) has been expanded a number of times since then.

LEFT: THE FORUM / FILE PHOTO
BELOW: THE FORUM / FILE PHOTO

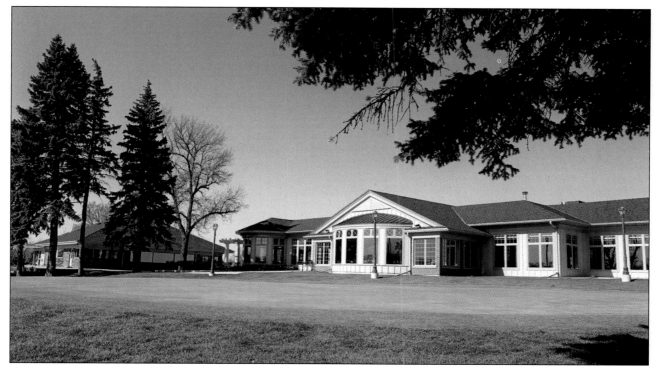

CCC CAMP

A Veterans' Civilian Conservation Corps camp was located at Mickelson Field between 9th and 11th avenues and west of the Red River in north Fargo during the late 1930s. The camp housed 200 CCC workers. In its beginning, it was a camp for veterans of World War I; later it housed younger people who needed work. The CCC was established by the Franklin D. Roosevelt administration to provide a government work-relief program to help get the drought- and depression-riddled nation back on its feet. The last camps were closed after World War II broke out Dec. 7, 1941.

THE FORUM / FILE PHOTO

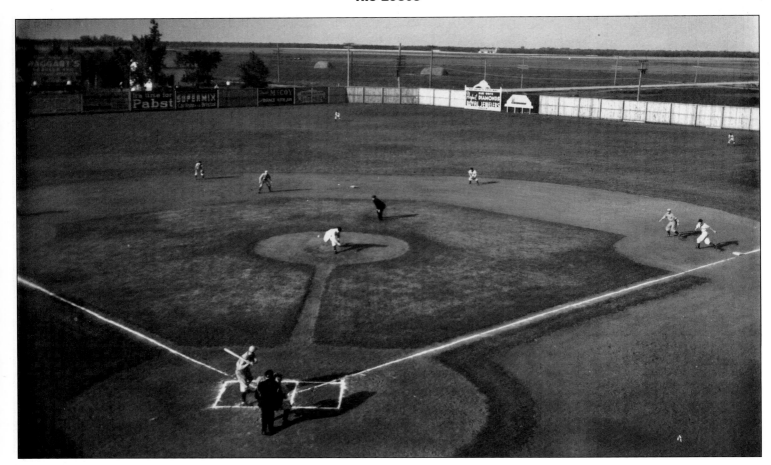

BATTER UP

Barnett Field, located on the current site of Fargo North High School at 19th Avenue and Broadway, was home to the Fargo-Moorhead Twins minor league baseball team. Many future major league stars, including Fargo's Roger Maris, played at Barnett Field.

DAVID ANDERSON PHOTOGRAPH COLLECTION, INSTITUTE FOR REGIONAL STUDIES, NDSU LIBRARIES

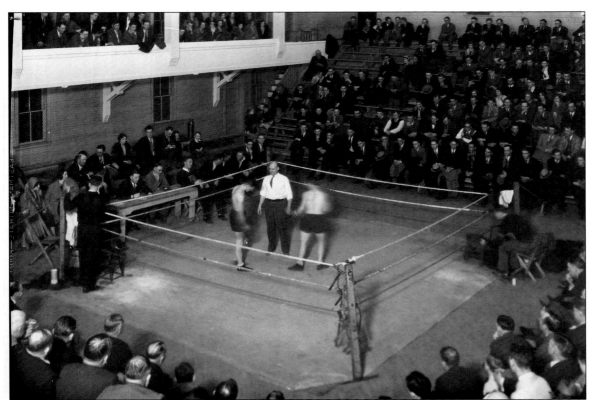

AND IN THIS CORNER

A large crowd is on hand for a 1931 boxing match at the North Dakota Agricultural College Armory, later known as Festival Hall. Note the early-day "luxury box" spectators in the balcony.

NDSU ARCHIVES

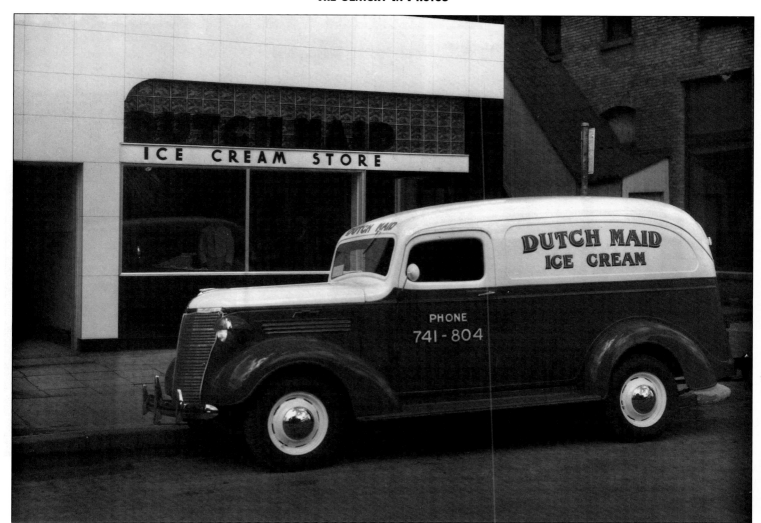

WE ALL SCREAM FOR ICE CREAM

The Dutch Maid Ice Cream Store on 8th Street just south of Main Avenue in Fargo was a popular gathering spot in the 1930s and 1940s. You could even get your ice cream delivered in those days. Dutch Maid also had a store on Broadway in downtown Fargo.

DAVID ANDERSON PHOTOGRAPH COLLECTION, INSTITUTE FOR REGIONAL STUDIES, NDSU LIBRARIES

MINNESOTA LANDMARK

Anyone traveling through Bemidji, Minn., has probably seen legendary lumberjack Paul Bunyan and Babe, the Blue Ox, on the shores of Lake Bemidji. It all began in 1937 as a project of the Bemidji Rotary Club. It was the first of many mascot-style statues to be erected in the region. In the early days, the car beneath Babe allowed it to take part in parades.

BELTRAMI COUNTY HISTORICAL SOCIETY

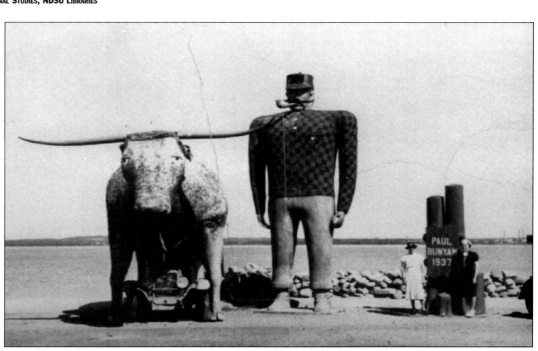

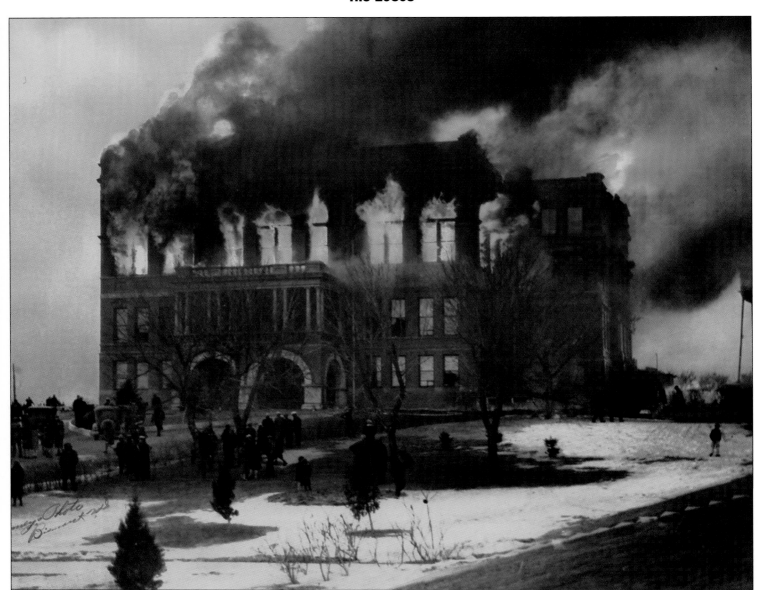

DOWN IN FLAMES

On Dec. 28, 1930, the old Dakota Territory Capitol, which also served as North Dakota's Capitol in Bismarck, was destroyed by fire. Gov. George F. Shafer broke ground for a new $2 million state Capitol (at right) Aug. 13, 1932. At the time, it was to become the largest building in the state. It was completed in 1934. It has expanded a number of times over the years.

TOP: THE FORUM / FILE PHOTO
RIGHT: THE FORUM / JANELL COLE

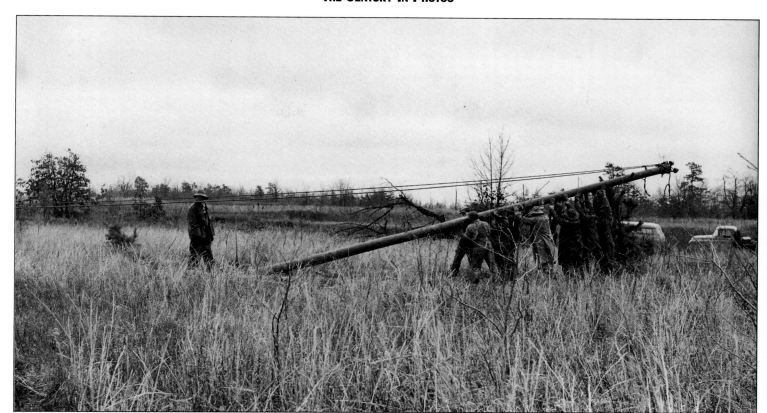

BRINGING POWER TO THE PEOPLE

Farmers help raise poles to bring electricity to the rural area. The Rural Electrification Association program started in the 1930s but many parts of North Dakota did not receive power until the late 1940s or early 1950s because of delays caused by World War II.

COURTESY OF CASS COUNTY ELECTRIC COOPERATIVE

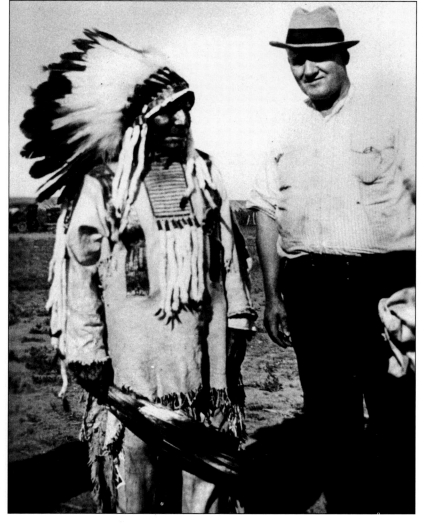

RESERVATION TOUR

U.S. Rep. Usher Burdick of Williston, N.D., and Old Bull, of Bullhead, S.D., visited area Indian reservations in the region during a 1931 trip. Usher, a Republican, was the father of U.S. Sen. Quentin Burdick of Fargo, who was elected on the Democratic Nonpartisan League ticket.

THE FORUM / FILE PHOTO

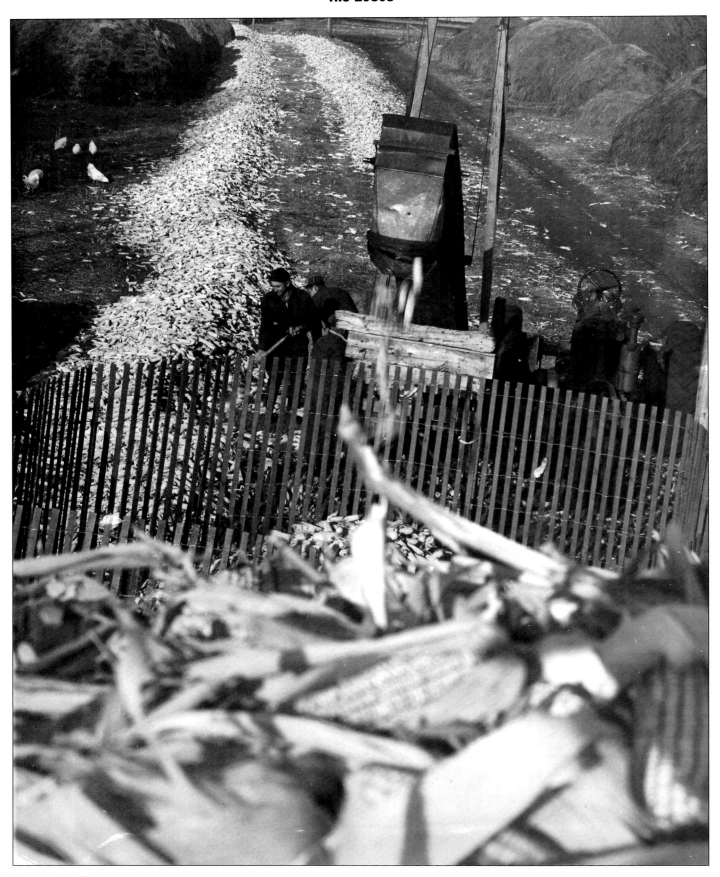

PICKING UP CORN

Farmers in North Dakota's Richland County pick up corn in November 1939 and place it in bins for livestock feeding. Richland is the state's top corn-producing county.

THE FORUM / FILE PHOTO

The 1940s

Recovering, going back to war

The United States was beginning to recover from the drought and depression of the 1930s when Japanese planes pulled a sneak attack on Pearl Harbor Dec. 7, 1941, damaging much of the nation's Pacific Fleet and plunging the country into World War II.

Plants quit producing consumer goods, such as cars and washing machines, in an all-out effort to manufacture war wares. It was a time when many women first entered the workforce and "Rosie the Riveter" worked alongside men on warships, tanks, planes and filling other military needs.

Rationing of food, gasoline and other consumer products was put into effect. There were even lines at neighborhood stores for a one-cent piece of bubble gum. The nation's young men were drafted and about 15 million American men and 338,000 women served in the armed forces.

Some other highlights were:

❏ A major snowstorm hit the Midwest on Armistice Day 1940, leaving 169 people dead, including 49 in Minnesota. Many of the Minnesota victims were duck hunters caught afield.

❏ The following spring, on March 15, 1941, another major snowstorm struck the Midwest and Canada, leaving 39 dead in North Dakota, 32 in Minnesota and eight in Canada.

❏ A special session of the Minnesota Legislature was called in 1942 to pass legislation allowing those in the armed forces to vote.

❏ It was Victory in Europe Day for allied forces on May 8, 1945.

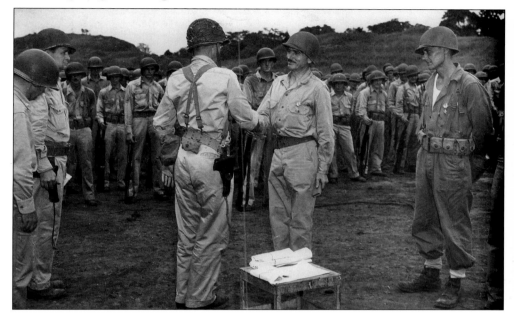

A LOCAL HERO

Col. Bryan E. Moore presents Major George Schatz of West Fargo with a Silver Star Medal for his heroic efforts during the battle for Guadalcanal, a South Pacific island, in 1943. The battle was the first stepping stone in the U.S. effort to drive the Japanese back to their homeland. Schatz, a member of North Dakota's 164th Infantry, drove a Jeep into the face of enemy fire to rescue and give aid to three seriously wounded soldiers, saving their lives. On the right is Staff Sgt. Paul Sanders of Harvey, N.D., who received a Silver Star Medal for similar deeds beyond the call of duty.
THE FORUM / FILE PHOTO

❏ On Aug. 6, 1945, the United States dropped its first atomic bomb on Japan's Hiroshima. Three days later another bomb was dropped on Nagasaki. It was estimated that 80,000 people died in Hiroshima and 39,000 in Nagasaki.

❏ Japan surrendered Aug. 14, 1945, with the formal surrender papers signed Sept. 2 aboard the USS Missouri.

❏ In 1946, Norwegian statesman Trygve Lie was chosen to be the first secretary-general of the United Nations.

❏ It was in 1946 that Dr. Benjamin Spock wrote his influential book on baby care, a book that changed the way many people brought up their children.

❏ A bill was approved by Congress in 1947 and signed by President Harry Truman creating Theodore Roosevelt National Memorial Park in the North Dakota Badlands. The park was dedicated June 4, 1949.

❏ Carl White opened a Dairy Queen in June 1948 in Fargo's Island Park area. The new, soft ice cream resulted in long lines of folks waiting to test the treat.

❏ The North Dakota Air National Guard out of Fargo dropped feed to starving animals in the western area of the state after a Feb. 5, 1949, storm dumped 16 inches of snow on top of 14 inches already on the ground.

GERMAN PRISONERS IN MOORHEAD

During World War II, German prisoners of war were housed in an onion warehouse in north Moorhead on 21st Street near 4th Avenue. The POWs worked on area farms. Most prisoners had been captured in Italy and Sicily, although a few were taken in north Africa. The first group of German POWs reached Moorhead May 28, 1944, and the last of them departed after harvest time in the fall of 1945. It was one of many POW camps in the Midwest.

CLAY COUNTY HISTORICAL SOCIETY, FLORENCE DRURY COLLECTION

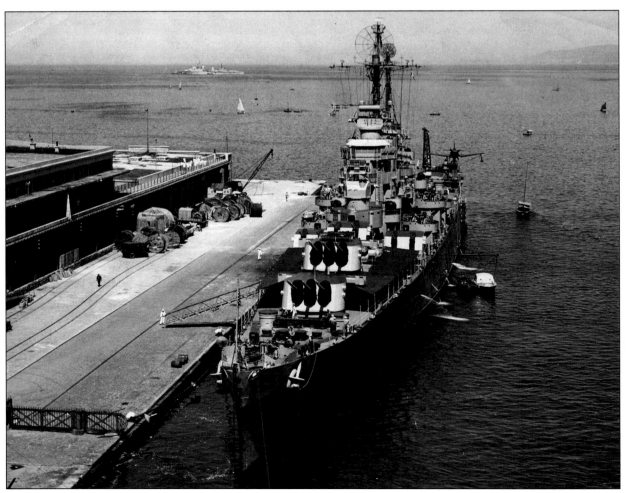

TOO LATE TO FIGHT

The USS Fargo is docked at Trieste, Italy, in July 1946. The ship was launched Feb. 25, 1945 with Mrs. Frederick O. Olsen, the wife of a Fargo city commissioner, acting as sponsor during the ceremonies. The new cruiser was commissioned Dec. 9, 1945, too late to play an active role in World War II. The ship was decommissioned in September 1949.

THE FORUM / FILE PHOTO

CARE GIVER

Anne Carlsen turned her birth deformities into assets at the Anne Carlsen Center for Children, named in her honor, at Jamestown, N.D. She taught there and served as principal, child guidance director and superintendent from 1941 until her retirement in 1981. When she was born to Danish immigrant parents Nov. 4, 1915, in Wisconsin, she had no arms past her elbows and a single leg so badly deformed it had to be amputated when she was 15. After her retirement, she continued to live at the school for children who are physically or multi-handicapped.

THE FORUM / FILE PHOTO

BROADWAY STAR

Dickinson, N.D., native Dorothy Stickney got her Broadway break in "The Squall" in 1926 and became known for playing character roles in hits like "Chicago" and "Front Page." Stickney also starred as the mother in "Life With Father," which played at the Empire Theater for seven years, making it the longest-running musical in Broadway history. She died in 1998 at age 101.

THE FORUM / FILE PHOTO

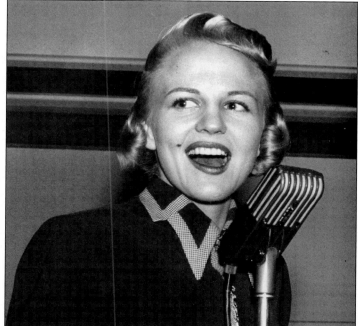

GRAMMY WINNER

Singer Peggy Lee was born Norma Egstrom May 16, 1920, in Jamestown, N.D. She launched her singing career on WDAY radio and at the Powers Hotel in Fargo in 1937 before rising to stardom with Benny Goodman's orchestra in the early 1940s. It was while at WDAY that she changed her name to Peggy Lee. She was nominated for an Academy Award for best supporting actress in the film, "Pete Kelly's Blues," and is a Grammy Award winner. She was inducted into the North Dakota Rough Rider Hall of Fame in 1975.

THE FORUM / FILE PHOTO

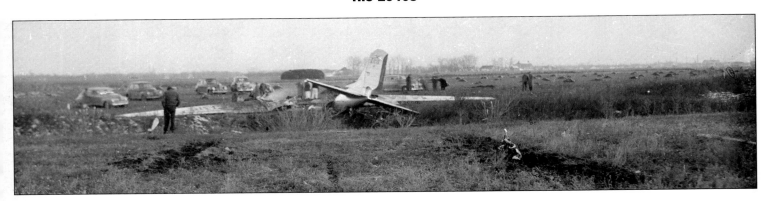

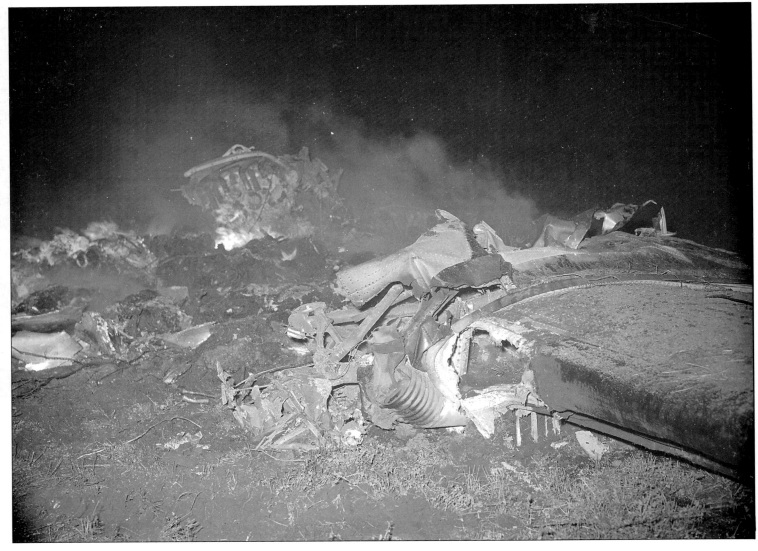

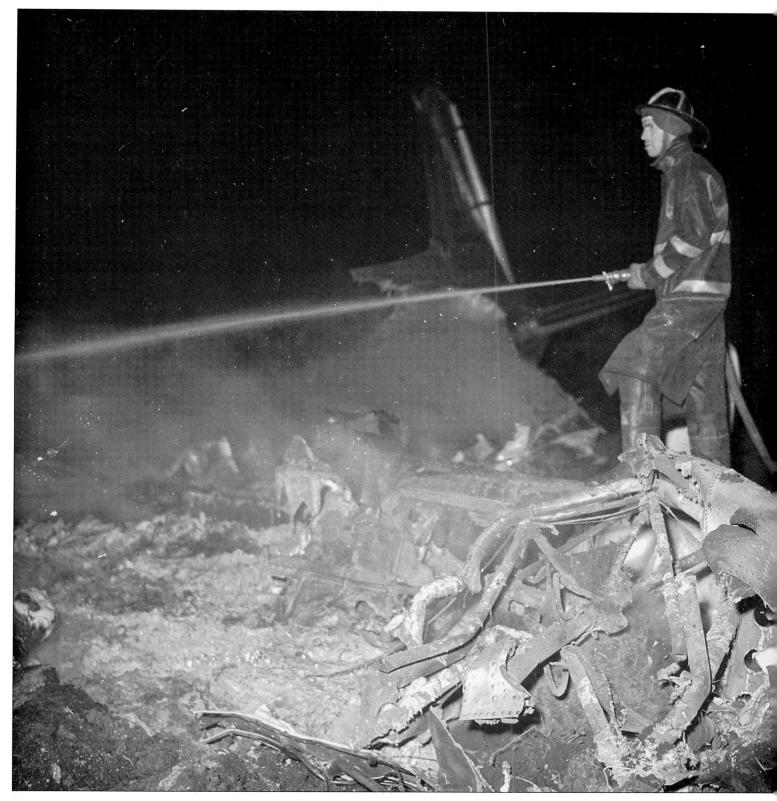

AIR TRAGEDY

A Moorhead fireman hoses the wreckage of a Northwest Airlines passenger plane that crashed at 2:04 a.m. Oct. 30, 1941. The plane went down just north of the Moorhead city limits where the American Crystal sugar beet plant stands today. Only the pilot survived. The plane was en route from Chicago to Seattle via Minneapolis and Fargo. It was to date the only commercial airline crash in northwestern Minnesota. The Civil Aeronautics Board found the crash was caused by icing and cleared the pilot, Capt. Clarence F. Bates, 41, of any responsibility. On the page at left are more photos of the wreckage and The Forum's extra edition headline.

ABOVE: CLAY COUNTY HISTORICAL SOCIETY
PAGE 46: CLAY COUNTY HISTORICAL SOCIETY

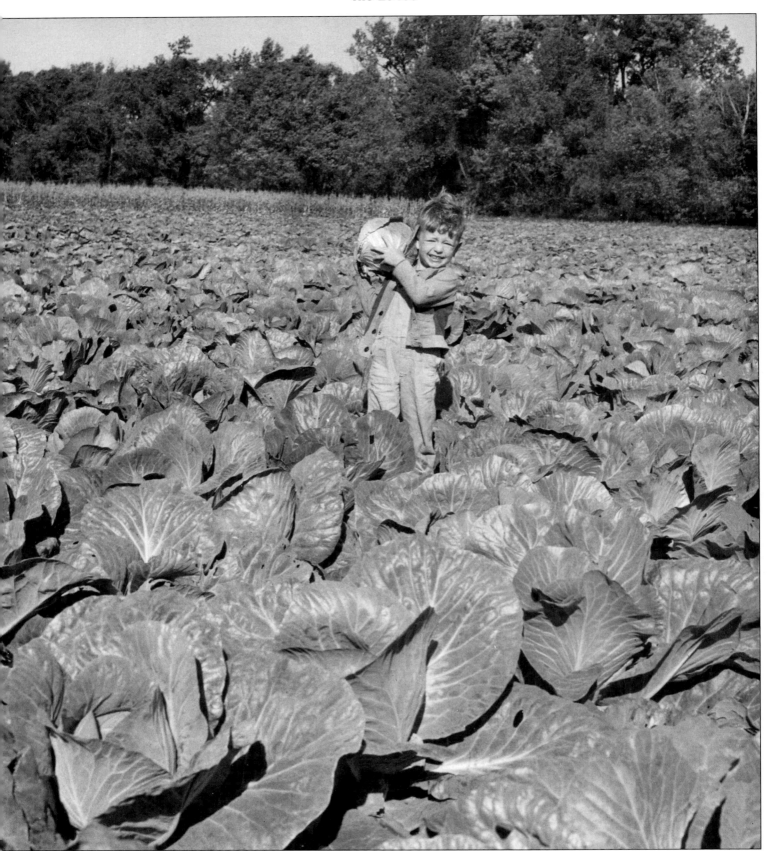

JUST SHOWIN' OFF

Five-year-old Eddie Evernham of Moorhead holds an 8-pound head of cabbage from one of several commercial cabbage patches in Clay County in the late 1940s. Eddie's father, William, was a foreman on the Ray Gesell farm two miles north of Moorhead along U.S. Highway 75. This photo was taken in September 1948. The farm also is known as the Probstfield Homestead and today is the site of the Old Trail Market.

THE FORUM / FILE PHOTO

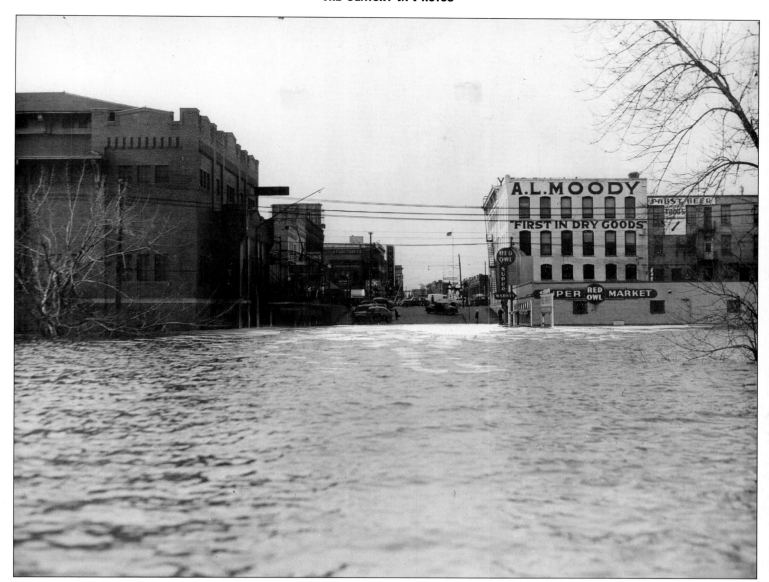

LAPPING UP BROADWAY

The Red River inundates several buildings at the foot of Broadway in Fargo during the spring of 1943. At right is the Red Owl Store and A.L. Moody's department store. At left is the old Crystal Ballroom and Fargo Armory. This scene was repeated several times in the late 1940s and early 1950s before dikes were built to protect Island Park and the former St. John's Hospital.

THE FORUM / FILE PHOTO

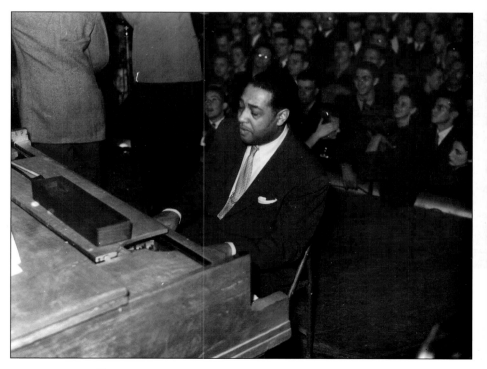

DUKE PLAYS THE CRYSTAL BALLROOM

Duke Ellington and his band visited Fargo's Crystal Ballroom Nov. 7, 1940. They drew a full house. The recording of the performance, released publicly in 1978, won a Grammy Award for best jazz instrumental performance by a big band.

COURTESY OF JACK TOWERS

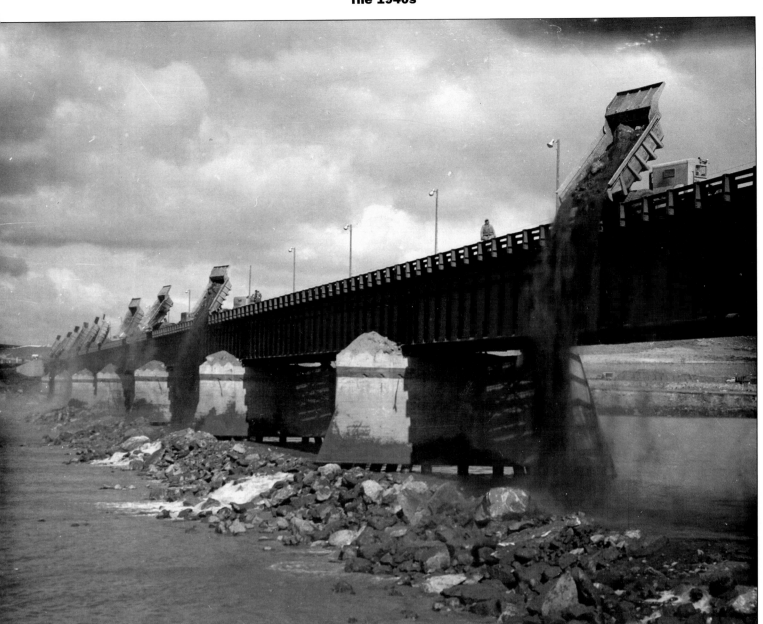

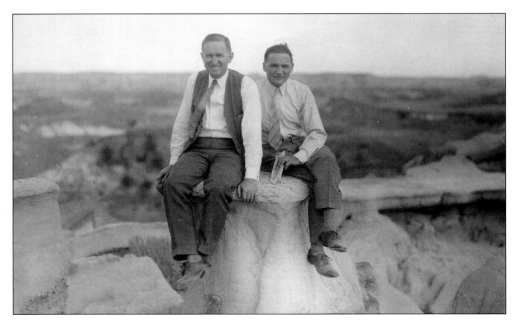

TAMING THE WIDE MISSOURI

Trucks dump rocks from a construction bridge across the channel of the Missouri River during the closure of Garrison Dam just west of Riverdale, N.D. Construction began in 1946 and was completed in 1953. It was built for flood control, navigation and the North Dakota dream of diverting Missouri River water across the state for irrigation and municipal water supplies.

THE FORUM / FILE PHOTO

LOOKS GOOD FROM HERE

Horace M. Albright (left) and U.S. Sen. Gerald P. Nye of North Dakota survey the fascinating formations and colorings of the Badlands from atop Cathedral Point near Medora. They were checking out the future site of Theodore Roosevelt National Park, which was established in 1947.

THE FORUM / FILE PHOTO

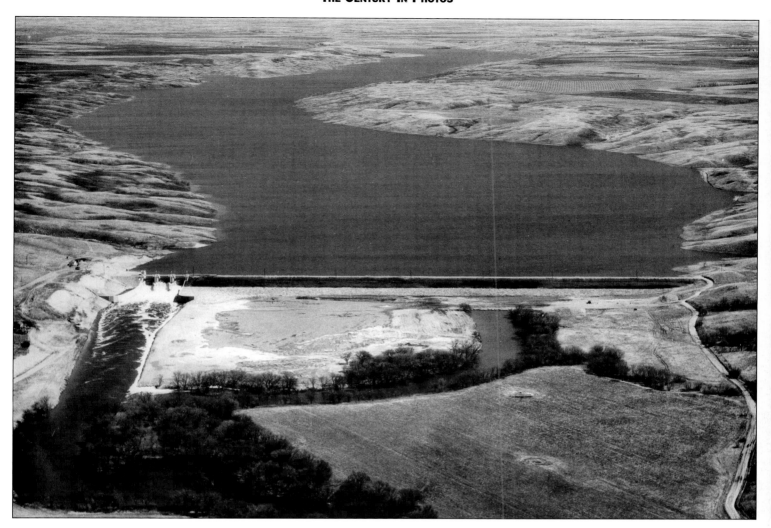

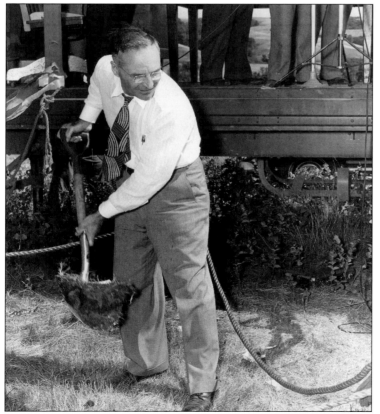

BUILDING BALDHILL DAM

North Dakota Gov. Fred G. Aandahl (left) breaks ground in August 1947 to signal the start of construction on Baldhill Dam nine miles north of Valley City on the Sheyenne River. The city of Fargo helped finance the dam for flood control and municipal water supplies. Above, the reservoir is filled for the first time after the spring runoff in 1950. The 27-mile body of water contained by Baldhill Dam became known as Lake Ashtabula.

TOP: THE FORUM / FILE PHOTO
LEFT: THE FORUM / FILE PHOTO

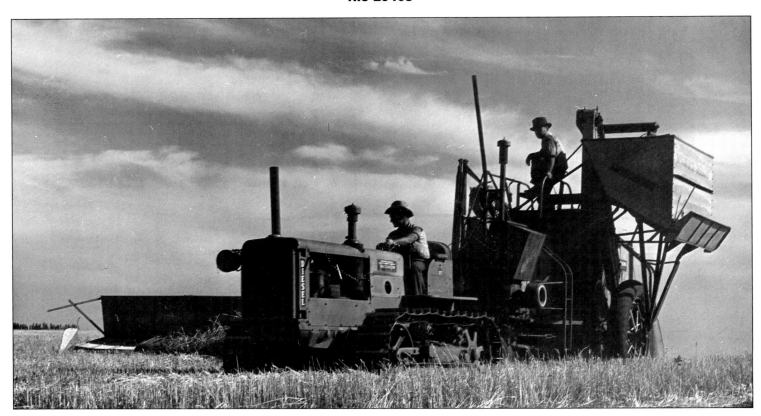

HARVEST TIME

An early-day threshing machine pulled by a crawler-type tractor harvests a grain field on the A.H. Meyer farm between Fargo and West Fargo, circa 1940.

THE FORUM / FILE PHOTO

CRYSTAL GROWS

The American Crystal plant is under construction in 1948 just north of Barney Lamm's Green Gable cabins, hangar and other facilities on the old Lamm farm on 11th Street North in Moorhead. The Denver-based American Crystal Sugar Co. became a grower-owned cooperative in 1973. Crystal has grown considerably over the years.

THE FORUM / FILE PHOTO

NORTH DAKOTA GIANT

Edward G. Melroe, Gwinner, became North Dakota's first major farm equipment manufacturer. He opened a small factory in Gwinner in 1947 to mass produce a windrow pickup, and later a spring-tooth harrow which was introduced in 1953. He developed the first windrow attachment for combines in the late 1920s.

THE FORUM / FILE PHOTO

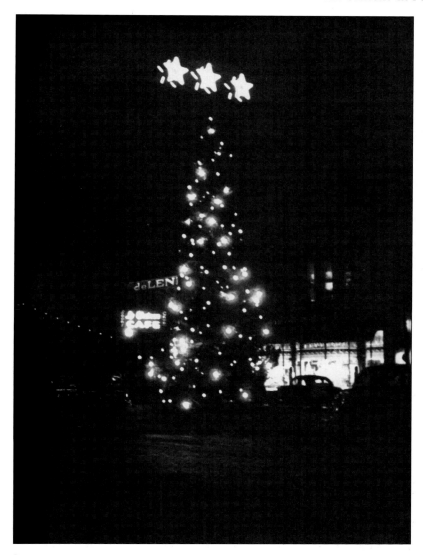

DECORATING DOWNTOWN FARGO

Traditionally, Fargo erected a Christmas tree on Broadway just north of the Northern Pacific Railroad tracks. This photo was taken Dec. 21, 1941, two weeks after World War II began. It was a time when Christmas shoppers flocked to downtown Fargo.

BILL RUDD PHOTOGRAPH COLLECTION, INSTITUTE FOR REGIONAL STUDIES, NDSU LIBRARIES

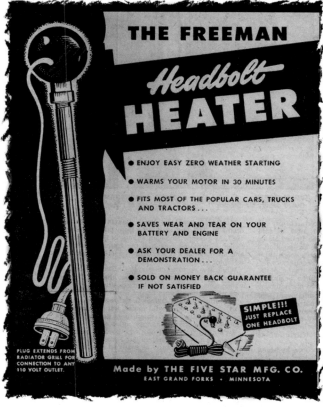

OUT OF NECESSITY

Andy Freeman of Grand Forks, N.D., invented the Freeman Headbolt Heater, the grand-daddy of modern plug-in heaters used to warm cars and trucks for cold-weather starts. He began working on the heater in the 1930s and got a patent on it in 1947. They sold for $10 each. It was named the headbolt heater because it replaced one of the headbolts in the car's engine.

THE FORUM / FILE PHOTO

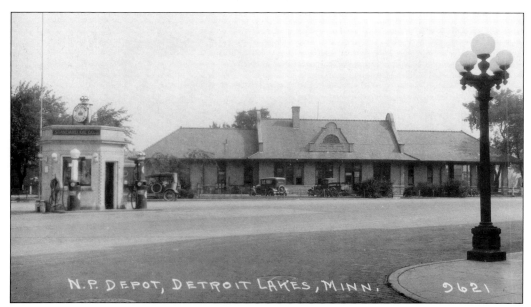

NOT MUCH BIGGER THAN A PHONE BOOTH

It was known across the country as the world's smallest gas station, located on U.S. Highway 10 at Minnesota Avenue in Detroit Lakes, Minn. The Standard Oil station existed until the 1960s when Highway 10 was widened. The former Northern Pacific Depot is in the background.

COURTESY OF CLIFF OFTELIE

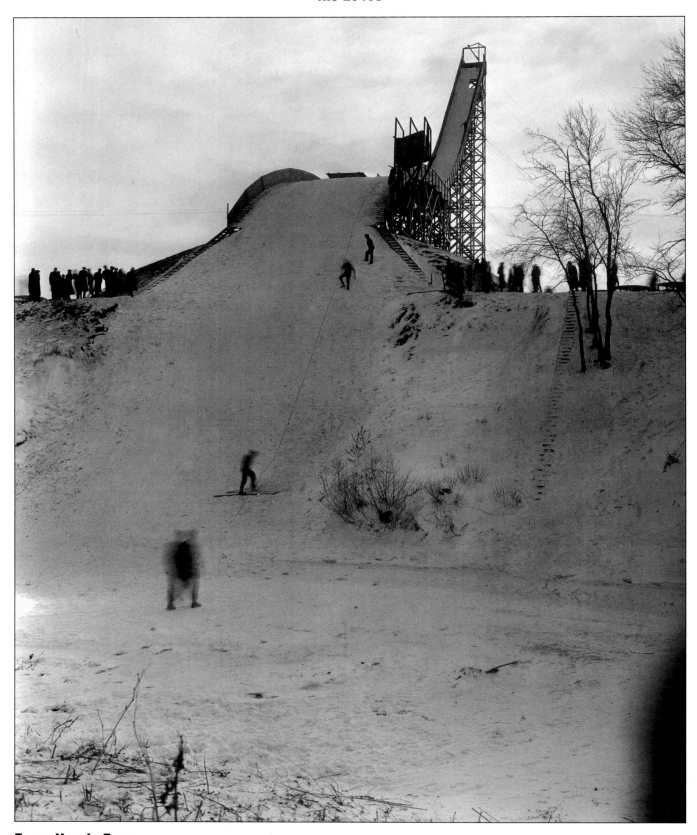

FLYING HIGH IN FARGO

North Dakota had numerous ski jumps like this one in north Fargo near today's entrance to Trollwood Park off Broadway. It was considered the largest ski jump in the U.S. at the time. It rose 140 feet above the prairie with a 200-foot runway. The Dovre Ski Club of Fargo constructed the jump in 1935 with 2-by-6 lumber bolted together and supported by a series of guide-wire cables. It was torn down in 1942 when the U.S. Civil Aeronautics Authority decided it was a potential hazard for planes landing at Fargo's nearby Hector Airfield. An effort to build a new slide on the same site in the late 1940s was rejected by the Cass County Commission.

DAVID ANDERSON PHOTOGRAPH COLLECTION, INSTITUTE FOR REGIONAL STUDIES, NDSU LIBRARIES

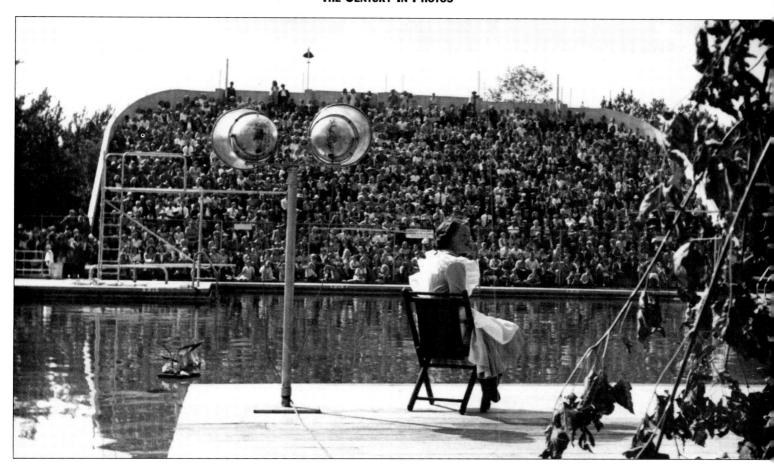

SUMMER SHOW

Pat Michelson looks across to a standing-room-only crowd during an open-air theatrical production at Fargo's original Island Park swimming pool in the summer of 1944. The pool was built as part of a WPA project in the 1930s. Its facade still stands today.

DAVID ANDERSON PHOTOGRAPH COLLECTION, INSTITUTE FOR REGIONAL STUDIES, NDSU LIBRARIES

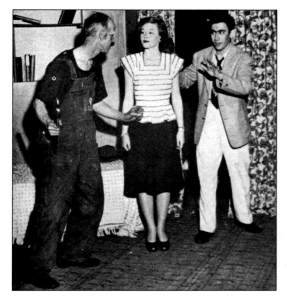

IT'S ALL AN ACT

The Fargo-Moorhead Community Theatre's first production in 1946 was "My Sister Eileen." It was presented at Moorhead Junior High School. In 1967, the FMCT moved into its current home, the Emma K. Herbst Playhouse at 333 4th St. S., Fargo.

COURTESY OF FMCT

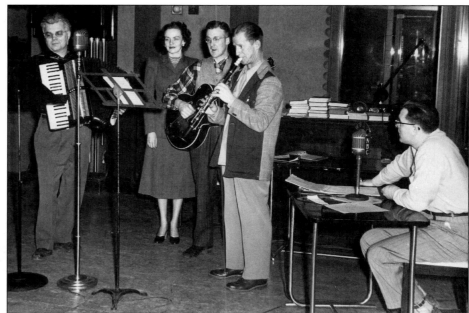

TAKING TO THE AIR WAVES

The Co-op Shoppers perform on WDAY-AM, the first radio station in this part of the country circa 1940. WDAY began broadcasting May 22, 1922. From left: Don (Axel) Wardwell, Dorothy (Linda Lou) Fandrich, Joseph (Little Joe) Stamness and Les (Shorty) Estenson.

COURTESY OF WDAY

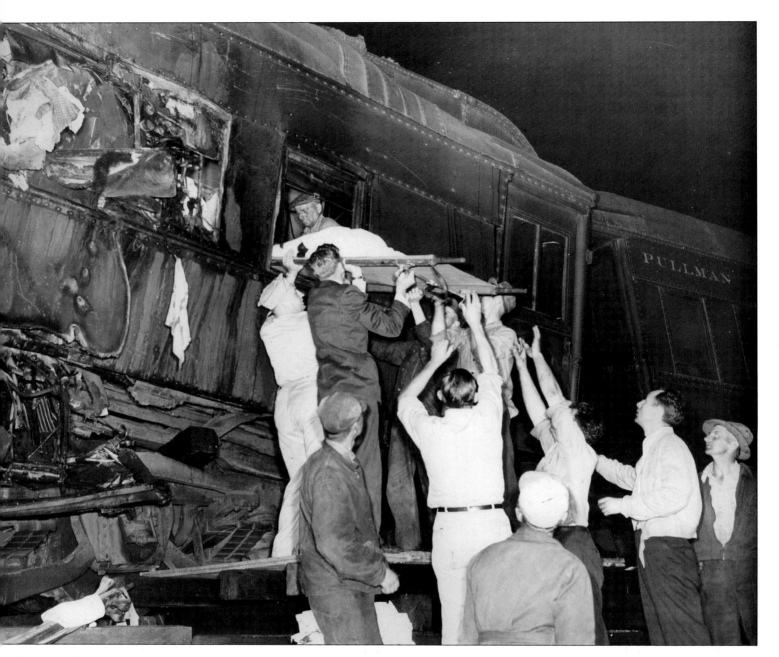

MICHIGAN DISASTER

Thirty-four passengers were killed Aug. 9, 1945, in North Dakota's worst railroad disaster near Michigan, 50 miles west of Grand Forks. The observation car of the Great Northern Empire Builder's lead train was plowed into by its second section. Rescue workers extricate bodies from the wreckage.

THE FORUM / FILE PHOTO

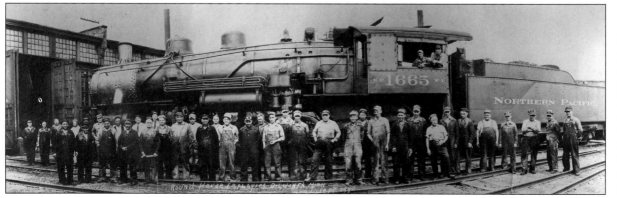

I'VE BEEN WORKING...

Northern Pacific Railroad workers pose at the Dilworth Roundhouse in 1940. The roundhouse was a major repair point for steam locomotives, which needed to be refilled with water and coal every 100 miles.

CLAY COUNTY HISTORICAL SOCIETY

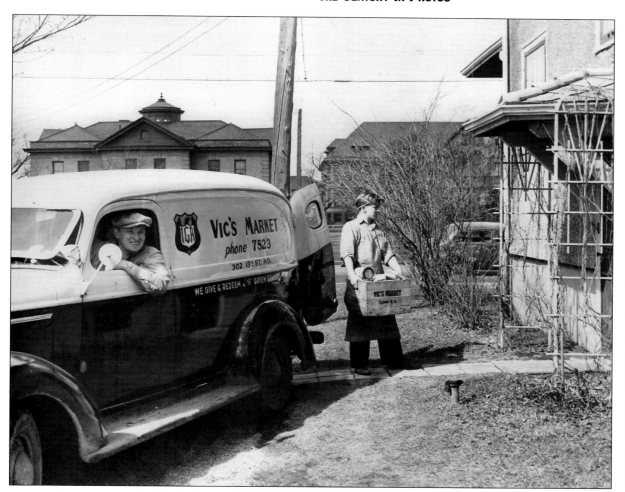

DELIVERING THE GOODS

A Vic's Market delivery boy unloads groceries at the home of David Anderson, 1340 12th Ave. N., Fargo, circa 1940. Vic's was located on North University Drive across from Woodrow Wilson School. It was one of Fargo's early-day supermarkets.

DAVID ANDERSON PHOTOGRAPH COLLECTION, INSTITUTE FOR REGIONAL STUDIES, NDSU LIBRARIES

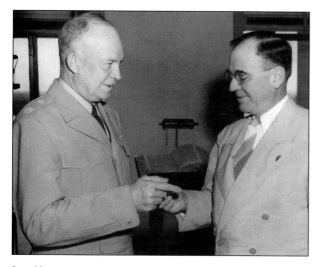

IKE HONORED

Lynn Standbaugh (right), a former American Legion national commander from Fargo, presents U.S. Army Chief of Staff Dwight D. Eisenhower with a life membership in the International War Veterans Alliance June 20, 1947. Standbaugh, a member of the board of directors of the Export-Import Bank of Washington, made the presentation at the Pentagon in Washington. Eisenhower, a World War II hero, later became president of the United States.

THE FORUM / FILE PHOTO

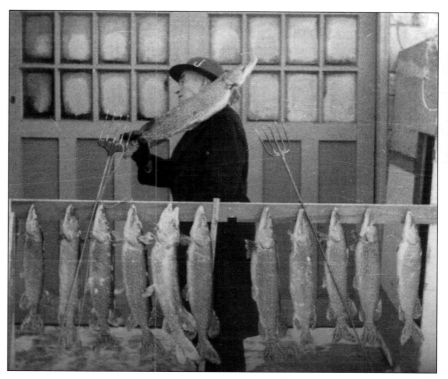

WHAT A DAY!

Winter spear fishing was good for Henry Wood as evidenced by this 1944 scene on the south shore of Little Detroit Lake at Detroit Lakes, Minn.

COURTESY OF LOHMAN FAMILY

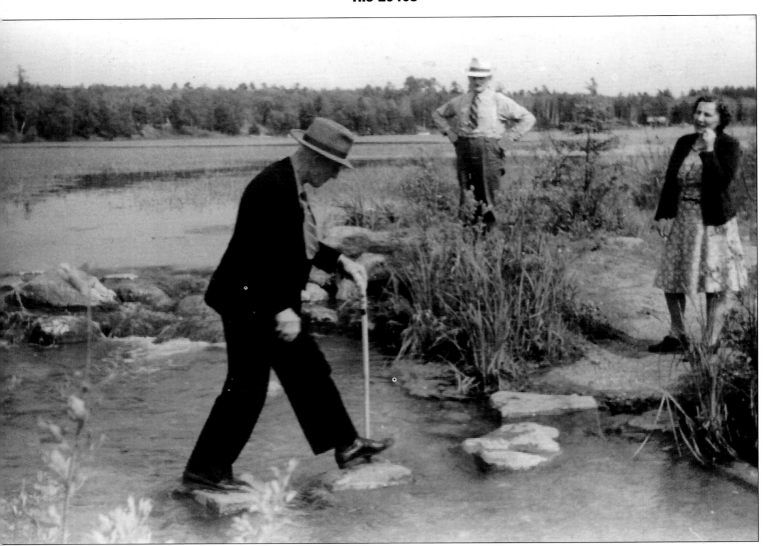

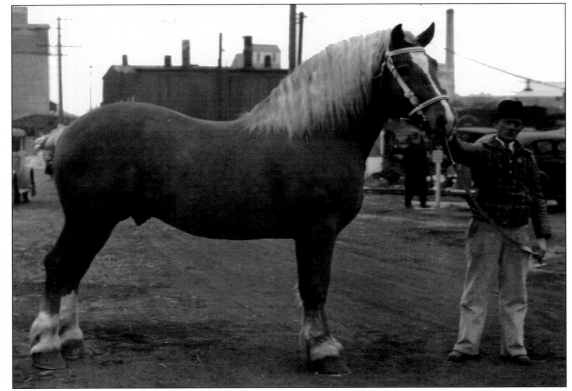

STEPPING OUT

The headwaters of the Mississippi River, located in Itasca State Park north of Park Rapids, Minn., has long been a popular tourist attraction. Stones in the river allow visitors to walk across without getting wet, as shown in this 1942 photo. From Itasca, the river flows 2,552 miles to the Gulf of Mexico.

COURTESY OF LOHMAN FAMILY

WINTER SHOWING OFF

Sollie Burchill, superintendent of the horses and cattle division of the North Dakota Winter Show in Valley City, poses with one of the prized Belgian horses of Charlie Brantner, Georgetown, Minn., March 4, 1942. The first Winter Show was held March 8-11, 1938.

COURTESY OF N.D. WINTER SHOW

The 1950s

Back on track, growing fast

As the 1950s began, the United States was on a roll with consumer goods again plentiful. Fast food outlets came on the scene and the neighborhood grocery stores began to lose their business to supermarkets.

It was one of the nation's periods of greatest economic growth. The population of the United States grew by about 28 million. Rock 'n Roll and Elvis Presley took the spotlight. Drive-in movie theaters popped up in community after community. The Korean War came and went.

Civil rights became a big issue and President Dwight Eisenhower sent troops into Little Rock, Ark., to enforce integration. Federal Judge Ronald Davies of Fargo signed the desegregation order.

Television became a part of every household and the space age began.

Some other highlights were:

❑ In 1950, civil defense authorities urged residents to build bomb shelters in their homes as the Cold War intensified and conflict began to brew in Korea.

❑ The first hydrogen bomb was exploded by the United States on its Pacific proving grounds on Nov. 1, 1952.

❑ Polio, a crippling disease that hit the nation's young people in epidemic proportions in the last years of the 1940s, was brought under control in 1954 when Dr. Jonas Salk developed the polio vaccine.

❑ Another spring of flooding on the Red River in April 1952 resulted in the evacuation of St. John's Hospital in Fargo. Up to 500 volunteers built sandbag dikes to protect the Veterans Administration Hospital.

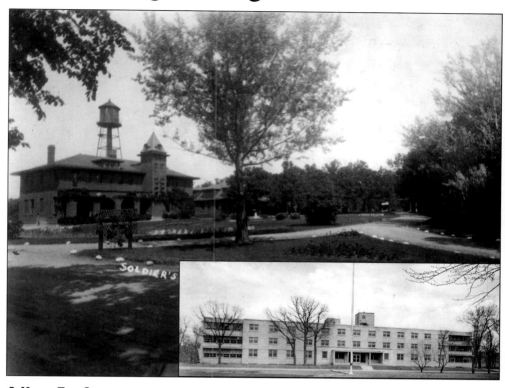

A HOME FOR SOLDIERS

North Dakota's first Soldiers' Home opened in Lisbon in August 1893. The first soldier to enter the home was George Hutchings, a 73-year-old veteran of the Civil War and a resident of Ransom County. On June 7, 1950, a new Soldiers' Home (inset) was dedicated by Gov. Fred G. Aandahl. It cost $638,000. The old Barracks Building was demolished in 1952.

THE FORUM / FILE PHOTOS

❑ Gabriel Hauge, a native of Hawley, Minn., and 1935 Concordia College graduate, joined Gen. Eisenhower's presidential campaign in 1952. Following Eisenhower's victory, Hauge became the president's administrative assistant for economic affairs.

❑ The Korean War armistice was signed July, 27, 1953, ending the conflict. Prisoner repatriation began Aug. 6.

❑ The first earth satellite was launched into space by the Soviet Union on Oct. 4, 1957. The manned satellite was called Sputnik 1, which means space traveler in Russian. The United States launched its first satellite Jan. 31, 1958.

❑ Minnesota's first Congresswoman, Democrat Coya Knutson of Oklee, lost her bid for re-election when her husband's letter "Coya, come home," was published in The Forum. She was elected to the U.S. House in 1954 after serving in the state Legislature.

❑ Democrat Quentin N. Burdick of Fargo became the first member of his party to be elected to Congress from North Dakota. The state's Democrats and Nonpartisan Leaguers joined forces in a 1956 merger.

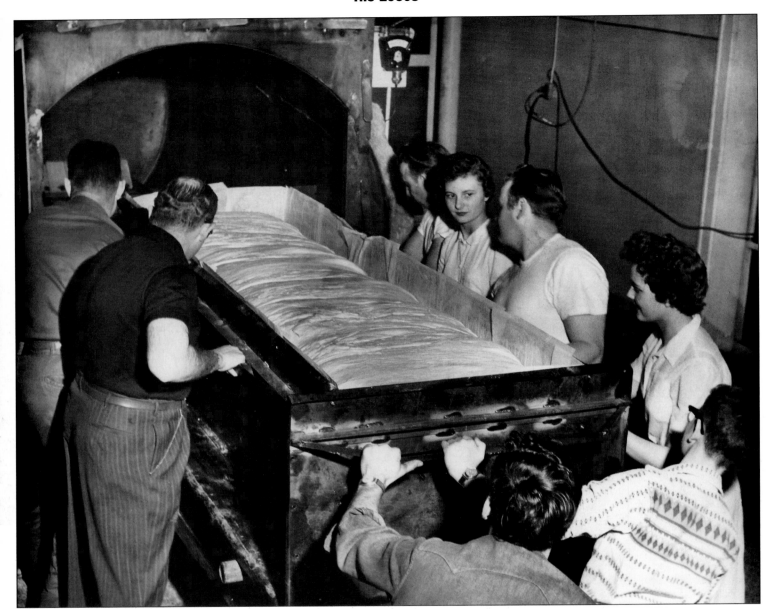

NO LOAFING AROUND

What was billed as the world's largest loaf of bread was baked at the Brownee Bakery in Fargo in January 1957. It took 12 days and 18 tries to bake the 375-pound loaf. It was 6 feet long and 2½ feet high. It was flown by Northwest Airlines to Minneapolis, where it was auctioned for $855 at a banquet honoring the state of North Dakota. The money was donated to charity. It was baked for a Greater North Dakota Association promotion and made national news. Brownee Bakery was located at 310 NP Ave.

TOP: THE FORUM / FILE PHOTO
RIGHT: THE FORUM / FILE PHOTO

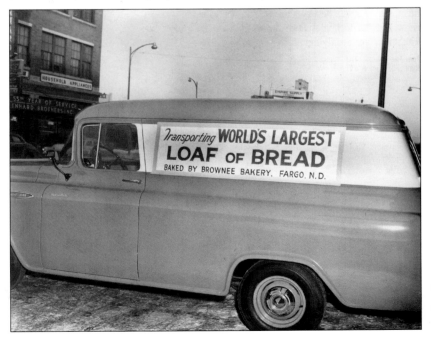

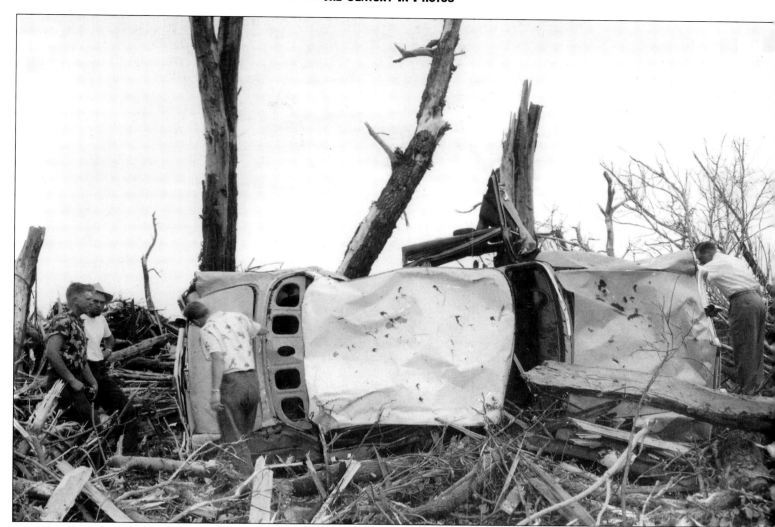

WALCOTT TWISTER

Two people were killed and nine were injured when a tornado struck Walcott, N.D., about 25 miles southwest of Fargo, July 2, 1955. It hit 15 farmsteads along a 12-mile stretch west of Walcott. Above, residents survey damage at the Wilfred Bakko farm, where a vehicle was slammed into a grove of trees. At right, Mrs. Loyle Christiansen looks at destruction in the kitchen of her family farmhouse.

TOP: THE FORUM / FILE PHOTO
RIGHT: THE FORUM / FILE PHOTO

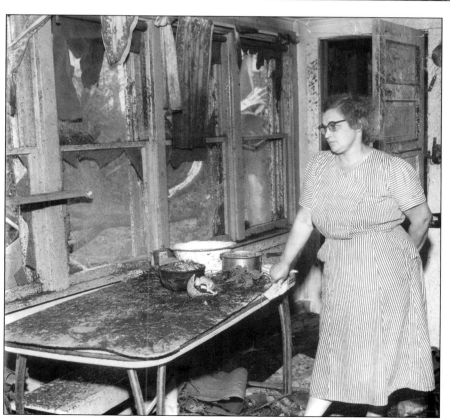

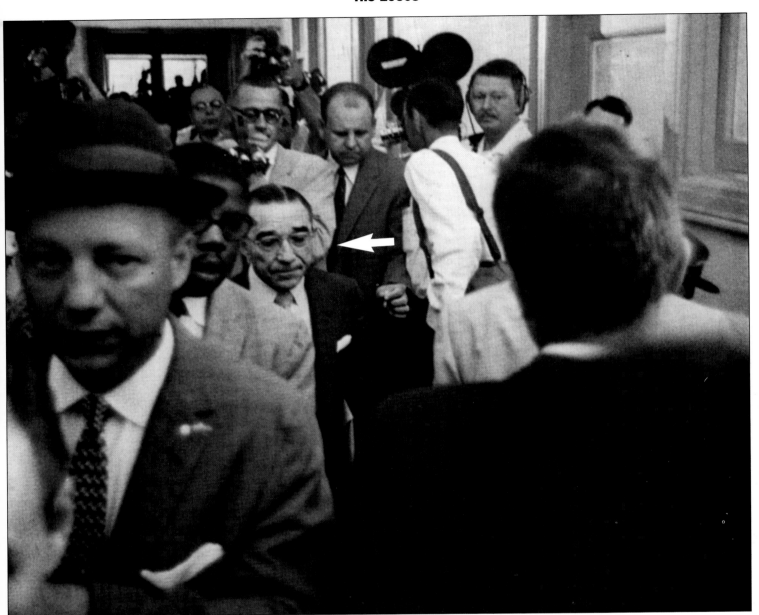

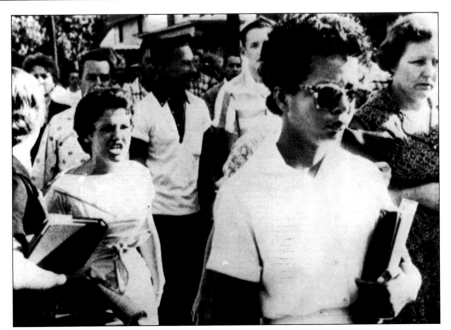

SHOWDOWN IN LITTLE ROCK

U.S. District Court Judge Ronald N. Davies of Fargo (arrow in center) made history in 1957 by ordering Central High School in Little Rock, Ark., to integrate. Davies was elevated to the federal bench by President Dwight D. Eisenhower in 1955. Judge Davies was thrust into the tense integration battle two years later when an Arkansas judge fell ill. At left, a crowd of white people, some shouting insults, follows Elizabeth Anne Eckford, 15, as she walks to a bus stop after National Guardsmen refused her entrance into the all-white Little Rock school. Until Davies' historic ruling, Gov. Orval Faubus blocked the admittance of Eckford and eight other blacks for 17 days.

TOP: ASSOCIATED PRESS
LEFT: ASSOCIATED PRESS

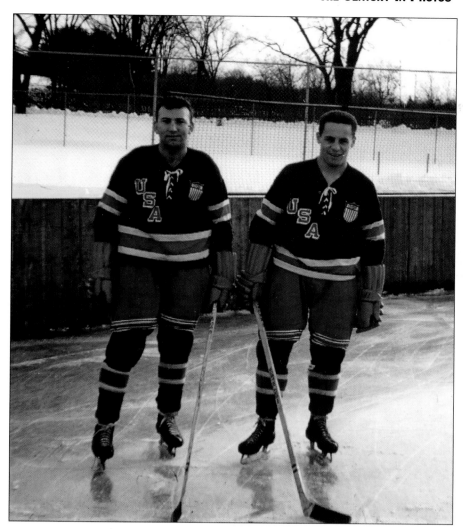

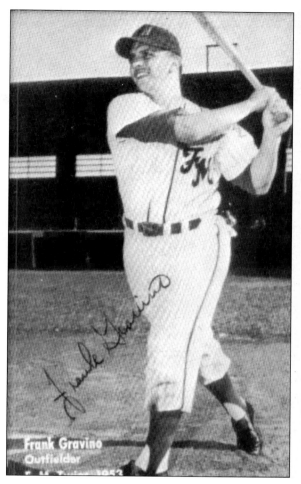

OLYMPIC MEDAL WINNER

John Noah (left) of Crookston, Minn., and later of Fargo, played on the 1952 U.S. Olympic hockey team that took second place and the silver medal at Oslo, Norway. Noah was an All-American at the University of North Dakota. With Noah is UND and Olympic teammate Andy Gambucci of Eveleth, Minn.

COURTESY OF JOHN NOAH

FAN FAVORITE

Slugger Frank Gravino was one of Fargo-Moorhead's all-time favorite athletes. He spent only three summers (1952-54) in the area, playing outfield for the minor league F-M Twins. But he left his mark – literally – on a house at 19th Avenue North and Broadway just beyond the left-field fence at Barnett Field. Several of Gravino's 140 home runs in three seasons banged off the house.

THE FORUM / FILE PHOTO

SKI GULLS IN FLIGHT

The top event in "The Ski Gulls" water show on Little Detroit Lake at Detroit Lakes, Minn., in the 1950s was a water pyramid. The show was presented during the annual Northwest Water Carnival in July. On the bottom, left to right are Jeff Baxter of Detroit Lakes, Dale Larson and Jim Olson of Fargo and Ellie (left) and Dorothy Stolp of Detroit Lakes. After a Stolp family visit to Florida where a water ski act was performed, the family brought the sport back to Detroit Lakes and were among the first in the area to enjoy water skiing as a sport.

COURTESY OF LOHMAN FAMILY

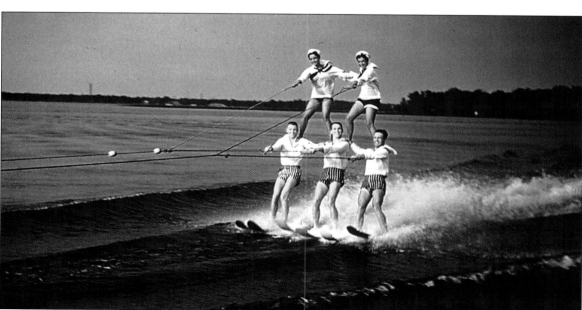

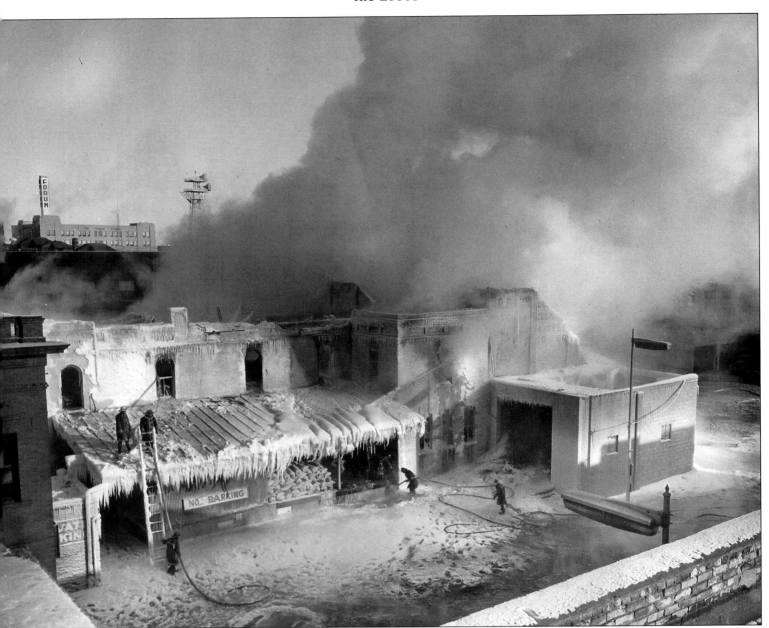

FROSTY FIRE AFTERMATH

On Nov. 29, 1958, a spectacular early-morning fire destroyed the R.F. Gunkelman & Sons seed processing plant and elevator in downtown Fargo. More than 60 firemen fought in sub-zero weather to keep the blaze from spreading to adjoining buildings at Broadway and Main Avenue. It was the second fire in two days for the firm, which also lost its seed-cleaning building in Grandin, N.D., about 20 miles north of Fargo.

THE FORUM / FILE PHOTO

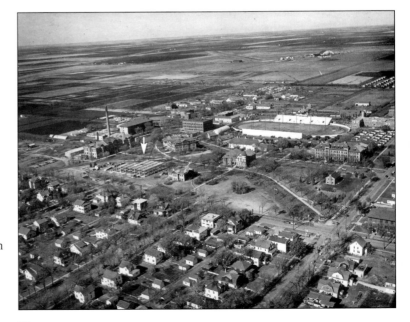

NDSU CAMPUS FROM THE AIR

North Dakota State University's Library (arrow) was under construction in this June 1950 aerial photo of the campus. Dacotah Field, where the Bison played their home football games, is near the top of the photo. Hector International Airport is at the top.

THE FORUM / FILE PHOTO

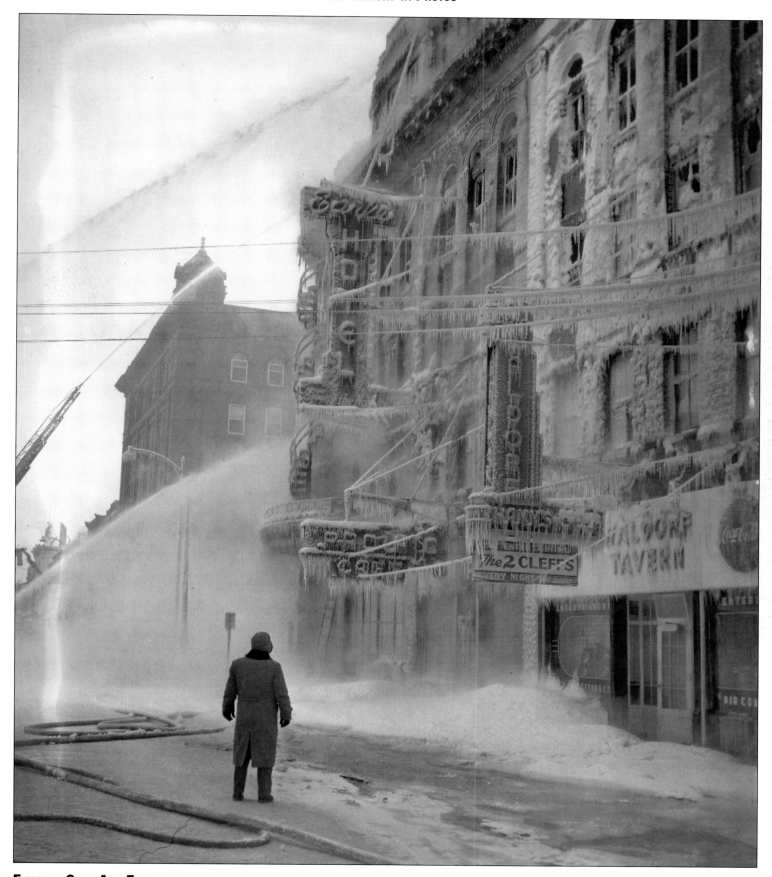

FIGHTING COLD AND FIRE

Three people died Dec. 13, 1951, when fire destroyed the Earle Hotel and adjacent Waldorf Tavern at Main Avenue and 7th Street just west of the old deLendrecie building. Among the victims was W.S. Hooper, 79, a retired Fargo postmaster.

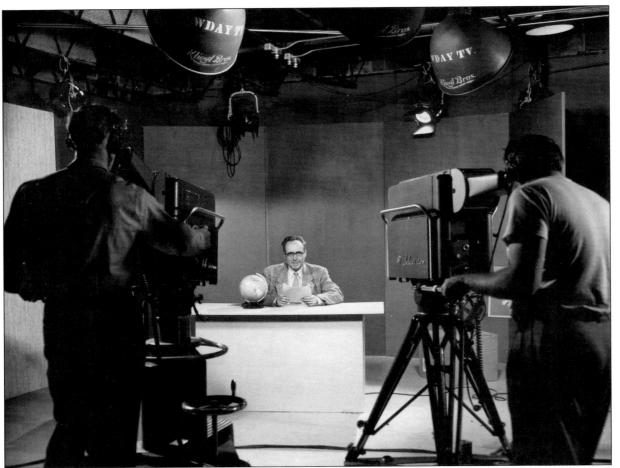

AND NOW THE NEWS

Television came to the Red River Valley June 1, 1953, when WDAY-TV went on the air. Announcer Jack Dunn is shown broadcasting in front of cameramen Jack Gauvitte (left) and Bill Snyder.

COURTESY OF WDAY

JAMESTOWN AUTHOR

Louis L'Amour, a Jamestown, N.D., native, wrote more than 100 books, mostly westerns. Nearly 200 million copies of his books were printed and translated into 20 languages. He died in June 1988. He received numerous writing awards, was inducted into the North Dakota Rough Rider Hall of Fame and has a school named after him in Jamestown.

THE FORUM / BRUCE CRUMMY

VEE'S BIG BREAK

Bobby Vee, shown here in a 1990 photo, was a 16-year-old Fargo Central High School student with his own rock 'n roll band, the Shadows, in 1959 when the band was asked to fill in at a concert in Moorhead. Buddy Holly, Ritchie Valens and J.D. "The Big Bopper" Richardson died in a plane crash in Iowa on their way to the Moorhead concert. Two weeks after that show, the Shadows booked their first paying concert and then recorded a song Vee had written, "Susie Baby." Vee went on to international rock music fame with chart-topping singles such as "Devil or Angel," "Rubber Ball" and "Take Good Care of My Baby." Vee was inducted into the North Dakota Rough Rider Hall of Fame in 1999.

THE FORUM / COLBURN HVIDSTON III

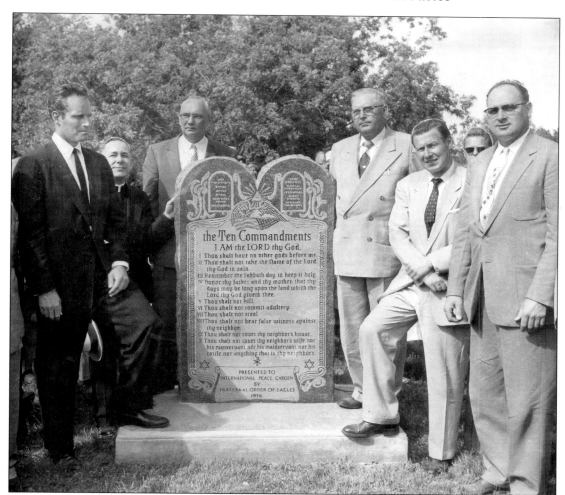

A GARDEN FOR PEACE

Movie actor Charlton Heston (left) unveils a Ten Commandments monolith presented by the Eagles in June 1958 at the International Peace Garden on the North Dakota-Manitoba border near Dunseith, N.D. Heston played the part of Moses in the movie, "The Ten Commandments," which was released later that year. From left: Heston; the Rev. Elwood Cassedy, Sentinel Butte, N.D.; E.J. Ruegemer, St. Cloud, Minn.; Lt. Gov. C.P. Dahl; Fargo Mayor Herschel Lashkowitz; and Jerome Docktor, Jamestown, N.D. More than 5,000 attended the ceremony. The International Peace Garden was dedicated July 14, 1932, as a symbol of Canadian and American friendship.

THE FORUM / FILE PHOTO

STRIKING OIL

A North Dakota dream came true when oil was discovered in April 1951 on the Clarence Iverson farm near Tioga in the northwestern part of the state. It was named the Clarence Iverson No. 1 well. The Oklahoma-based Amerada Petroleum Co. made the discovery. Efforts to find oil in North Dakota date back to 1916, when the first wildcat well was drilled three miles southeast of Williston.

COURTESY OF BILL SHEMORRY

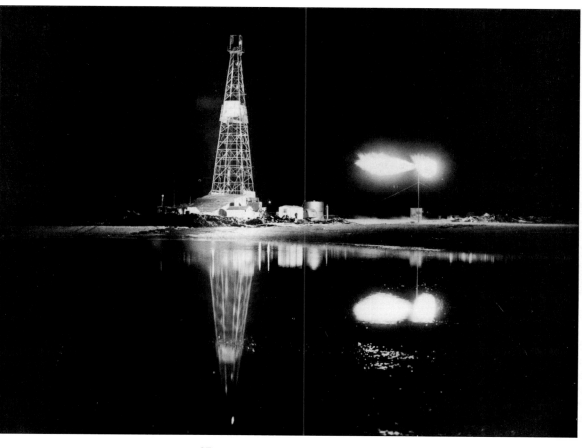

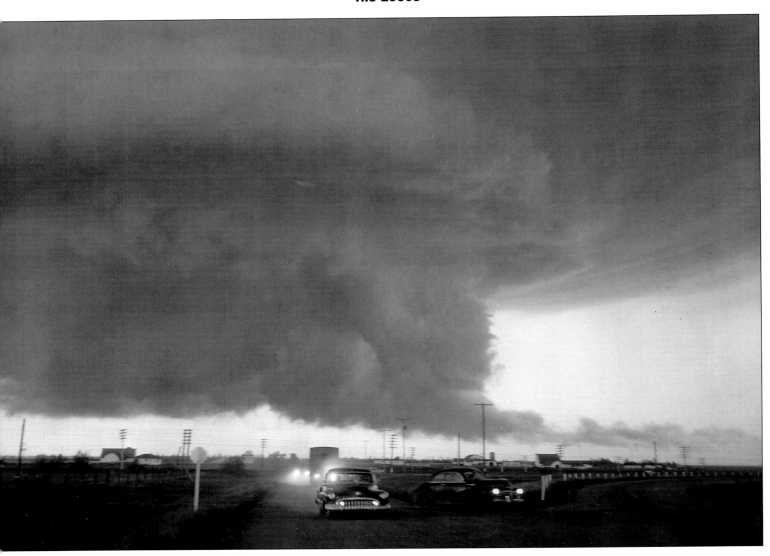

KILLER TORNADO

A tornado bears down on Fargo the evening of June 20, 1957. The tornado left 13 people dead and more than 100 injured. It destroyed or damaged 1,364 dwellings, four churches, three schools and at least 15 commercial buildings and displaced 2,000 people.

THE FORUM / FILE PHOTO

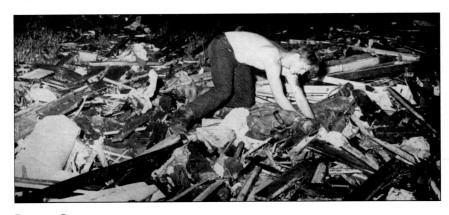

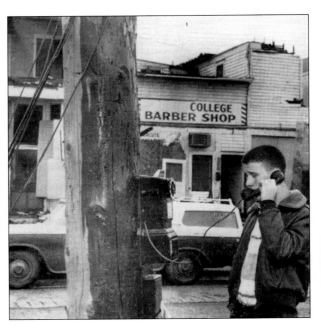

DEADLY AFTERMATH

An unidentified survivor bends over the body of a youngster found lying among the twisted wreckage of a home in the Golden Ridge area of northwest Fargo. Police and firemen searched through the night looking for additional victims. At right, Mike O'Leary uses a temporary telephone at University Drive and 13th Avenue North after the phone booth on the corner was blown away.

TOP AND RIGHT: THE FORUM / FILE PHOTOS

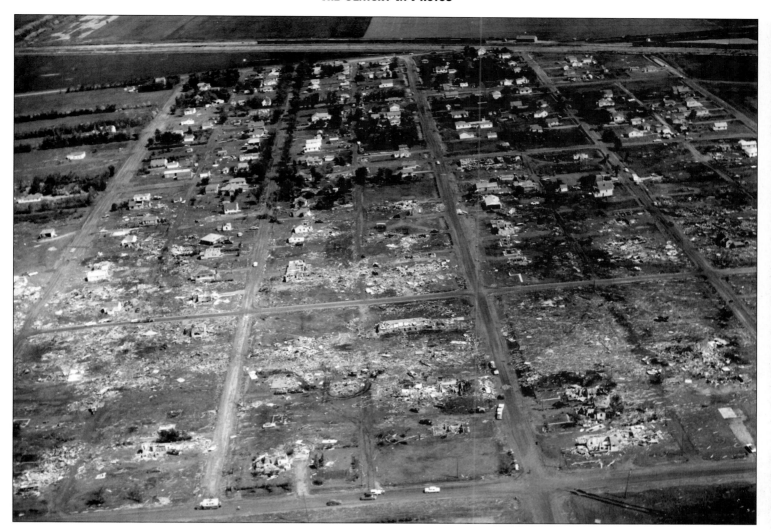

A NEIGHBORHOOD DESTROYED

The Golden Ridge area, located on the northwest side of Fargo west of 25th Street between 7th and 12th avenues, was devastated by the June 20, 1957, Fargo tornado.

THE FORUM / FILE PHOTO

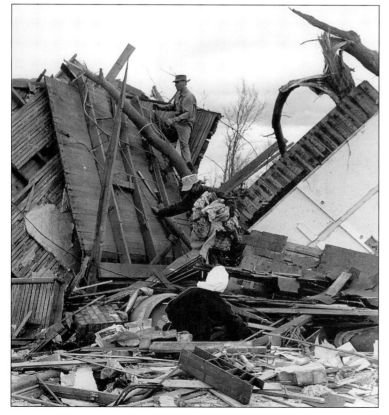

THE FARGO FORUM — Morning Edition

VOL. 24, NO. 301 — FARGO, N. D., FRIDAY MORNING, JUNE 21, 1957 — Sixteen Pages — Price Five Cents

At Least 7 Killed, Scores Injured As Tornado Smashes North Fargo

THE RUBBLE

Fargo residents carry out the grim task of digging through the ruins of their homes. Many of the homes in the Golden Ridge area were rebuilt.

THE FORUM / FILE PHOTO

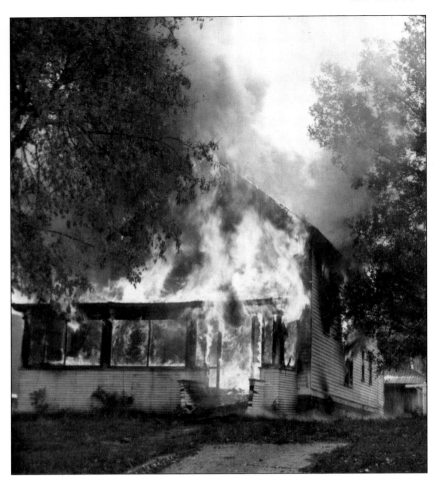

Revitalizing Fargo

A two-story house at 304 3rd St. N. is torched as part of Fargo's Urban Renewal Project in October 1959. The Fargo Fire Department, as part of Fire Prevention Week, burned the house down to show how quickly fire can destroy a structure. It was located in Fargo's first Urban Renewal district, which became home to the Fargo Civic Memorial Auditorium and City Hall complex.. Fargo's second Urban Renewal Project took place in the Main Avenue area.

TOP: INSTITUTE FOR REGIONAL STUDIES, NDSU LIBRARIES
LEFT: INSTITUTE FOR REGIONAL STUDIES, NDSU LIBRARIES

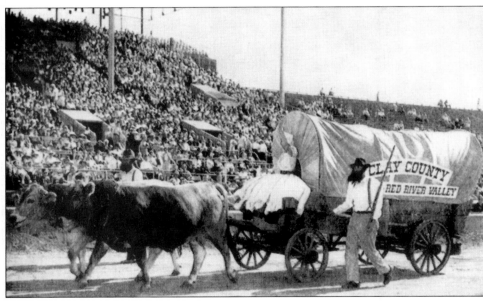

Parade Entry

Beverly Mann, a Moorhead State student from Breckenridge and Clay County Centennial Queen, rides in the county's entry in the Parade of the Century May 10, 1958 at the Minnesota State Fairgrounds in St. Paul. The replica pioneer wagon was pulled by a team of purebred Brown Swiss oxen trained by Barnesville area farmer John Nelson, who walks alongside the entry.

THE FORUM / FILE PHOTO

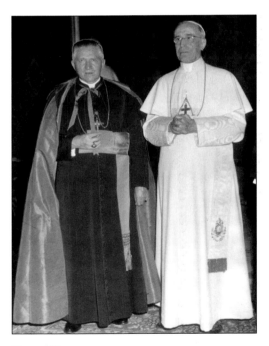

Papal Visit

Longtime Fargo Catholic Diocese Bishop Aloisius J. Muench (left) is shown with Pope Pius XII at the Vatican. Pope Pius XII named Muench the Papal ambassador to Germany in 1950. Muench was elevated to Cardinal by Pope John XXIII in 1959. He died Feb. 15, 1962.

THE FORUM / FILE PHOTO

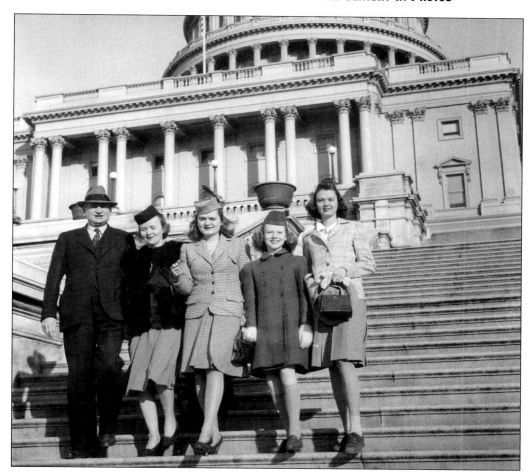

'WILD BILL' LANGER

William "Wild Bill" Langer, one of North Dakota's political giants, was never far from controversy. His political career elevated him to the governor's office during the depths of the depression and, eventually, carried him to the U.S. Senate. While governor, he was convicted of conspiracy, forced from office, exonerated in court and re-elected. Langer is shown in this 1941 photo on the steps of the U.S. Capitol building with his wife, Lydia, and three of their four daughters: Lydia, Cornelia and Mary. Daughter Emma is not pictured. Langer died Nov. 9, 1959 at the age of 73.

THE FORUM / FILE PHOTO

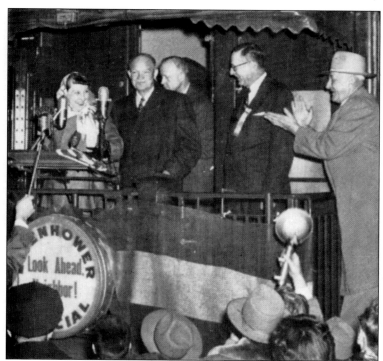

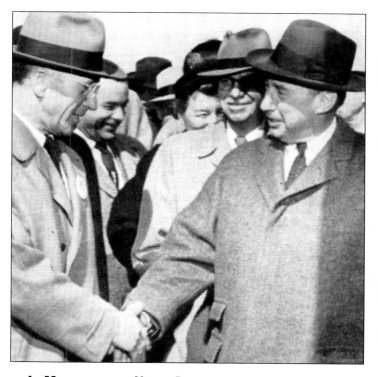

HITTING THE CAMPAIGN TRAIL ...

U.S. Sens. Milton Young (second from right) and William Langer (far right) look on as Gen. Dwight D. Eisenhower and wife Mamie make a campaign stop in Valley City, N.D., in October 1952. Eisenhower went on to defeat Sen. Adlai Stevenson to become president.

THE FORUM / FILE PHOTO

... IN MINNESOTA AND NORTH DAKOTA

Moorhead Mayor Thorney Wells (left) welcomes Presidential candidate Adlai Stevenson during a campaign visit to the Fargo-Moorhead area in March 1956. Stevenson lost his rematch with President Dwight D. Eisenhower.

THE FORUM / FILE PHOTO

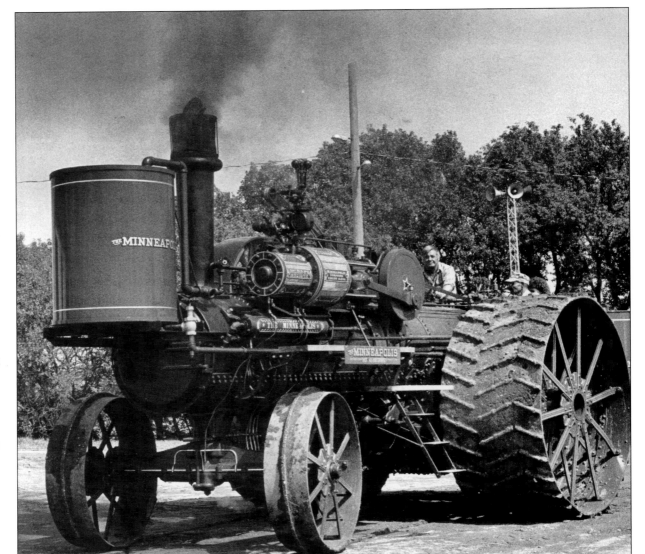

ROLLING ALONG IN ROLLAG

The Western Minnesota Steam Threshers' Reunion was launched in 1953 near Rollag in Clay County. The Labor Day weekend event has grown into one of the area's most popular annual attractions. Richard Rorvig (driving the rig at right) spent three years restoring a Minneapolis single-tandem compound 45-hp steam engine, the largest and rarest steam engine. It was built by the Minneapolis Threshing Machine Co. and is the sole survivor of only seven such machines built by the company in 1907.

THE FORUM / FILE PHOTO

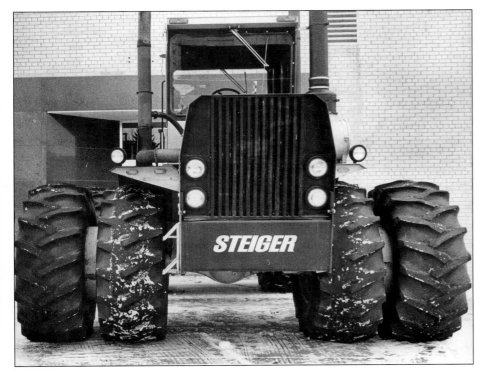

THE GREEN MACHINE

Douglass and Maurice Steiger manufactured their first large, four-wheel-drive tractor during the winter of 1957-58 to meet the unique needs of their Red Lake Falls, Minn., farm operation. The Steigers incorporated the business in 1969 and moved their manufacturing facilities to Fargo. At Steiger's peak in the 1970s, upwards of 1,100 people worked in the company's Fargo plant. That was roughly 3 percent of the community's total non-farm work force at the time. The company's boom went bust in the 1980s due to farm economy problems worldwide. In 1986 Steiger filed for Chapter 11 bankruptcy protection. Later that year, Tenneco Inc., the parent company of Case, bought the Steiger operation. The plant continued to produce four-wheel-drive tractors under the Steiger name, but their color was changed from Steiger green to Case red. In 1997 the Fargo plant built its 40,000th four-wheel-drive tractor under the Steiger name.

THE FORUM / FILE PHOTO

The 1960s

Interrupting the peace and quiet

The 1960s started quietly, then turned into one of the most tumultuous periods in U.S. history. There was the Cuban crisis with Russian missiles placed on Cuban soil. War clouds gathered before the Soviet Union agreed to remove the missiles. Just a little over a year later, President John F. Kennedy was assassinated while riding in a car carrying him and his wife through Dallas Nov. 22, 1963. Vice President Lyndon B. Johnson took the presidential oath.

Dr. Martin Luther King Jr., a leader in the civil rights movement, brought 20,000 demonstrators to Washington in 1963 and gave his "I have a dream" speech. He was assassinated in Memphis in 1968. President Kennedy's brother, New York Sen. Robert F. Kennedy, who previously was attorney general, was shot and killed in a Los Angeles hotel June 5, 1968. And, in 1969, Sen. Ted Kennedy, D-Mass., the brother of John F. and Robert, hit the spotlight when he drove off a bridge at Chappaquiddick, killing Mary Jo Kopechne.

The turbulence caused by the Vietnam War reached its peak in August 1968 when police and Army troops clashed with 10,000 to 15,000 anti-war demonstrators during the Democratic National Convention in Chicago. Facing the draft, many young men fled to Canada, rather than go to Vietnam.

As the decade ended in 1969, astronaut Neil Armstrong landed on the moon, giving the American public something to cheer about.

Some other highlights were:

❏ Seven years after Garrison Dam's closure, the huge North Dakota reservoir it created was filled for the first time in 1960.

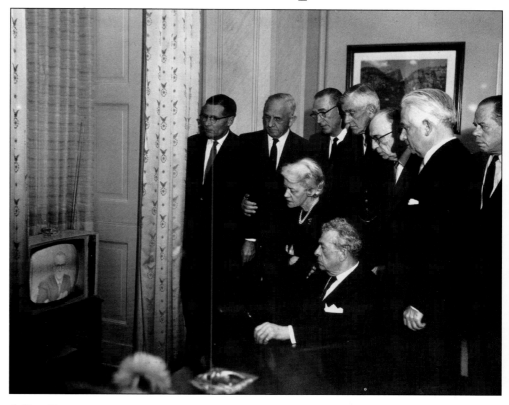

A SAD DAY

U.S. Sen. Milton R. Young, R-N.D. (third from left, standing) and other senators watch television news reports of the assassination of President John F. Kennedy in Dallas Nov. 22, 1963. The shooting shook the nation. Vice President Lyndon B. Johnson took over as president.

MILTON R. YOUNG PHOTOGRAPH COLLECTION, INSTITUTE FOR REGIONAL STUDIES, NDSU LIBRARIES

❏ The passage of an initiated measure by voters in 1960 changed North Dakota Agricultural College to North Dakota State University of Agriculture and Applied Sciences.

❏ Former Minnesota Gov. Orville Freeman served from 1961 to 1969 under Presidents John F. Kennedy and Lyndon B. Johnson as secretary of agriculture. He was governor from 1955 to 1961.

❏ In 1965, Hubert H. Humphrey became the first Minnesotan to win election to national office when he was sworn in as vice president Jan. 20. In 1968, Humphrey became the first Minnesotan nominated by a major political party for president of the United States, but he lost to Richard Nixon in a close election.

❏ Three astronauts died in a flash fire during a 1967 test of their Apollo spacecraft at Cape Kennedy.

❏ In 1968, Congress authorized North Dakota's Garrison Diversion Project. The controversial project is still a long way from being completed.

❏ In 1968, the Pope issued a ban on all artificial birth control devices.

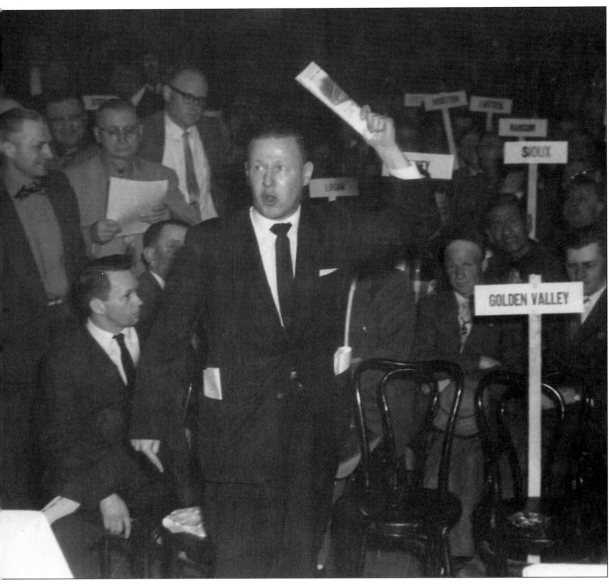

MR. MAYOR

Herschel Lashkowitz served as Fargo's mayor from 1954 to 1974 and was a state senator from 1974 until a heart attack and bypass operation, plus the toll of Parkinson's disease, forced him to leave the 1989 Legislature and enter a Fargo nursing home. The volatile Lashkowitz was responsible for Fargo's two urban renewal projects and much of the diking of the Red River. He once declared virtual one-man rule – he being the one man – when the other four city commissioners walked out as Lashkowitz used a meeting as a platform to attack The Forum for what he termed "slanted reporting." Lashkowitz is shown here on the floor at a state Nonpartisan League convention.

INSTITUTE FOR REGIONAL STUDIES, NDSU LIBRARIES

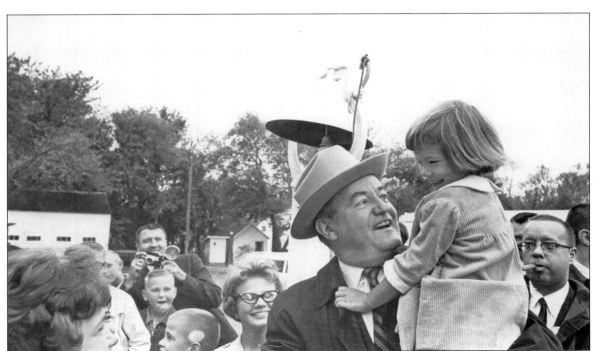

CAMPAIGNING DOWN ON THE FARM

Vice Presidential candidate Hubert H. Humphrey, D-Minn., is greeted by 3-year-old Amy Olson of Seattle at the National Plowing Contest near Buffalo, N.D., in September 1964. The contest was held on the farm of Olson's uncle and aunt, the Elmer Fraases, 32 miles west of Fargo. Incumbent Democratic President Lyndon B. Johnson didn't make it to the Plowing Contest, but Humphrey, his running mate, did. So did Sen. Barry Goldwater, R-Ariz. Two months later, Johnson defeated Goldwater in a landslide.

THE FORUM / FILE PHOTO

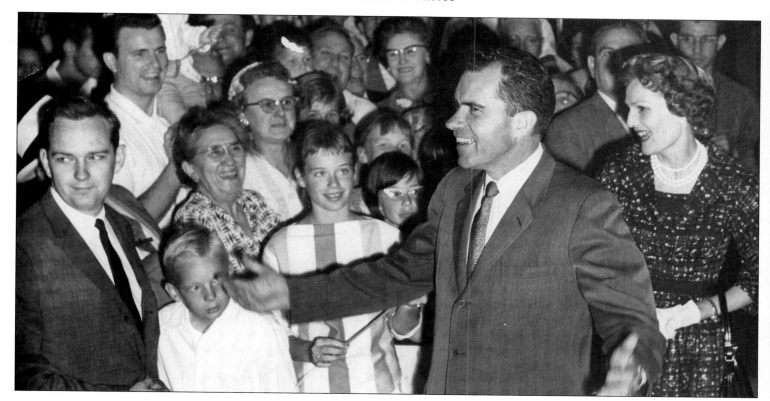

WARM GREETING

Enthusiastic crowds almost overwhelmed Vice President Richard M. Nixon and his wife, Pat, when they visited Fargo on a campaign swing in June 1960. Nixon told a Forum reporter, "This is the most colorful reception we have ever seen, and considering the time we arrived here (8:30 p.m.) and the size of the city, it was the biggest reception we ever have had." Nixon and opponent John F. Kennedy both visited Fargo on the same day. Kennedy won the election. Nixon was elected president in 1968 and 1972.

THE FORUM / FILE PHOTO

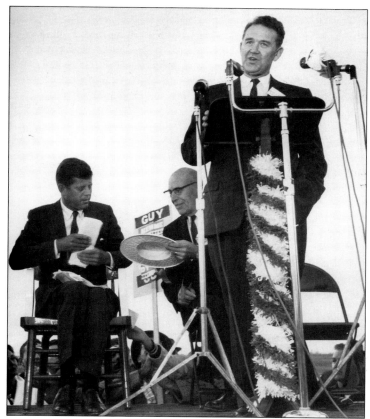

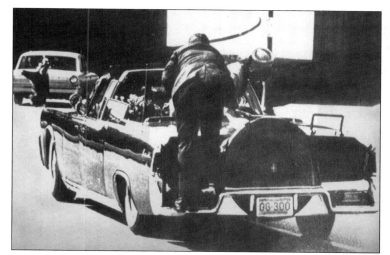

THE NEXT PRESIDENT

U.S. Rep. Quentin Burdick, D-N.D., introduces presidential candidate John F. Kennedy (left) at a political rally in June 1960 at the Red River Valley Fairgrounds on Fargo's north side. Kennedy defeated Richard M. Nixon in one of the closest presidential elections in U.S. history. Nixon carried 26 states to Kennedy's 22, but the Democrat received more electoral votes.

THE FORUM / FILE PHOTO

HEROIC EFFORTS

Secret Service Agent Clinton J. Hill covers President John F. Kennedy and First Lady Jacqueline Kennedy Nov. 22, 1963 in downtown Dallas after an assassin struck. Hill remained spread-eagled across the limousine until it arrived at Parkland Memorial Hospital. The president was killed. Eleven days later, Hill, a native of Washburn, N.D., and a graduate of Concordia College in Moorhead, received the Treasury Department's highest honor for "exceptional bravery." In 1967, Hill was named chief of White House security.

ASSOCIATED PRESS

GOING, GOING, GONE

Fargo's Roger Maris hammers his 61st home run at Yankee Stadium in New York Oct. 1, 1961, to break Babe Ruth's major league record for homers in a season. Maris, who played minor league baseball for the Fargo-Moorhead Twins (inset), was a high school football star at Fargo Shanley. His record stood until 1998 when Mark McGwire hit 70 home runs.

MAIN PHOTO: ASSOCIATED PRESS; INSET: THE FORUM / FILE PHOTO

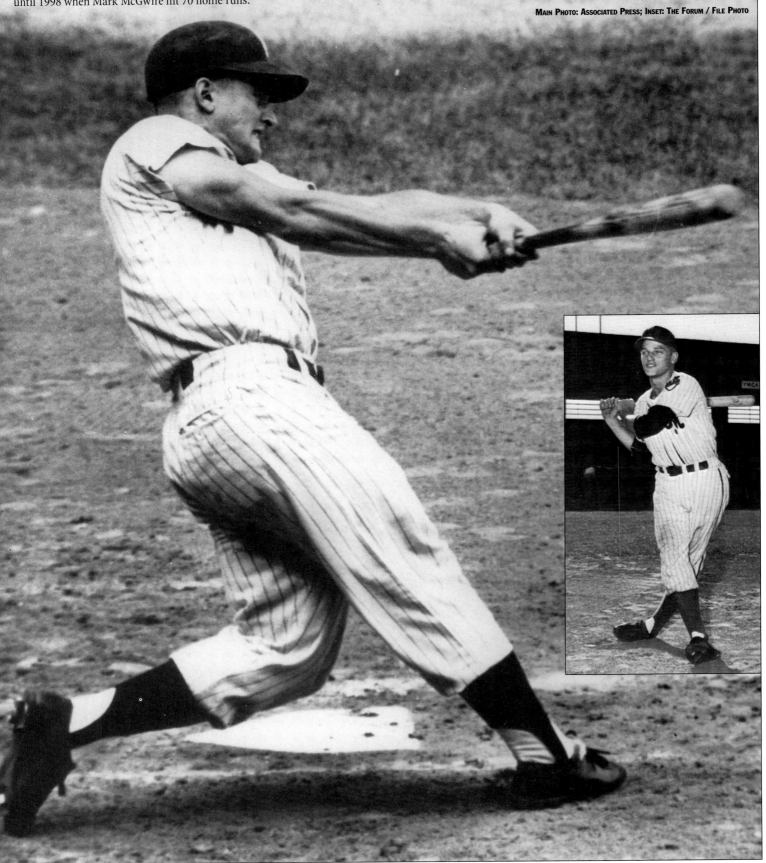

WATER CARNIVAL

The 1960 Northwest Water Carnival parade heads down Washington Avenue in Detroit Lakes, Minn. The annual summer celebration started in 1936 and continues today, with the parade as one of its top attractions. Parades like these were popular throughout the region.

COURTESY OF LOHMAN FAMILY

ON BROADWAY

The WDAY Band Festival Parade was an annual event in Fargo in the 1950s and 1960s. In this 1966 photo, the Kindred (N.D.) High School band marches south on Broadway. The event drew bands from throughout North Dakota and western Minnesota. It was one of the biggest parades in the region. It was carried live on WDAY-TV.

COURTESY OF WDAY

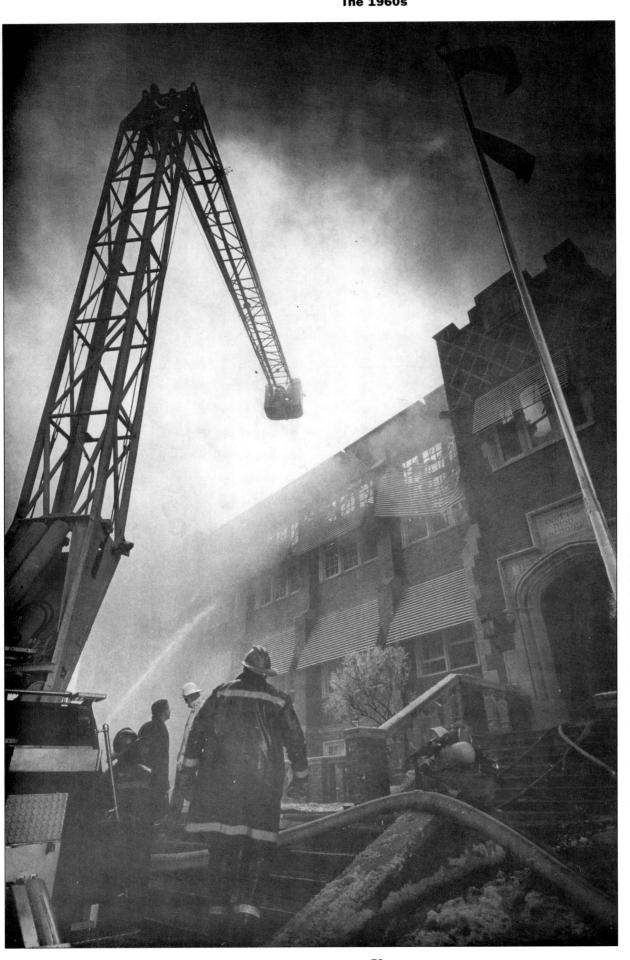

CENTRAL HIGH GOES UP IN FLAMES

A fire April 19, 1966, destroyed Fargo's Central High School, which was located across 10th Street west of the Cass County Courthouse. The school was a total loss; damaged was estimated at $700,000 to $1 million. Central students completed the school year at North High School and other facilities. Construction began almost immediately at South High, using the same building plan as the nearly new North High. The first Central grade and high school also was destroyed by fire in 1916. The second Central High School was built on the same site in 1921.

THE FORUM / FILE PHOTO

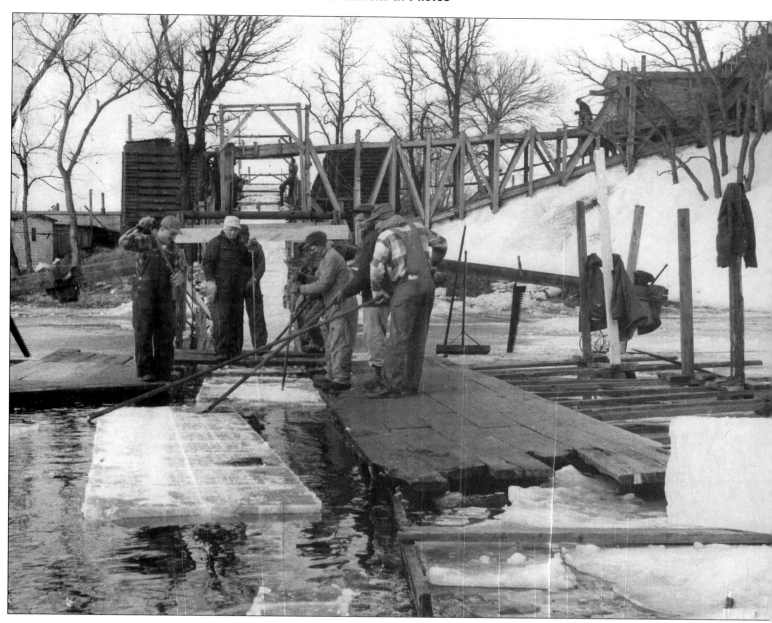

KEEPING IT COOL

The Fargo-Detroit Ice Co. was founded in 1888 by John K. West. The company harvested ice from Minnesota's Detroit Lake and supplied it to the Northern Pacific Railroad, the Fargo-Moorhead area, Idaho, Wyoming, Nebraska, Illinois, South Dakota and the state of Washington. Some of the ice found its way into the deep South, touching the states of Texas and Florida. At one time some 4,000 boxcars with about 150 tons of ice were shipped from Detroit Lakes. Ice harvesting ended in 1970 when the company yielded to modern refrigeration and freezing techniques. Above, in 1960, workmen move ice blocks to a conveyor system for storage in the ice house, which was located where the Detroit Lakes Holiday Inn stands today. At left, a gas-powered saw cuts ice in 1963.

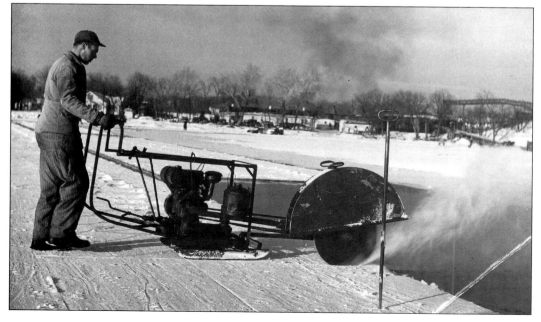

TOP AND LEFT: BECKER COUNTY HISTORICAL SOCIETY

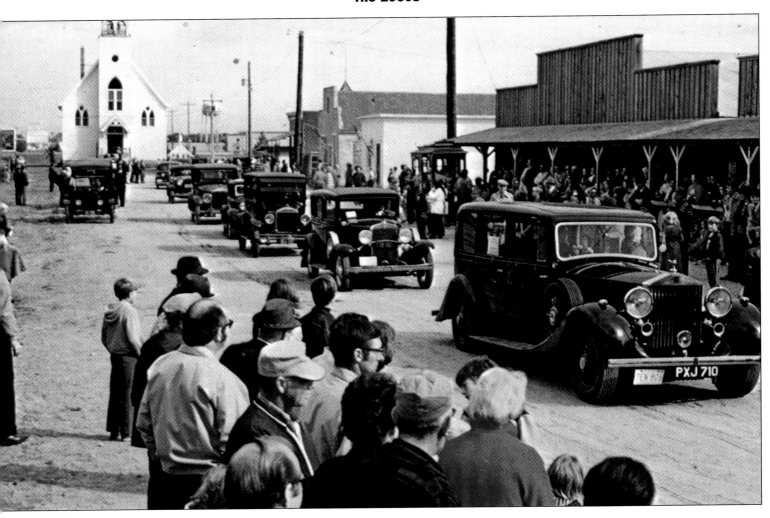

TURNING BACK THE CLOCK

Vintage cars parade through the streets of Bonanzaville USA, a pioneer village on the Red River Valley Fairgrounds in West Fargo. At left: Ken McIntyre, Harwood (left) and Palmer Forness, Fargo, play checkers in Bonanzaville's country store. Bonanzaville is made up of buildings moved from rural sites to the fairgrounds. It was born in 1967 when the fairgrounds moved from north Fargo to West Fargo and the fair board asked the Cass County Historical Society to begin a Pioneer Village as a year-round attraction.

TOP: INSTITUTE FOR REGIONAL STUDIES, NDSU LIBRARIES
LEFT: THE FORUM / FILE PHOTO

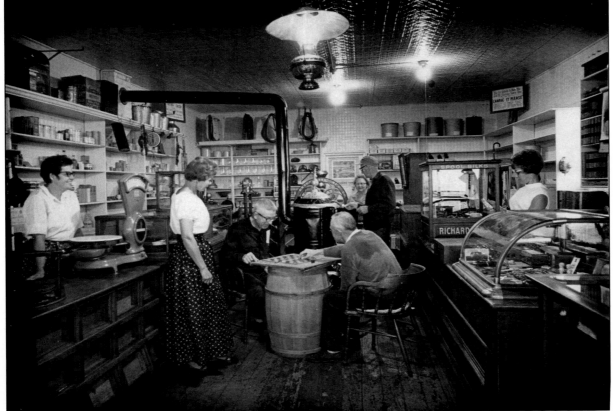

MOUNTAIN OF SNOW

Children make the best of a bad situation after a three-day blizzard paralyzed the region March 4-6, 1966. It buried passenger trains, and it took days to dig out. Snowfall totals were 14 inches at Fargo, 29 inches at Grand Forks, 30 at Devils Lake and 35 at Mobridge, S.D. Because of the huge drifts, the area was described as "a drifted wasteland." Twenty lives were lost in the region and 28,000 head of cattle perished in North Dakota alone.

THE FORUM / FILE PHOTO

FUN IN THE SNOW

The propeller-driven snowmobile (above) of the 1940s and '50s gave way in the '60s (right) to track-driven machines. At right, modern-day snowmobilers take a lunch break in the Smoky Hills State Forest east of Detroit Lakes, Minn.

ABOVE: COURTESY OF LOHMAN FAMILY
RIGHT: COURTESY OF LOHMAN FAMILY

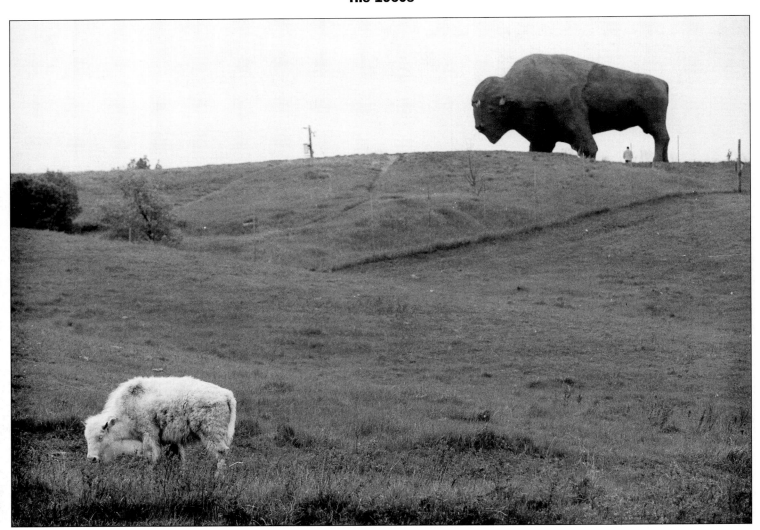

ONE BIG BISON

The world's largest buffalo at the Frontier Village in Jamestown, N.D., was officially dedicated by Gov. Nelson Rockefeller of New York in 1960. It gained national recognition at the time. In the foreground is White Cloud, an albino bison born in 1997 near Michigan, N.D., on the Sherik Buffalo Farm. The arrival of a white buffalo – an event viewed as sacred among Native Americans – attracted attention across North America.

THE FORUM / FILE PHOTO

FIVE OF A KIND

The Fischer quintuplets make a rare public appearance in 1967 in Aberdeen, S.D. Born in September 1963 to Andrew and Mary Ann Fischer, they were only the second set of quints to survive in North America. From left: Mary Margaret, Mary Magdalene, James Andrew, Mary Catherine, baby sister Cindy and Mary Ann.

ASSOCIATED PRESS

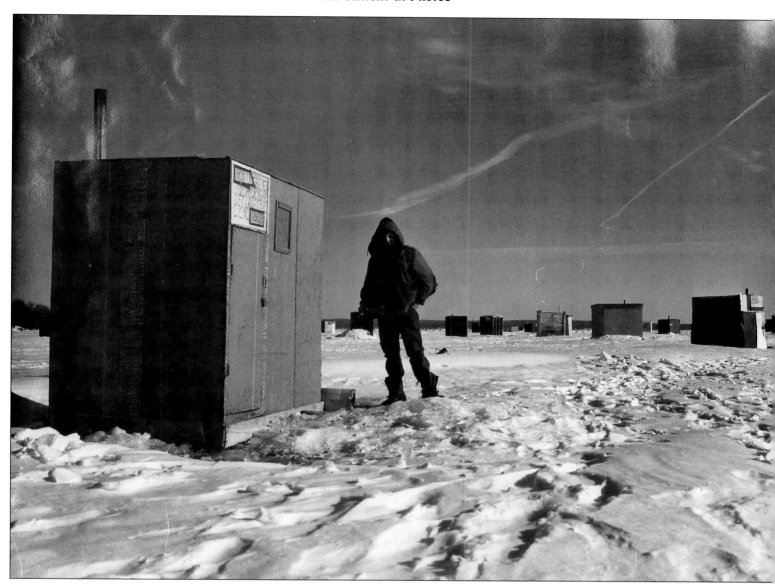

TOWNS ON A LAKE

Ice fishing villages pop up every winter on many Minnesota lakes, like these on Little Detroit Lake at Detroit Lakes, circa 1960.

TOP: BECKER COUNTY HISTORICAL SOCIETY
LEFT: BECKER COUNTY HISTORICAL SOCIETY

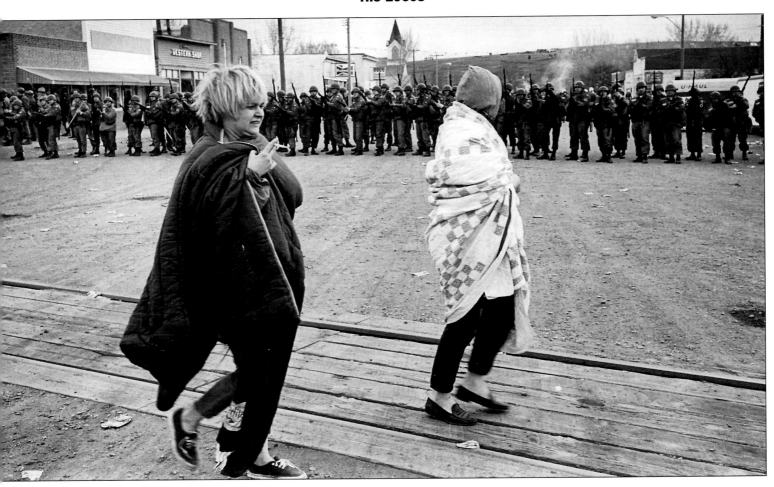

ZIP TO ZAP

National Guard troops (above) are called in as revelers get out of hand during the infamous Zip to Zap college spring break event in May 1969. Guardsmen kicked more than 2,000 beer-drinking students out of the central North Dakota town of Zap. A night of uncontrolled drinking led to vandalism, including a huge bonfire on Main Street fueled by wood from abandoned buildings. There were numerous fights and at least one bar was vandalized. After a call from the mayor, helmeted guardsmen, carrying rifles with bayonets, forced the students from town. At left, partiers trashed this bar when the price of beer was doubled.

TOP: THE FORUM / FILE PHOTO
LEFT: THE FORUM / FILE PHOTO

HAPPY, AND EMPLOYED

A smiling Harvey McDonald celebrates after staff members at the Tamarac Job Corps Center announce he has been hired by a Minneapolis firm as a heavy equipment operator. President Lyndon B. Johnson created the Jobs Corps in the 1960s to help train young people for employment. There were a number of camps in this area, including this one at Tamarac National Wildlife Refuge northeast of Detroit Lakes, Minn.

THE FORUM / COLBURN HVIDSTON III

RED HATS ON DUTY

During the flood of 1969, the North Dakota State University football team helped plug breaks in the dikes. Known as the Red Hats and commanded by Fred Schlanser, they rushed through Fargo to repair leaking dikes.

THE FORUM / FILE PHOTO

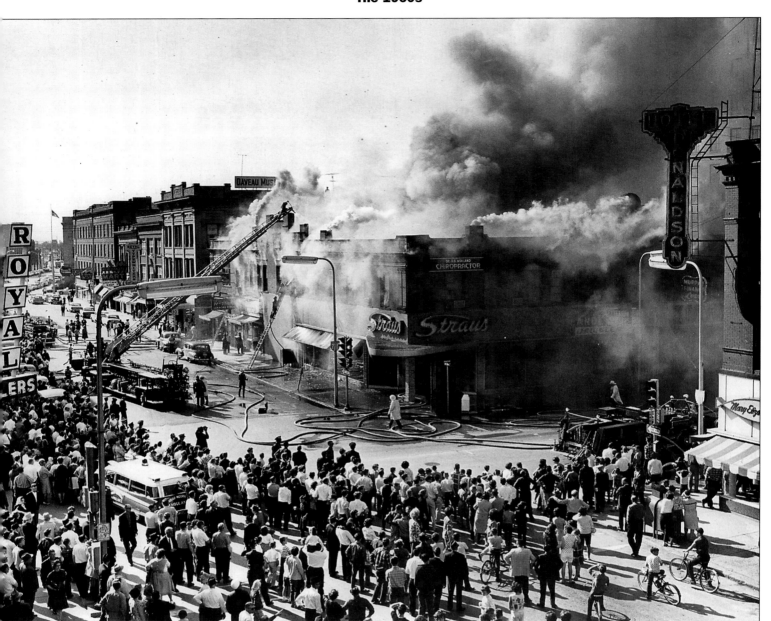

DRAWING A CROWD

Firefighters battle a blaze that destroyed the Straus store in downtown Fargo in 1963. The clothing store was rebuilt on the same site at Broadway and 1st Avenue North and remained there until 1997 when the business moved to 13th Avenue South.

THE FORUM / FILE PHOTO

CIVIC PRIDE

Fargo's Civic Memorial Auditorium opened its doors Jan. 20, 1960 to an overflow crowd of 4,200 people for All-Star Wrestling. The first function in the building– a sales meeting for a heating equipment and supply firm – was held earlier in the day. Work started in August 1958 on the auditorium/City Hall complex. The police department was the last group to move into City Hall, making their move in January 1960. Centennial Hall, located on the east end of the auditorium, was later added.

THE FORUM / FILE PHOTO

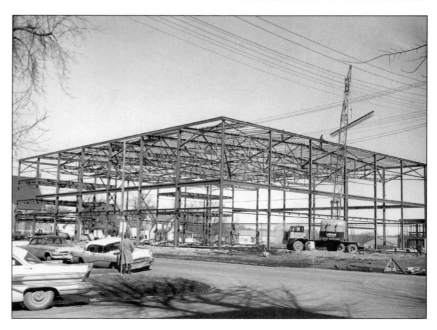

The 1970s

Resignations and inflation

With the Vietnam War coming to an end, it appeared the 1970s would bring the nation back to the calm of the 1950s. But, it wasn't going to be that way. President Richard Nixon resigned because of the Watergate scandal, the first American president ever to resign from office.

Spiro T. Agnew, Nixon's vice president, resigned earlier after pleading no contest to taking kickbacks from contractors while governor of Maryland. After Jimmy Carter took over the reigns of the presidency, interest rates soared and the nation went through the worst period of inflation in its history.

Some other highlights were:

❑ On Jan. 9, 1970, fire destroyed two of the University of North Dakota-Ellendale's oldest buildings, representing 80 percent of its classrooms. The college was closed June 1, 1971, becoming the only state-operated college or university in North Dakota ever to close. The remaining facilities were sold to Trinity Bible College.

❑ An amendment to the U.S. Constitution was ratified by the 38th state on June 30, 1971, lowering the voting age to 18.

❑ Amtrak, the nation's new rail passenger system, went into operation on May 1, 1971.

❑ Environmental Protection Agency announced a near total ban of the insecticide DDT, effective Dec. 31, 1972.

❑ Capt. Loren Torkelson of Crosby returned to North Dakota in 1973. He was the state's only Vietnam prisoner of war.

❑ Some 200 to 300 militant American Indian Movement members seized a church and trading post at Wounded Knee, S.D., Feb. 27, 1973. The hamlet was evacuated.

❑ When the final ballots were tallied for the Nov. 7, 1974, election, North Dakota incumbent Republican Sen. Milton R. Young defeated Democratic-NPL challenger William L. Guy by 185 votes. It was one of the closest races for such a high office in the state's history.

❑ North Dakota Republican Thomas Kleppe of Bismarck took over as secretary of the Interior Oct. 10, 1975.

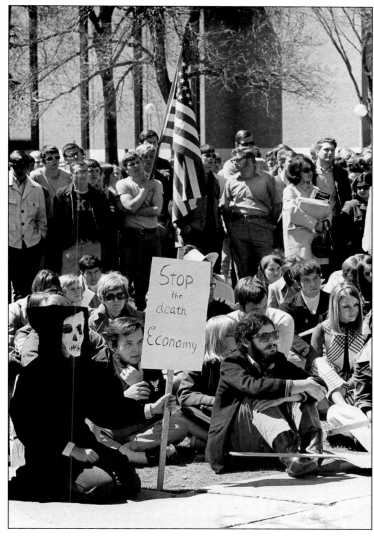

ANTI-WAR RALLY

Moorhead State University students rally after voting to strike following the shootings of students at Ohio's Kent State University in 1970. Four were killed at Kent State while protesting the United States' involvement in the Vietnam War.

THE FORUM / FILE PHOTO

❑ U.S. Rep. Bob Bergland, a Minnesota Democrat, was appointed secretary of agriculture by President-elect Jimmy Carter Dec. 20, 1976. He served until January 1981.

❑ Sen. Hubert H. Humphrey, D-Minn., lost his battle with cancer Jan. 13, 1978, after 32 years of public service.

❑ U.S. Senate voted on April 18, 1978, to turn the Panama Canal over to Panama Dec. 31, 1999.

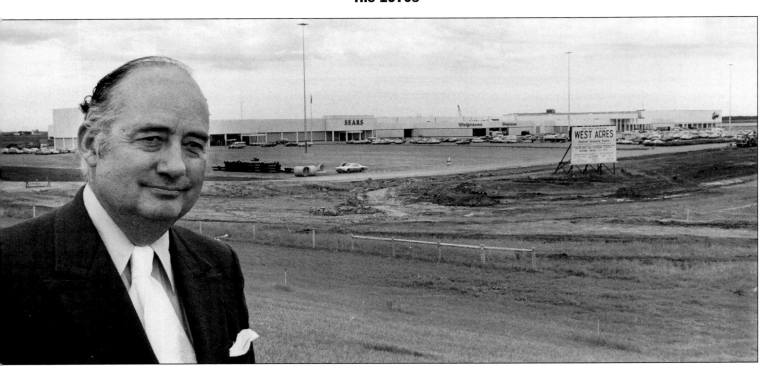

A New Way To Shop

A dream came true for Fargo developer Bill Schlossman when West Acres regional shopping center opened on Fargo's southwest edge in August 1972. The $15 million facility began as an 800,000-square-foot complex housing some 80 stores and service units. The site was selected because it was near the intersection of Interstates 29 and 94.

The Forum / Colburn Hvidston III

A Family Tradition

The Fourth of July means a trip to Moorhead State University for many area families, and that means flags and ice cream take center stage. Since 1973, the university has held a celebration and fireworks display every Fourth of July. The event has grown every year.

Moorhead State University Archives

STARVING DEER

Russell Dohn, a Wishek, N.D., service station operator, carries a dead deer from a deer-feeding site south of Venturia, N.D., on the South Dakota border, during the winter of 1977-78. Rain at the time of freezeup made it impossible for the deer to get food. Wildlife clubs throughout the region went into action to bring food supplies to the starving deer herds.

THE FORUM / BRUCE CRUMMY

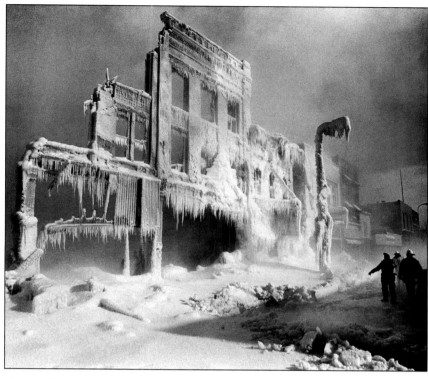

GRAND FORKS BLAZE

A fire in February 1979 at Grand Forks, N.D., left 29 people homeless when the downtown Gotzin Building was destroyed. The fire gutted three businesses, damaged another and sent people fleeing into the street wearing only bedclothes and slippers.

THE FORUM / BRUCE CRUMMY

TUNNELING HOME

The 1970s was a decade marked by heavy snowfall. This scene was recorded in the winter of 1977-78 just west of New England in southwestern North Dakota.

THE FORUM / DAVE WALLIS

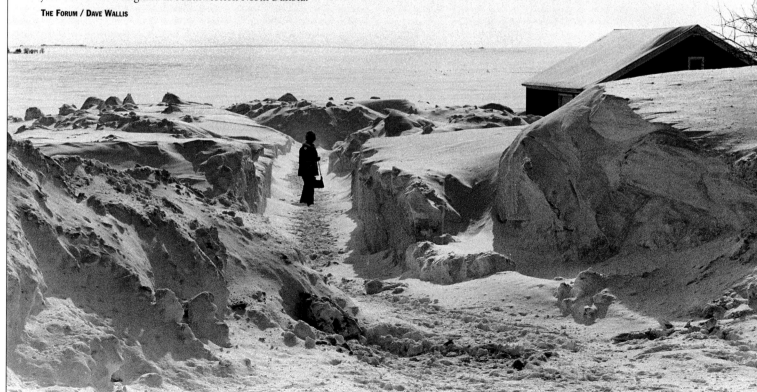

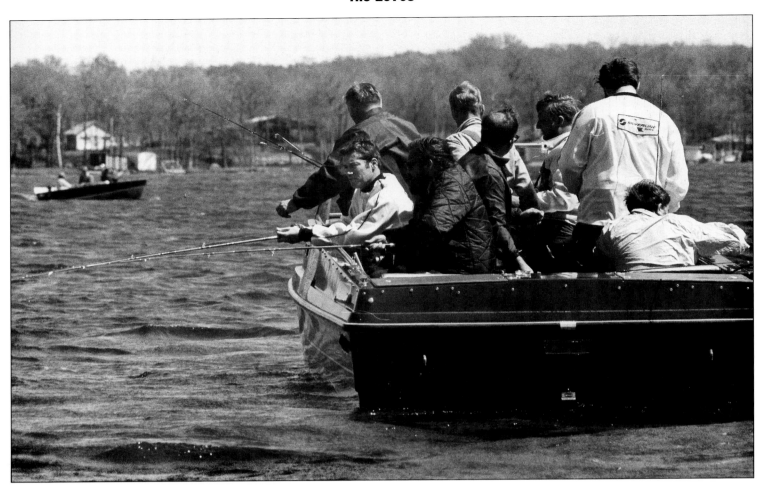

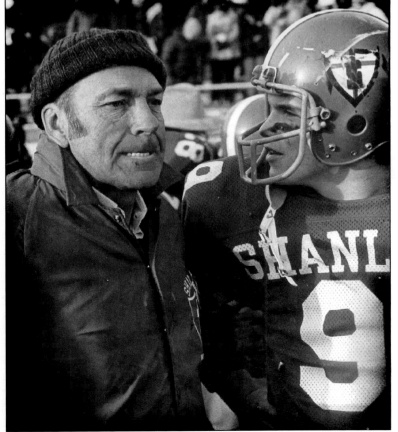

Good-Luck Governor

Minnesota Gov. Wendell Anderson (light jacket) fishes on Pelican Lake near Pelican Rapids during the 1971 Governor's Fishing Opener. Anderson had a successful day, catching a limit of northern pike and three walleyes. The governor's party was hosted by Fair Hills Resort.

THE FORUM / COLBURN HVIDSTON III

Record-Setting Coach

Fargo Shanley's Sid Cichy, the winningest football coach in North Dakota history, fights back tears as he stands with his son Steve during the closing moments of the 1977 Class A championship game at Dacotah Field in Fargo. In the final game of Sid's career, Steve led the Deacons past Bismarck Century for the school's 15th state title. Cichy compiled a record of 289 wins, 91 losses and 3 ties.

THE FORUM / DENNIS DOEDEN

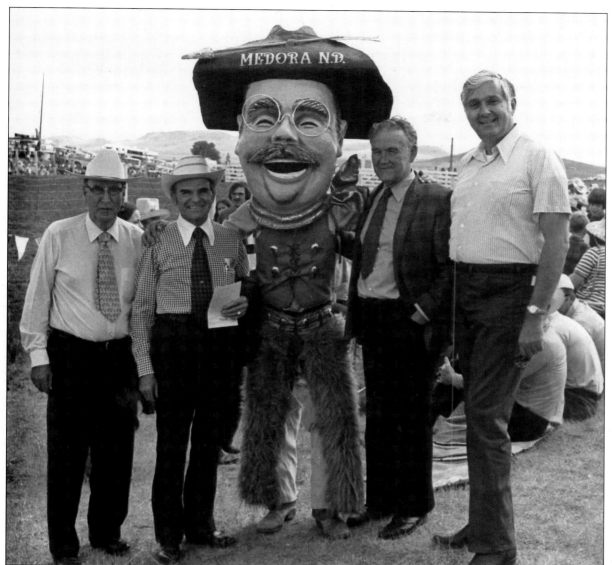

THE WILD WEST

Medora has become North Dakota's No. 1 tourist attraction. The state's political leaders, from left: U.S. Sen. Milton R. Young, Gov. Arthur Link, U.S. Sen. Quentin Burdick and U.S. Rep. Mark Andrews pose with a man in a Teddy Roosevelt costume, circa 1970s.

INSTITUTE FOR REGIONAL STUDIES, NDSU LIBRARIES

MULTI-MILLION-DOLLAR BUST

The world's only ballistic missile defense system was dedicated in October 1974 at Nekoma in northeastern North Dakota. The multi-million-dollar complex, which contained 30 Spartan long-range and 60 Sprint short-range missiles, was deactivated a mere four months after it was put on active duty. The base was closed down after it was determined the missile system technology was out of date.

THE FORUM / FILE PHOTO

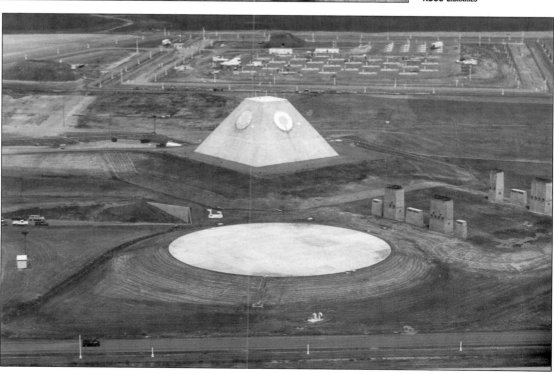

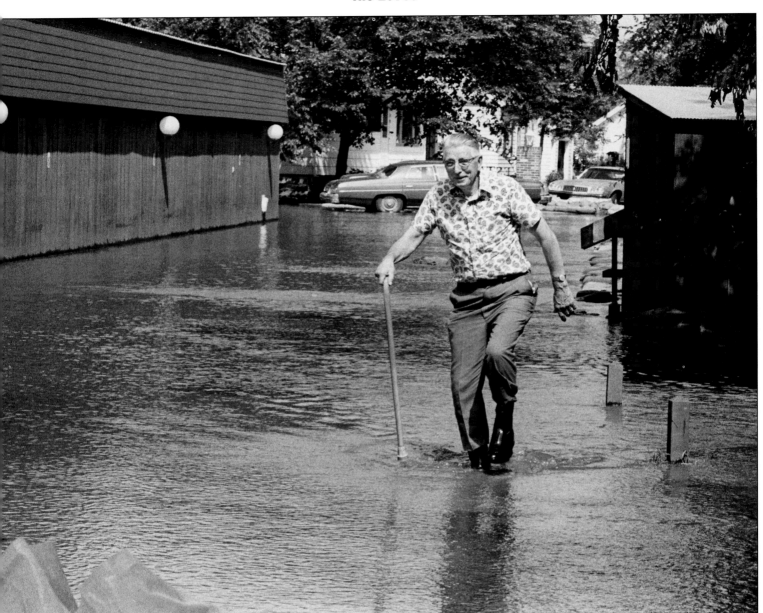

MID-SUMMER MESS

Oscar Erickson of West Fargo picks his way through a flooded driveway at Sheyenne Estates in July 1975 after a storm dumped 10 inches of rain in an area from Valley City, N.D., to east of Detroit Lakes, Minn., causing major flooding. Tornado, wind and water damage was extensive. At left, Greg Kemp, 4, and his grandfather, Jerry Joubert, of Argusville, N.D., cross a sandbag wall at Joubert's farm home. The dike was built as the Sheyenne River started to rise an inch per hour.

TOP: THE FORUM / FILE PHOTO
LEFT: THE FORUM / FILE PHOTO

SUNNY DAY ON CAMPUS

Students stroll through campus at Moorhead State University, circa 1970s.

MOORHEAD STATE UNIVERSITY ARCHIVES

POET LAUREATE

Henry R. Martinson, Fargo (right) and Lydia O. Jackson, Grafton, were designated as associate poets laureate of North Dakota by the 1975 Legislature. Martinson, who homesteaded near Crosby in northwestern North Dakota, was active in the state's labor movement. He served as state deputy commissioner of labor from 1937-65. He compiled and published a book of poems entitled "Old Trails and New."

THE FORUM / FILE PHOTO

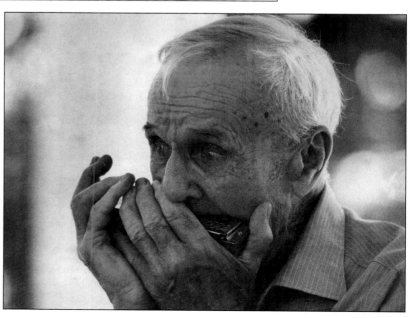

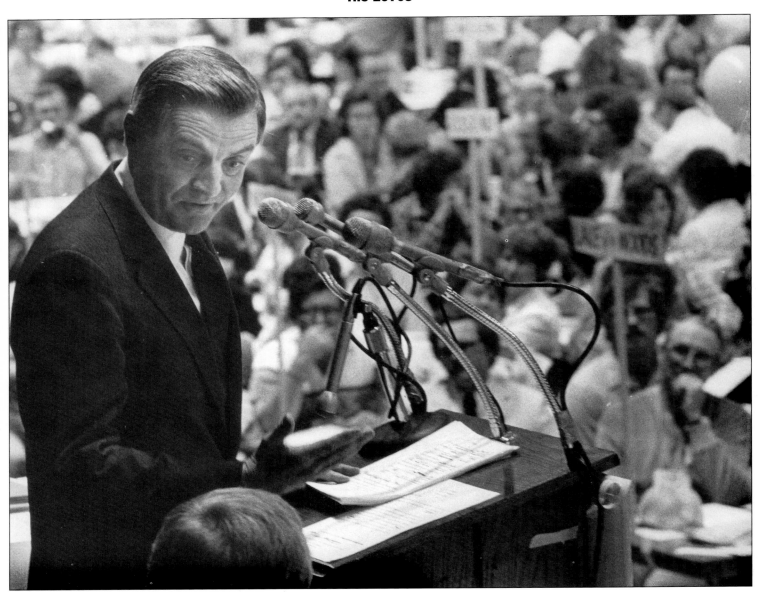

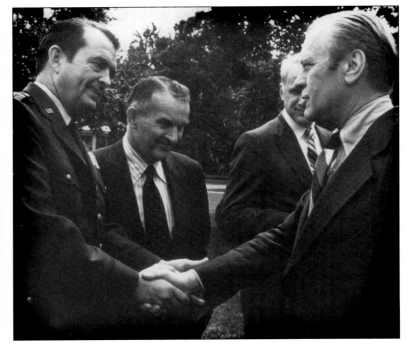

MR. VICE PRESIDENT

Minnesota's Walter Mondale rose to the top of the political ladder in the 1970s, serving as vice president under Jimmy Carter from 1977-80. Mondale was appointed to the U.S. Senate in 1964 to replace Hubert H. Humphrey, who had been elected vice president. Here, Mondale addresses Minnesota's 7th District DFL Convention.

THE FORUM / FILE PHOTO

NEW CHAIRMAN

President Gerald R. Ford (right) congratulates Air Force Gen. David C. Jones of Minot, N.D., who was appointed chairman of Joint Chiefs of Staff June 21, 1978 and served until 1982. In that capacity, he was a senior military adviser to the president, the National Security Council and the secretary of Defense. During the Korean War, Jones accumulated more than 300 hours on bombardment missions over North Korea. The first North Dakota native to earn a spot among the Joint Chiefs was Army Gen. Harold Johnson, who was born in Bowesmont and grew up in Grafton. Johnson, who served as Army chief of staff from 1964-68, was selected by President Lyndon Johnson over 43 other generals who had greater seniority. Admiral William Owens, a 1958 graduate of Bismarck High, was named vice chairman of the Joint Chiefs by President Bill Clinton in 1994.

THE FORUM / FILE PHOTO

The 1980s

Economic resurgence, and some dry times

When President Ronald Reagan took office in 1981, the economy was the nation's No. 1 concern. The largest tax cut in U.S. history was passed by Congress and the nation's economic recovery started to surge in 1983.

Hard times struck the nation's farm belt and by the mid-1980s American farmers were more than $200 billion in debt. In this region, drought conditions toward the end of the decade hit farmers hard and river and lake levels dropped.

The space program continued and in 1986 the space shuttle Challenger exploded after liftoff, claiming the lives of six astronauts and New Hampshire high school teacher Christa McAuliffe.

Some other highlights were:

❏ The U.S. Olympic Committee voted April 4, 1980, against U.S. participation in the Moscow summer games. Earlier, President Jimmy Carter had announced sanctions against Russia for the Soviet invasion of Afghanistan.

❏ Former President Ronald Reagan was shot and seriously wounded March 30, 1981, in Washington, D.C. Also seriously wounded were a Secret Service agent and press secretary James Brady.

❏ Minnesota native son Walter Mondale won the Democratic presidential nomination and carried only his home state in the 1984 November general election. Ronald Reagan was re-elected by the greatest Republican landslide in history.

❏ President Ronald Reagan produced the nation's first trillion dollar budget in 1987.

❏ Minnesota voters approved a

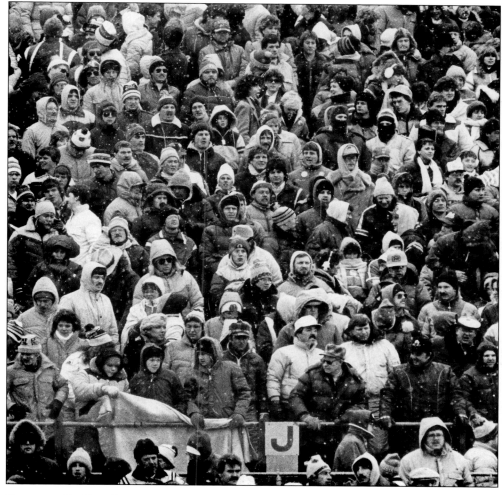

CHEERING ON THE CHAMPS

Bundled-up fans jam North Dakota State University's Dacotah Field for one of many playoff football games during the 1980s. Bison football was at its peak. NDSU won NCAA Division II championships in 1983, '85, '86, '88 and 1990 and finished second in '84. In 1993 the Bison moved indoors to the Fargodome.

THE FORUM / COLBURN HVIDSTON III

constitutional amendment in 1988 authorizing a state lottery and establishment of an environmental trust fund with a portion of the lottery receipts.

❏ Steve Berrell, 20, a graduate of Fargo South High School attending Syracuse University, died along with 257 other people on Pan Am Flight 103 Dec. 21, 1988 when a bomb exploded and sent the

plane down at Lockerbie, Scotland.

❏ The Berlin Wall was torn down in 1989 after standing as a barrier between East and West during some 30 years of what was called "The Cold War."

❏ On Oct. 17, 1985, just before a World Series game, an earthquake struck the San Francisco Bay area, causing 62 deaths.

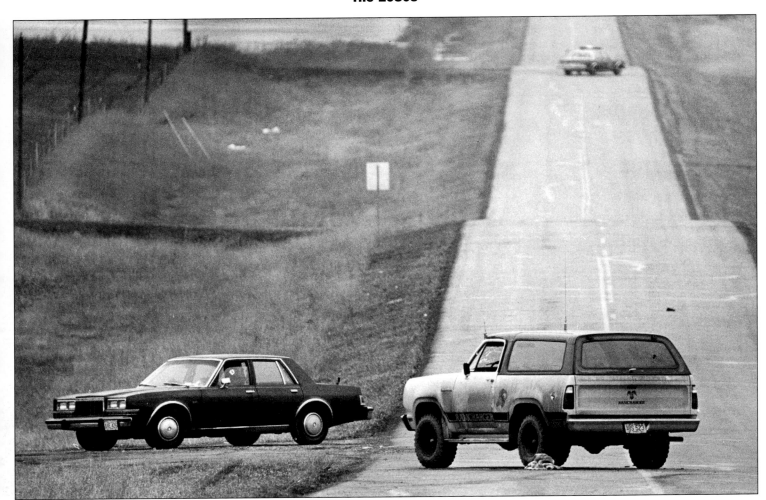

MEDINA MASSACRE

In February 1983, U.S. Marshal Kenneth B. Muir, Fargo, and Deputy U.S. Marshal Robert S. Cheshire, Bismarck, were killed when they attempted to stop tax protester Gordon Kahl of Heaton, N.D. Three other law enforcement officers were wounded in the battle just outside of Medina, 30 miles west of Jamestown. Kahl, 63, fled the scene of the shooting and was killed nearly four months later in a gun battle with law enforcement authorities in an Arkansas farmhouse. A county sheriff also was killed in that battle. Kahl's son, Yorie Von Kahl of Heaton, and Scott Faul of Harvey, N.D., also were charged with murder. David Broer of Streeter, N.D., was charged with assault. At right, Yorie Von Kahl (left), Broer (center) and Faul are led from the federal courthouse in Fargo after being sentenced. Yorie Von Kahl and Faul were convicted of second-degree murder and sentenced to life in prison; Broer was convicted of conspiracy and harboring a fugitive.

TOP: THE FORUM / BRUCE CRUMMY
RIGHT: THE FORUM / BRUCE CRUMMY

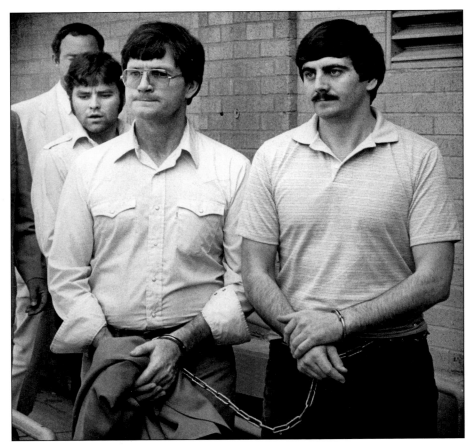

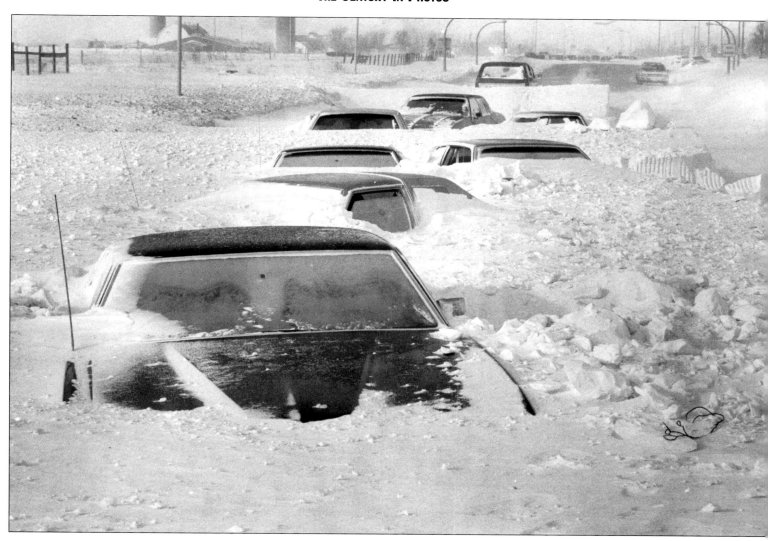

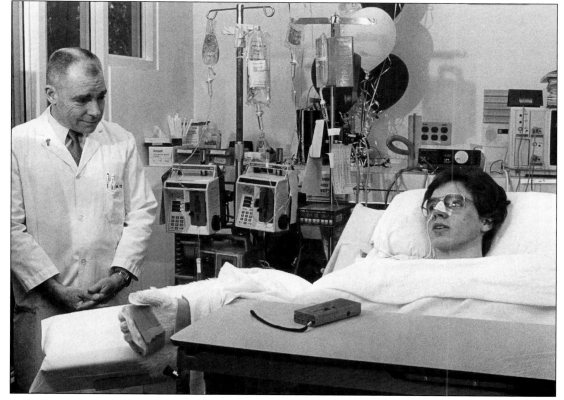

FATAL BLOW

Four Fargo residents, including three teen-agers, were found dead on Fargo's 19th Avenue North near Hector International Airport following a Feb. 4, 1984, blizzard. They had been shopping at West Acres and were trying to return home when they became stuck along with a number of other vehicles. The blizzard claimed 23 lives, including 16 from Minnesota and seven from North Dakota.

THE FORUM / COLBURN HVIDSTON III

RECUPERATING

Bennett Stebleton answers a reporter's questions in February 1989 from his bed in the intensive care unit at MeritCare Hospital as Dr. David Todd looks on. Stebleton was being treated for frostbite suffered a week earlier after he was stranded in a snowbound car for $2\frac{1}{2}$ days near Egeland in northeastern North Dakota.

THE FORUM / DAVE WALLIS

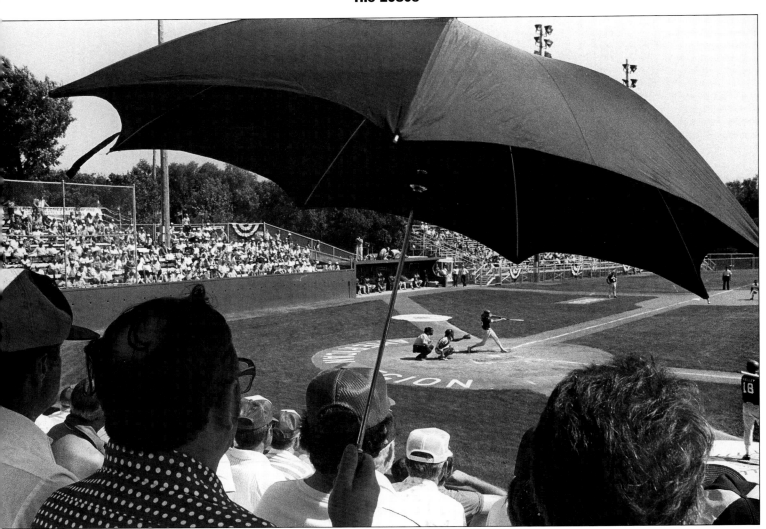

WORLD SERIES COMES TO FARGO

Huge crowds turned out when Fargo's Jack Williams Stadium hosted its first American Legion Baseball World Series in September 1983. Because of the success that year, Fargo also hosted the event twice in the 1990s. A strong commitment from the Gilbert C. Grafton Post in Fargo helped bring Legion ball to prominence.

THE FORUM / FILE PHOTO

FLYING HIGH

Members of the Fargo-Moorhead Acro Team fly over NBC "Today Show" weatherman Willard Scott at a Fargo Civic Memorial Auditorium presentation. The Acro Team, designated as official goodwill ambassadors for the state of North Dakota, has made hundreds of national appearances since the 1970s.

THE FORUM / COLBURN HVIDSTON III

DARLING OF NORTH DAKOTA

Actress Angie Dickinson, a native of Kulm, N.D., pitches in to help North Dakota Gov. George Sinner deep-fry a pitchfork loaded with steaks at the Schollander Pavilion on the Red River Valley Fairgrounds in West Fargo. The event, held in May 1988, was a fund-raising birthday party, sponsored by Gov. Sinner's re-election committee. Angie decided to campaign for Sinner after meeting him at her induction into the North Dakota Rough Rider Hall of Fame.

THE FORUM / DAVE WALLIS

CONCRETE SIGNING

Country singer Lynn Anderson, a Grand Forks, N.D., native, signs her name in Fargo's Walk of Fame in July 1989.

THE FORUM / COLBURN HVIDSTON III

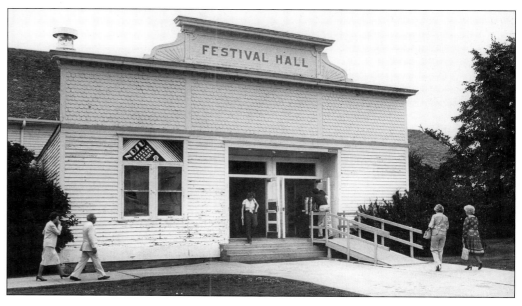

FAREWELL TO FESTIVAL HALL

The weathered, rickety, barnlike Festival Hall, built in 1897 on the North Dakota State University campus, held its final performances July 6, 1982. It was replaced by a state-of-the-art performance center. Festival Concert Hall now is part of the Reineke Fine Arts Center.

THE FORUM / DAVE WALLIS

KICKIN' UP THEIR HEELS

Country music fans by the thousands arrive every August in Detroit Lakes, Minn., for WE Fest. The first one was held in 1983 under the theme, "WE in '83 Country Music Festival." It draws some of the top headliners in the world of country music to Soo Pass Ranch.

THE FORUM / FILE PHOTO

THE PLACE TO BE

In 1965, a major renovation of the city beach on Big Detroit Lake in Detroit Lakes, Minn., was begun, creating a huge sandy beach that annually draws thousands of sunbathers and tourists. This July 4, 1987 scene is typical of the popular hangout.

THE FORUM / BILL MARCIL JR.

OVER THE OVERPASS

Two Minneapolis area men escaped serious injury in November 1982 when their truck swerved to avoid hitting a car and plunged off the eastbound lane of Interstate 94 at the I-29 interchange in Fargo.

THE FORUM / BRUCE CRUMMY

RED-LIGHT SPECIAL

The Moorhead Kmart store was open late one Saturday night in September 1982 after a car, attempting to stop along U.S. Highway 10 at about midnight, turned off onto a service road and smashed into the store. The driver was injured. Cleanup workers were faced with fitting the battered car back through the hole it made in the store's south wall.

THE FORUM / BRUCE CRUMMY

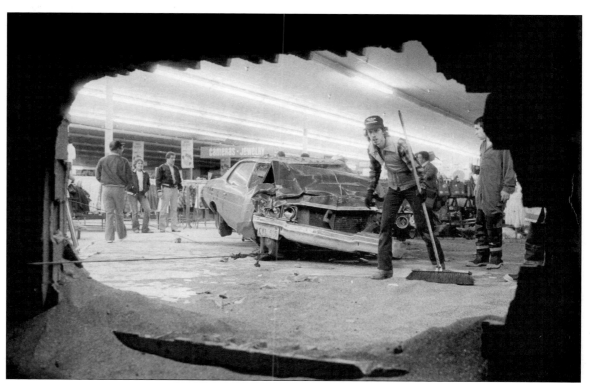

MOURNING MARIS

Many giants of Major League Baseball came to Fargo in December 1985 for the funeral of home run king Roger Maris. Above, pallbearers file into St. Mary's Cathedral. They include, from right to left: Mike Shannon, Moose Skowron, Whitey Ford, Whitey Herzog and Mickey Mantle. Maris, who grew up in Fargo, died of cancer at the age of 51. More than 1,000 people attended his funeral. Maris is buried at Holy Cross Cemetery north of Hector International Airport.

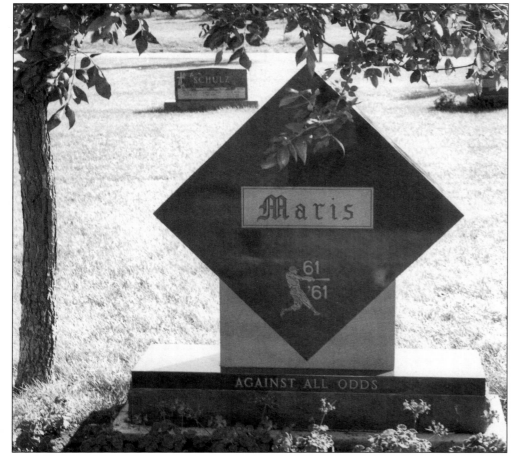

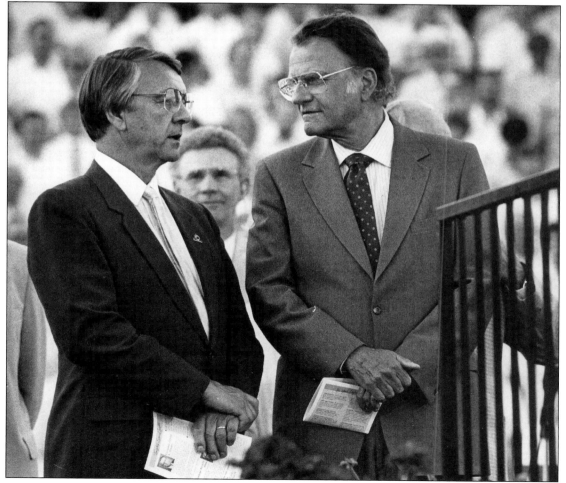

OVERFLOW CROWD

A crowd of 21,150 fills Dacotah Field at North Dakota State University June 19, 1987, to hear world-renowned evangelist Billy Graham. At left, Graham (right) and North Dakota Gov. George Sinner speak briefly before the governor introduced Graham.

TOP: THE FORUM / COLBURN HVIDSTON III
LEFT: THE FORUM / COLBURN HVIDSTON III

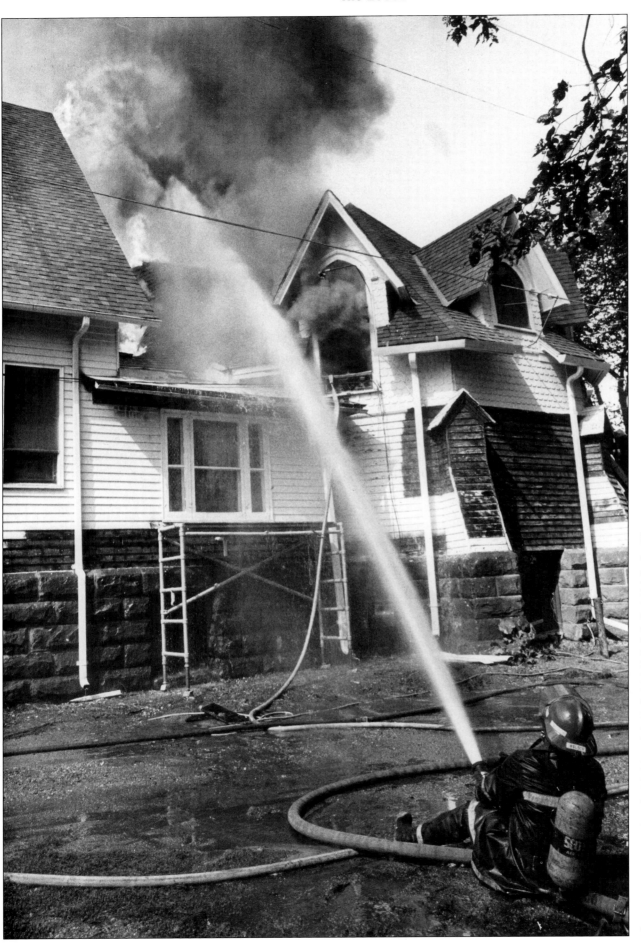

LANDMARK LOST

On Sept. 12, 1989, fire destroyed Fargo's historic Gethsemane Episcopal Cathedral southeast of the Cass County Courthouse. The cathedral was listed on the National Register of Historic Places. Work began on the original church in 1890 or 1891 but was stopped in 1893 because of a nationwide financial panic. It was finally completed and dedicated on a snowy February day in 1900. The church gained cathedral status in 1913. After the 1989 fire, a new church was erected at 3600 25th St. S. It was dedicated in May 1993.

THE FORUM / DAVE WALLIS

SYNTHETIC GAS

The Great Plains Gasification Plant, the nation's first commercial-scale synthetic fuel facility, went into operation in 1985 near Beulah, N.D., about 60 miles northwest of Bismarck. The controversial $2.5 billion facility, built by a consortium of energy companies, was designed to produce coal-based fuels. The plant brought nearly 1,000 jobs to the state.

THE FORUM / FILE PHOTO

GOVERNOR CITY

North Dakota Gov. George Sinner speaks at a dedication ceremony in June 1987 following the unveiling of a billboard along Interstate 94 just west of Casselton. The billboard proclaims Casselton as home to four governors, including Sinner. Also listed are William L. Guy, William Langer and Andrew H. Burke. The billboard was donated by Newman Outdoor Advertising of West Fargo and its unveiling was part of Casselton's Community Days.

THE FORUM / BRUCE CRUMMY

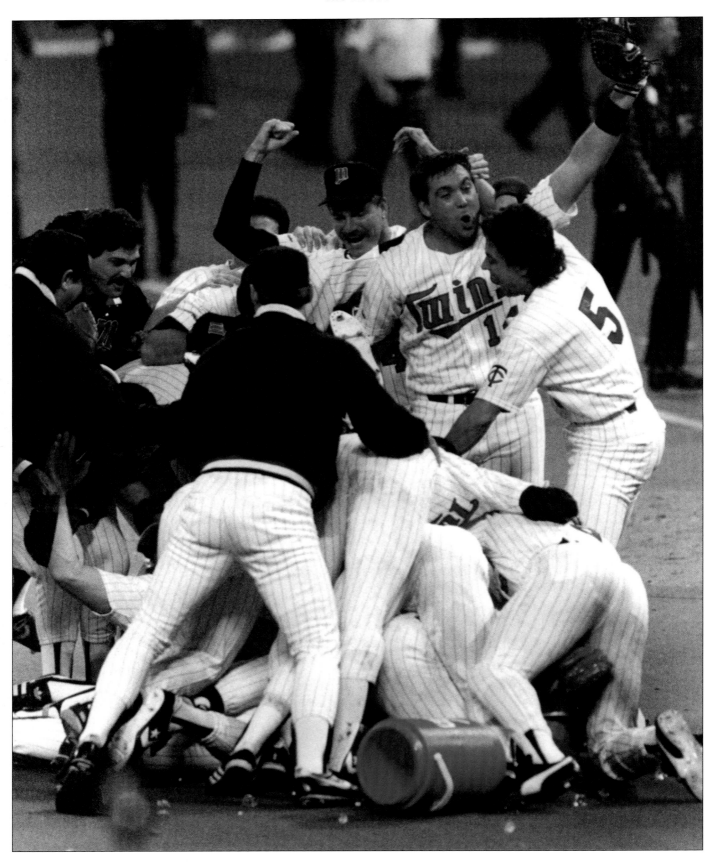

WORLD CHAMPIONS PILE ON

The Minnesota Twins celebrate their first World Series baseball championship in October 1987 after defeating the St. Louis Cardinals in Game 7 at the Metrodome in Minneapolis. Included in the celebration (at far right) are Roy Smalley (5) and Minnesota's home-grown star, Kent Hrbek (with glove raised). The Twins won again in 1991, beating the Atlanta Braves in seven games.

ASSOCIATED PRESS

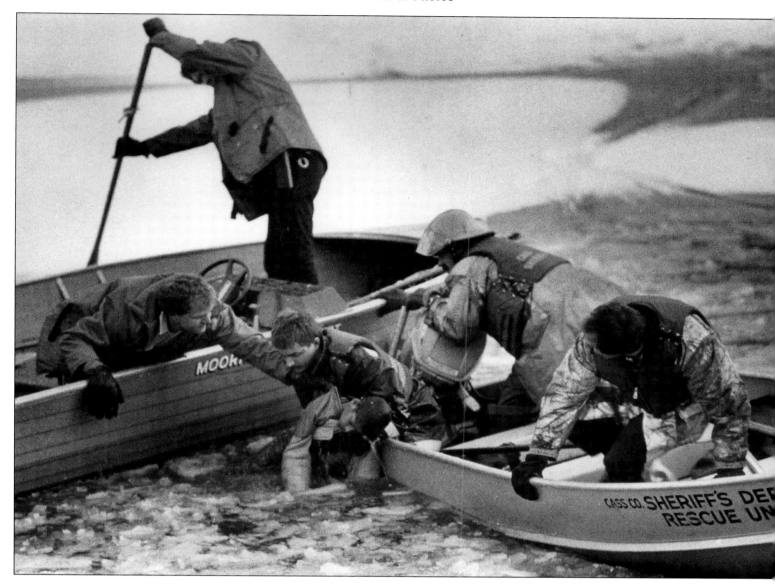

The Forum

FARGO-MOORHEAD • SUNDAY, DECEMBER 13, 1987 ONE DOLLAR

Garza's miracle enters 10th day

SURVIVAL STORY

Alvaro Garza Jr. is pulled from the Red River by Fargo-Moorhead area rescue squad members Dec. 4, 1987. The 11-year-old was trapped under the ice for nearly 45 minutes. When pulled from the river, Garza had no pulse and was not breathing. Two weeks later, after what was described as a miraculous recovery, Alvaro steps off an elevator at MeritCare Hospital with his family after being released to go home. From left are Alvaro's brother, Joey; Dr. William Norberg; a pediatric critical care specialist; Alvaro Jr.; his mother, Mary Helen; and his father, Alvaro Sr.

TOP: THE FORUM / COLBURN HVIDSTON III
RIGHT: THE FORUM / COLBURN HVIDSTON III

CENTENNIAL PLANTING PROJECT

President George Bush discusses the newly planted Centennial Tree with Lindsy Tscheider of Bismarck as North Dakota Gov. George Sinner looks on in April 1989. Bush praised the state's efforts to plant 100 million trees as part of its centennial observance. At right, Kevin Locke of Mobridge, S.D., performs a Native American hoop dance during the centennial celebration in Bismarck. The Mandaree Singers of New Town, N.D., provided music for Locke.

TOP: THE FORUM / COLBURN HVIDSTON III
RIGHT: THE FORUM / COLBURN HVIDSTON III

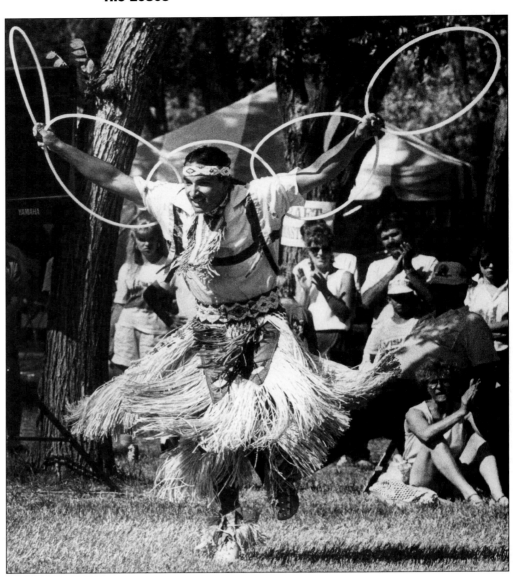

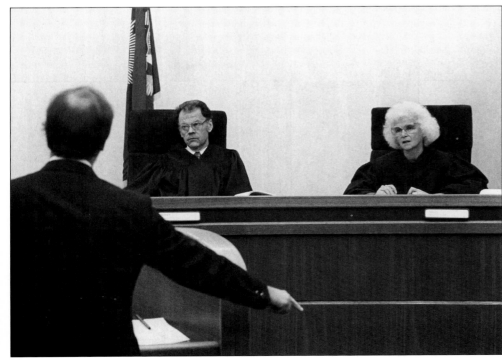

FIRST WOMAN JUSTICE

Beryl Levine, Fargo, was the first woman to serve on North Dakota's Supreme Court. She was appointed in January 1985 by Gov. George Sinner. She retired in March 1996.

THE FORUM / FILE PHOTO

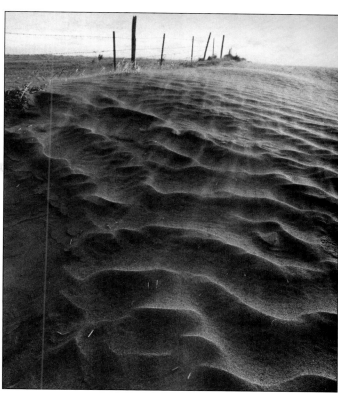

DRY TIMES

Drought hit the region in the late 1980s. Winds blew the topsoil into dunes on Steve Voeller's farm near Rugby in north-central North Dakota in June 1988. At left, the Red River bottom beneath Fargo's Broadway bridge is strewn with dead branches and the river reduced to a trickle in July 1988. The drought lasted through 1992. In 1993, a wet cycle began and since then North Dakota's Devils Lake has risen 25 feet.

TOP: THE FORUM / BRUCE CRUMMY
LEFT: THE FORUM / NICK CARLSON

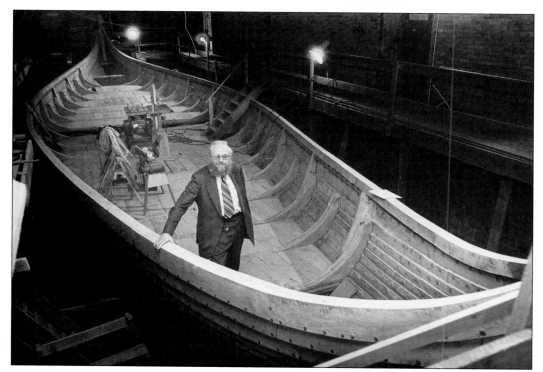

A SHIP OF DREAMS

Robert Asp started building his Hjemkomst Viking ship in the 1970s in a warehouse in Hawley, Minn. Asp, a Moorhead school counselor, dreamed of sailing his ship from America to Norway, but died in December 1980 before the trip was made. A crew of 12 sailed it from Duluth, Minn., to Bergen, Norway, in 1982.

THE FORUM / DAVE WALLIS

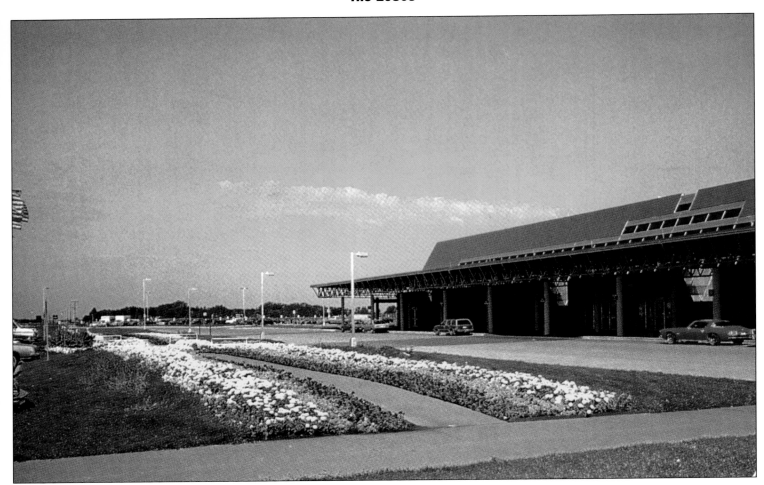

OUR FRONT DOOR

Fargo's current Hector International Airport terminal opened in January 1985. The facility is located west of the old terminal building, which had been in use since 1953. The old terminal had 23,000 square feet of space; the new one has 76,000 square feet on two levels. "It's going to be kind of the front door to the community," said John Campbell, then executive vice president of the Fargo Chamber of Commerce.

INSTITUTE FOR REGIONAL STUDIES, NDSU LIBRARIES

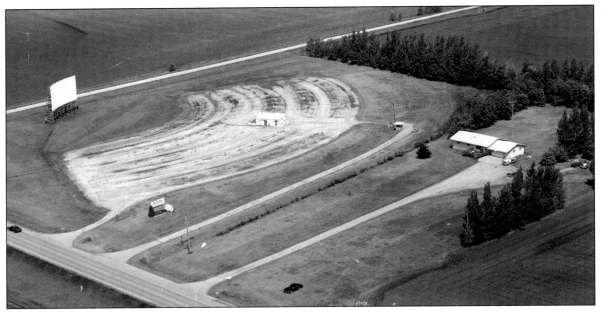

DRIVE-IN THEATER STILL OPERATING

While most of the drive-in theaters built across the country in the 1950s have disappeared, there are still some left. One is located just outside Warren about 20 miles northeast of East Grand Forks, Minn. Called the Sky-Vu Drive-In, it is owned by Leonard Novak of Warren, who says it is the only drive-in theater between Minneapolis and the Canadian border. It was built in 1953. He has owned the theater for 26 years, and previously was a projectionist at the theater. The first drive-in theater opened in June 1933 in Camden, N.J. Fargo's Star-Lite Drive-in was located across 19th Avenue, north of the Fargodome, while Moorhead's Moon-Lite Drive-in was located along U.S. Highway 75, a few blocks south of Interstate 94. They, too, were built in the early 1950s and disappeared from the scene in the 1980s.

COURTESY OF LEONARD NOVAK

The 1990s

Stock market rises, farm prices fall

The latter days of the 1990s found the nation embroiled in a sex scandal surrounding President Bill Clinton and former White House intern Monica Lewinsky. Clinton was impeached by the House, but there were not enough votes in the Senate to uphold it.

The stock market soared across the 11,000 mark in July 1999 as an economic meltdown occurred in Asia. The nation's farmers were going through one of their worst periods in history due to low farm prices and a lack of world demand for farm goods. Congress approved a $6.8 billion farm bailout package.

As the decade began, President George Bush ordered tens of thousands of U.S. troops to Saudi Arabia after Iraq invaded and took over Kuwait, an oil-rich country between Iraq and Saudi Arabia. On Feb. 23, 1991, allied troops defeated Iraq's military forces after 100 hours of ground fighting. American casualties totaled 305 dead and 467 wounded. As the decade was ending, Americans were involved with NATO forces to stop the ethnic cleansing in Kosovo, a part of Yugoslavia.

It was a decade that started with a drought across the region and ended with too much water on the landscape. North Dakota's Devils Lake doubled in size, forcing many residents to move to higher ground.

The Internet came into people's lives as a new way to explore the world. There was an explosion in telecommunications. The cellular phone became almost a necessity.

Some other highlights were:

❑ Minnesota's population increased 7.3 percent between 1980 and 1990, making it the fastest growing state in the region.

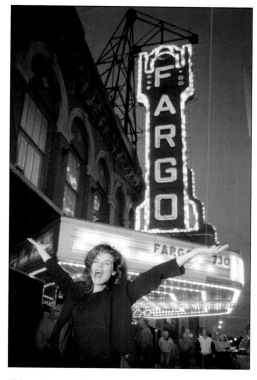

'YOU BETCHA'

Fargo actress Kristin Rudrud shows her excitement at the regional premiere of the movie "Fargo" March 21, 1996 at the historic Fargo Theatre. Rudrud received good reviews for her performance as the kidnapped wife in the movie.

THE FORUM / NICK CARLSON

❑ Yellow ribbons and American flags were displayed by citizens in 1990 and 1991 to show support for troops in the Persian Gulf to oust Saddam Hussein from Kuwait.

❑ The dissolution of the Union of Soviet Socialist Republics in 1991 marked the end of the Cold War that had dominated international politics since 1947.

❑ Major league baseball players went on strike Aug. 11, 1994. The strike ended April 15, 1995.

❑ On Oct. 16, 1995, former football star

O.J. Simpson was found innocent in the June 1994 murder of his former wife and a male friend.

❑ A record Minnesota low of 60 degrees below zero was recorded Feb. 2, 1996 at Tower.

❑ Mark McGwire of the St. Louis Cardinals broke the home run record of 61 set in 1961 by the late Roger Maris, who grew up in Fargo. McGwire broke the record Sept. 8, 1998, and went on to hit a record-setting 70 home runs for the season.

❑ Two youthful gunmen killed 13 other students, a teacher and themselves on April 20, 1999, at Columbine High School in Littleton, Colo., in the deadliest school shooting in American history.

❑ The Minnesota Legislature approved a record $2.9 billion package of tax relief moments before it adjourned May 17, 1999. The bill contained $1.25 billion in sales tax rebates, a $1.6 billion across-the-board income tax cut and $50 million in farm property tax relief.

❑ Tragedy again struck the family of President John F. Kennedy July 17, 1999, when a plane piloted by John F. Kennedy Jr., 38, crashed into the Atlantic Ocean en route to a family gathering at Martha's Vineyard in Massachusetts. Also dying in the crash were Kennedy's wife, Carolyn Bessette Kennedy, and her sister, Lauren Bessette. Kennedy Jr. was 3 when he captured the attention of the nation by saluting the casket of his father outside the church in Washington, D.C., where the funeral was held. President Kennedy was assassinated in Dallas Nov. 22, 1963.

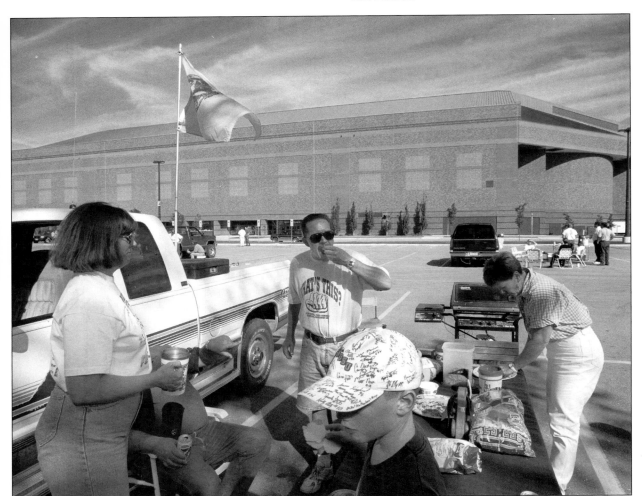

CENTER OF ATTENTION

North Dakota State University fans enjoy pre-game snacks before a September 1996 football game against Texas A&M-Kingsville at the Fargodome. The dome, located on the north edge of NDSU, opened Dec. 2, 1992, with concert seating for 27,647 or in-the-round seating for 28,509. Since its opening, the $48 million facility has been home to NDSU football, other college and high school sporting events, specialty shows and some of the biggest names in the entertainment industry. Meeting rooms and a new lobby are being added as the century ends.

THE FORUM / DAVID ARNTSON

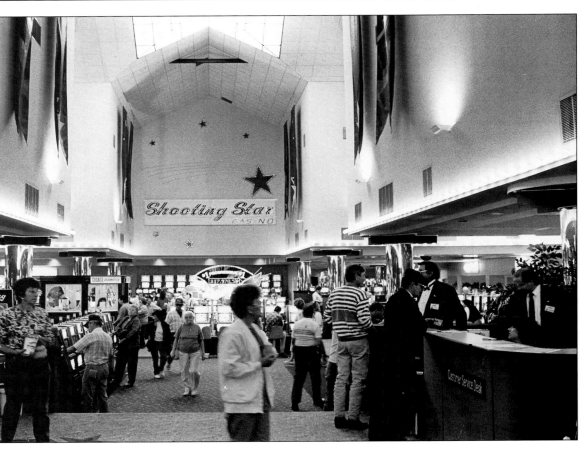

TAKING A CHANCE

Shooting Star Casino opened its doors in May 1992 at Mahnomen, Minn. The White Earth Band of Chippewa operated a temporary casino from August 1991 until the opening of the $15 million facility. The casino, open 24 hours a day, drew 200,000 people to its opening weekend.

THE FORUM / COLBURN HVIDSTON III

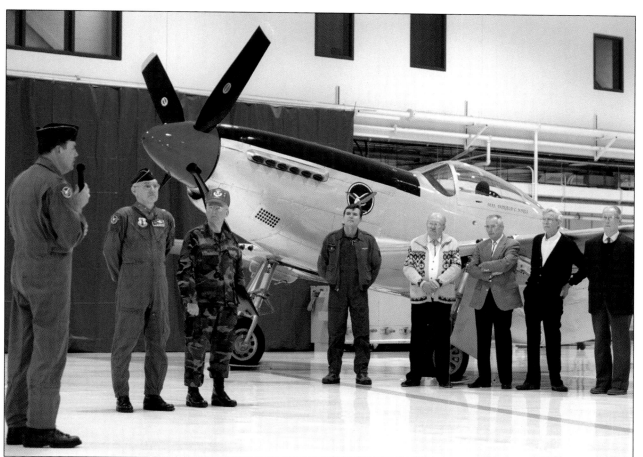

HOOLIGANS ARE CHAMPIONS

Four members of the original North Dakota Air National Guard unit are recognized during a ceremony on the 50th anniversary of the unit's formation in January 1997 at Hector International Airport in Fargo. The four, at right, Harley Horken, Robert Olwin, Al Kvant and Fred Quam, listen as Col. Mike Haugen, far left, introduces them. Also shown are Brig. Gen. Alan Henderson, Col. Al Lerberg and Bob Odegaard. The Air Guard unit has won high honors in competition with regular Air Force units.

THE FORUM /
DAVE WALLIS

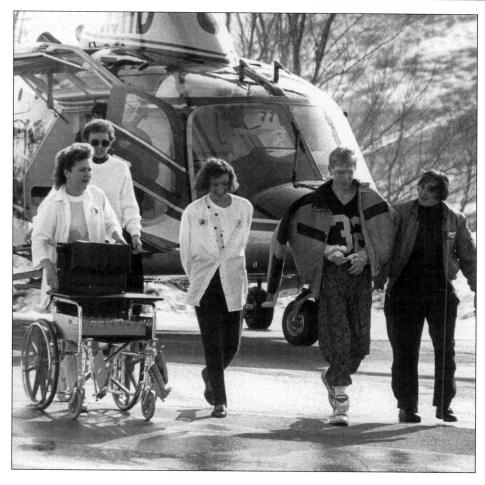

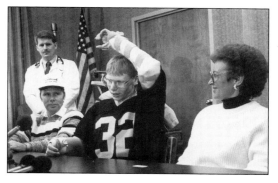

A HAPPY ENDING

In January 1992, John Thompson, 18, had his arms torn off in an accident at the family farm near Hurdsfield, N.D., 70 miles northeast of Bismarck. He fell backward onto a tractor's power takeoff while grinding feed. His right arm was taken off at the shoulder and his left arm at the elbow. His parents, Larry and Karen Thompson, were not home at the time. John managed to open the door to the house and make a phone call by putting a pencil in his mouth to summon aid from a nearby relative. While waiting for help, he stood in the bathtub so blood would not drip on the carpet. His arms were reattached at a Minneapolis area hospital. At left, Thompson arrives in Harvey, N.D., on his way home six weeks after the accident. Above, Thompson and his parents meet the press during the homecoming. Since that time, John has made farm safety speeches across the country.

TOP: THE FORUM / COLBURN HVIDSTON III
LEFT: THE FORUM / COLBURN HVIDSTON III

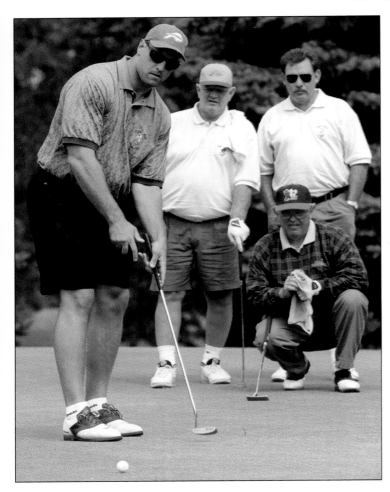

But You Should See Him Tackle

Phil Hansen (left) rolls a putt at the 1998 Roger Maris Celebrity Golf Tournament in Fargo. Hansen played high school football at Oakes, N.D., and was an All-American at North Dakota State before being drafted by the NFL's Buffalo Bills in 1991. The defensive end played in Super Bowls his first three seasons. In 1996 he signed a four-year contract extension worth $8.7 million.

THE FORUM / DAVID ARNTSON

On Top Of The Heap

The 1990s were glory days for the North Dakota State University women's basketball program. The Bison won five NCAA Division II championships in six years, including four straight from 1993-96. Above, coach Amy Ruley advises All-American center Kasey Morlock. Below, Lynette Mund and Jen Rademacher celebrate the 1995 title at the Bison Sports Arena. Rademacher played on four national championship teams in four seasons.

TOP: THE FORUM / NICK CARLSON
BELOW: THE FORUM / NICK CARLSON

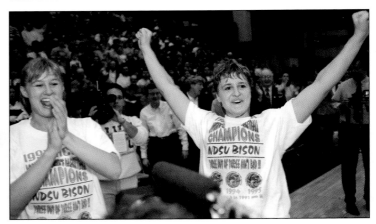

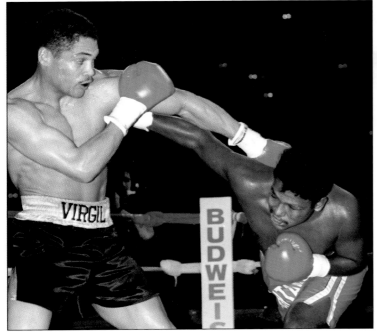

King Of The Hill

North Dakota's Virgil Hill (left) dodges a punch by Saul Montana in a November 1993 boxing bout at the Fargodome. Hill, who called Grand Forks and Williston his home, won a silver medal at the 1984 Olympic Games in Los Angeles and went on to dominate the light heavyweight division as a pro. He defended the light heavyweight class an all-time record 21 times. In May 1999, Hill won for the 45th time in 48 pro bouts when he defeated Glen Thomas at Minot, N.D.

THE FORUM / COLBURN HVIDSTON III

SUCCESS STORIES

Baseball captured the region's imagination in the 1990s through three stories – North Dakotans Rick Helling and Darin Erstad made it to the big leagues and minor-league ball returned to Fargo-Moorhead when the RedHawks joined the Northern League in 1996. Above left, Helling delivers a pitch for the Texas Rangers during his breakout 1998 season when he won 20 games and earned a $10.5 million, three-year contract. He grew up in Lakota in north-central North Dakota and played his last two seasons of American Legion ball in Fargo. At left, Jamestown product Erstad takes a mighty cut during the 1998 season for the California Angels. He hit .313 with 18 home runs, 28 doubles and 59 RBI in the first half of '98, earning a trip to the All-Star Game and the praise of several opposing managers, who dubbed him one of baseball's brightest new stars. Above, fans have been flocking to Newman Outdoor Field on the NDSU campus to watch the RedHawks, who won the Northern League championship in 1998.

TOP LEFT: THE FORUM / COLBURN HVIDSTON III
TOP RIGHT: THE FORUM / DAVE WALLIS
LEFT: THE FORUM / COLBURN HVIDSTON III

RELIGIOUS ROOTS

The Stavkirke was a dream that Fargoan Guy Paulson saw come true when he erected the replica Norwegian church on the grounds of the Heritage Hjemkomst Interpretive Center in Moorhead. It was dedicated in June 1998.

THE FORUM / COLBURN HVIDSTON III

THE KID SHINES

Fargo blues performer Jonny Lang, 18, opens for the Rolling Stones in a February 1999 Fargodome concert. It was a return to his roots for the former Kid Jonny Lang, who at age 12 was already making headlines.

THE FORUM / COLBURN HVIDSTON III

RESTORATION IN THE ROUND

Lonnie Halverson of Wahpeton, N.D., restored a 1926 carousel originally used in New York state and later stored in a garage in Pelican Rapids, Minn. The Prairie Rose Carousel made its debut in Wahpeton's Chahinkapa Park on Thanksgiving Day 1992.

THE FORUM / FILE PHOTO

SEVEN DIE IN MOORHEAD FIRE

Terriann Carrillo, 31, and her six children died of smoke inhalation in January 1995 when fire destroyed their south Moorhead apartment. It was the largest toll of lives ever in a Moorhead fire. Authorities said alcohol, cigarettes and smoke alarm tampering contributed to the deaths. Above, family and friends leave after the burial service at Riverside Cemetery. At left, firefighters inspect the damage at the four-plex building at 921 9th St. S.

TOP: THE FORUM / DAVE WALLIS
LEFT: THE FORUM / NICK CARLSON

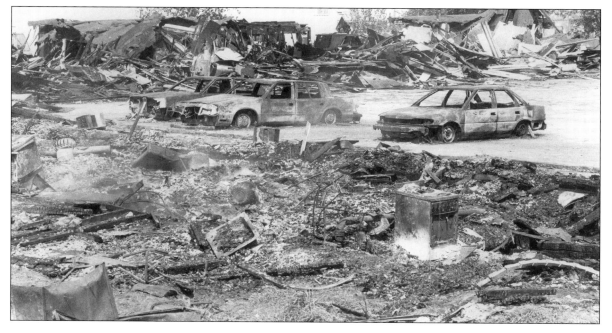

DEADLY MOTEL BLAZE

Three people died May 20, 1991, when a fire destroyed half of the Sunset Motel, 731 Main Ave., West Fargo. The destroyed portion of the business was rebuilt.

THE FORUM / COLBURN HVIDSTON III

FLOOD TAKES ITS TOLL

Clockwise from top: In the historic flood of April 1997, water surrounds houses in the Timberline area of southwest Fargo; Minnesota National Guardsmen evacuate Eva Ambuehl, 91, one of the last Ada residents to be rescued when floodwaters swept through the Norman County seat 45 miles northeast of Moorhead; wind and ice snapped utility poles along Interstate 94 between Fargo and Casselton in the last of 13 winter storms or blizzards of the winter/spring of 1996-97; the 2,000-foot KXJB-TV tower

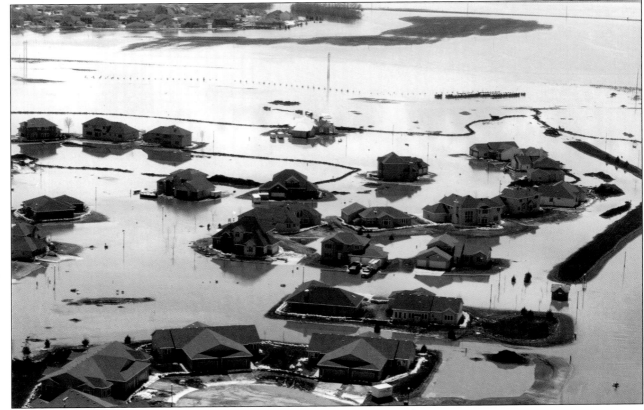

near Clifford, N.D., went down during the last blizzard. A new 2,063-foot tower was put into operation in August 1998. The station used a microwave relay to transmit to cable TV channels in the area until the tower was rebuilt. Fargo-Moorhead received a record 116.6 inches of snow that winter and the Red River in Fargo crested at a record of 39.5 feet on April 18.

TOP: THE FORUM / DAVE WALLIS
RIGHT: THE FORUM / COLBURN HVIDSTON III
BELOW LEFT: THE FORUM / NICK CARLSON
BELOW RIGHT: THE FORUM / DAVE WALLIS

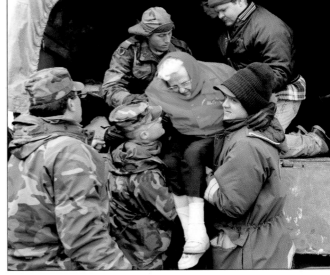

The Forum

THURSDAY, APRIL 17, 1997 FARGO-MOORHEAD
50 CENTS

HIGH 60°
LOW 30°
Mostly sunny
Weather details, A2

Ann Landers A11
Business B3-4
Classified C7-12
Comics/Crossword B6
Diversions B1-2
Metro & State C1
Obituaries C4
Opinion A4
Records C4
Sports D1-6
Television/Movies A11

Flood of '97

Red sets record

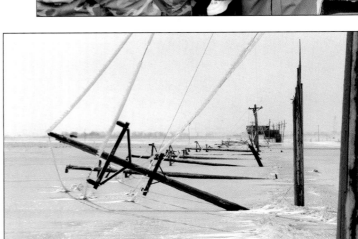

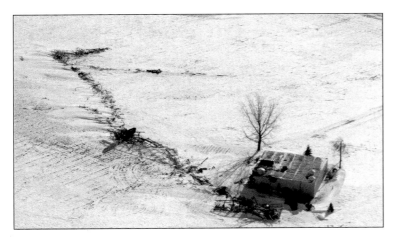

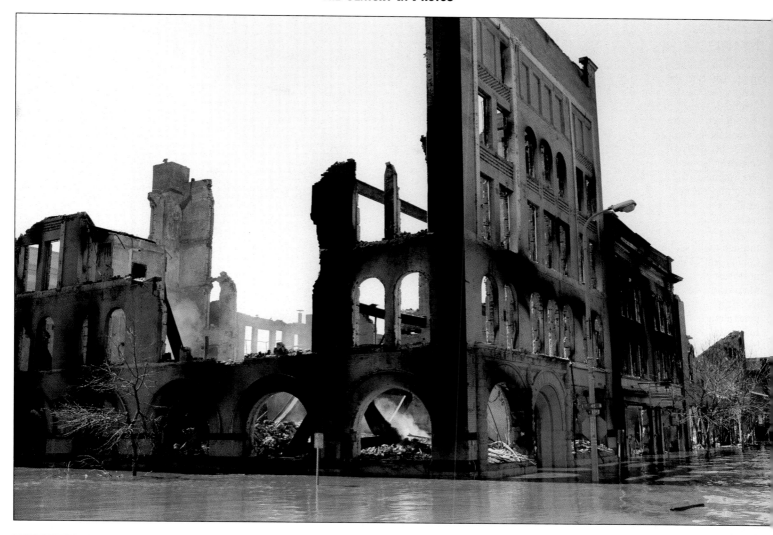

FIRST FLOODWATERS, THEN FIRE

The remains of the Security Building in Grand Forks, N.D., are a grim reminder of the fire that demolished a number of downtown structures when floodwaters poured into town in April 1997. The photo, taken two days after the flood, looks down 3rd Street North from 1st Avenue. Below, President Bill Clinton consoles Grand Forks Mayor Pat Owens at a news conference at Grand Forks Air Force Base. Clinton visited Grand Forks after floodwaters breached the city's dikes, forcing evacuation of residents.

TOP: THE FORUM / COLBURN HVIDSTON III
BELOW: THE FORUM / DAVE WALLIS

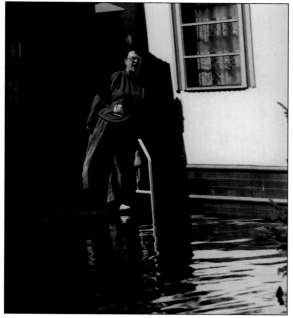

BARELY ABOVE WATER

With floodwaters lapping at her Bois de Sioux Mobile Estates home in Breckenridge, Minn., Karen Boothby yells to passing relief agency workers ferrying groceries.

THE FORUM / BRUCE CRUMMY

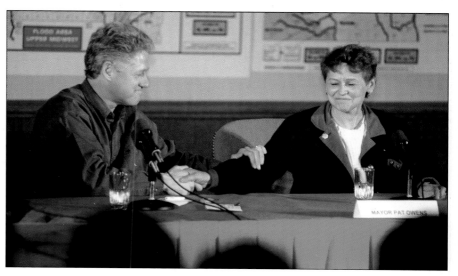

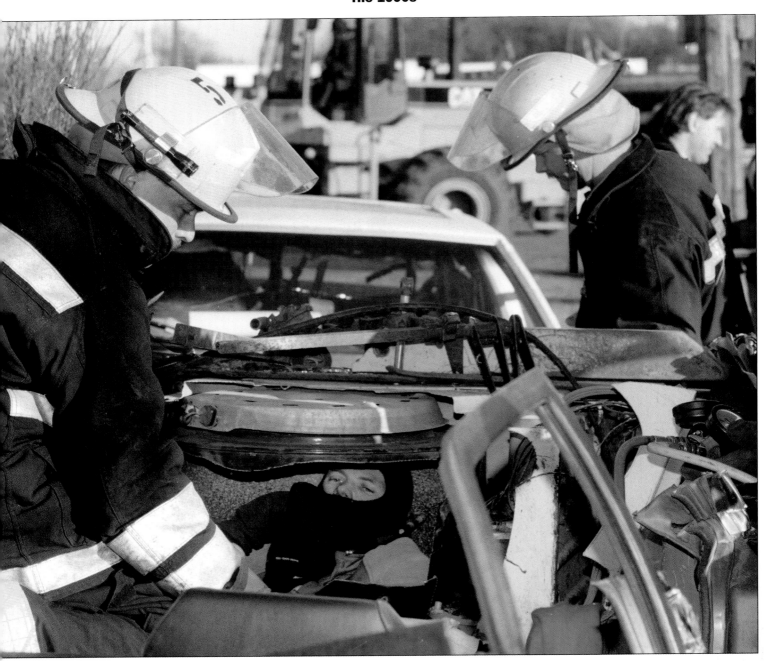

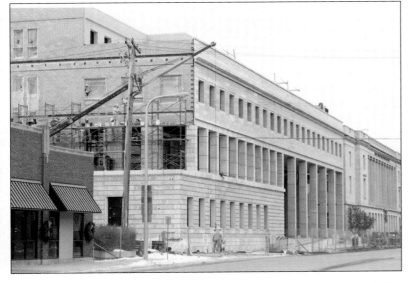

MAKING A STATEMENT

Fargo firefighers cut abortion protester Tim Lindgren of Moorhead from a clothes dryer drum in the back of a junked station wagon in November 1994 at the Women's Health Organization's clinic at 11 14th St. S., Fargo. Demonstrations were common at the clinic during the 1980s and 1990s. Lindgren and Ronald Dale Shaw of Bismarck, N.D., blocked the clinic's driveway for four hours.

THE FORUM / NICK CARLSON

COURTHOUSE EXPANDS

The Quentin N. Burdick Federal Courthouse, located on 1st Avenue North in downtown Fargo, is shown under construction in 1998. The $15 million addition was dedicated in July 1998 in honor of Burdick, a Fargo Democrat who served in the U.S. Senate. Burdick was elected to the U.S. House of Representatives in 1958. When Sen. William Langer died two years later Burdick won a special election for the Senate seat. He served until his death in September 1992 at age 84.

THE FORUM / DAVE WALLIS

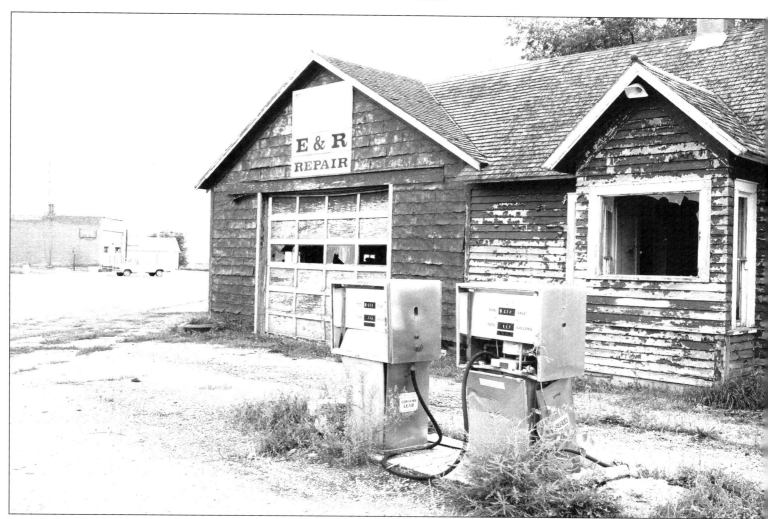

A DYING TOWN

Dazey, a community of about 90 people located northwest of Valley City in Barnes County, is symbolic of what is happening in North Dakota's rural communities. Below, a photograph from the early part of the century shows a thriving community and (above) is a September 1997 view of one of the community's closed businesses. The population of Dazey peaked at 293 in 1920. The 1990 census put it at 129; it was estimated at 121 in 1994.

TOP: THE FORUM / DAVE WALLIS
BELOW: INSTITUTE FOR REGIONAL STUDIES, NDSU LIBRARIES

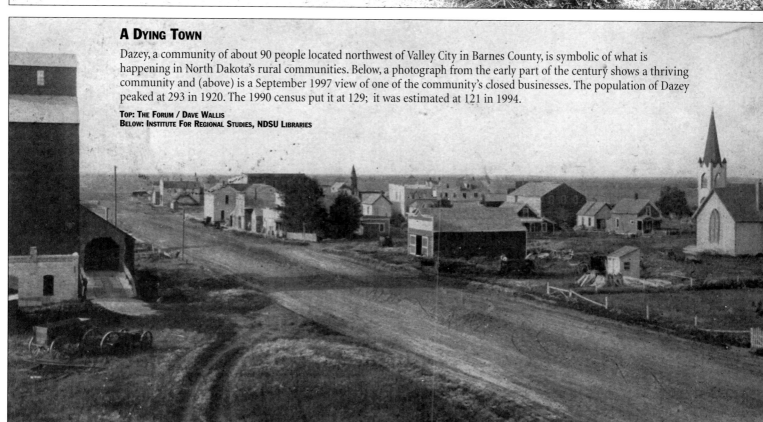

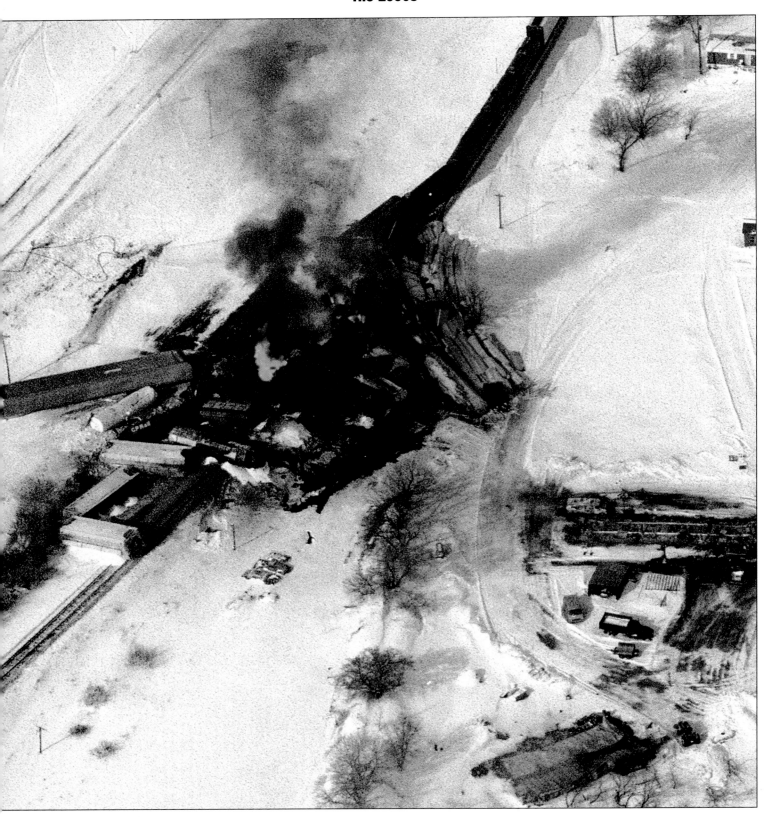

DERAILMENT, BLAZE INJURE 16-YEAR-OLD

Chad Yale of Burlington, N.D., was critically burned when a 58-car Canadian Pacific Railway train derailed Feb. 27, 1994, near his home and a propane tank burst into flames. Burlington is northwest of Minot. About 1,500 people were evacuated from the town and surrounding area because of fears of further explosions and had to stay away from their homes overnight. Chad, who was 16 at the time, was given a 1- to 2-percent chance of survival. He was flown to the St. Paul Ramsey Medical Center Burn Unit. He recovered, but the accident left him without his right arm. He also had multiple skin grafts and plastic surgery. An insurance settlement enabled Chad to build a sports complex in Minot that contains a bar, restaurant and outdoor volleyball court. He also is involved in ownership of baseball clubs.

THE FORUM / NICK CARLSON

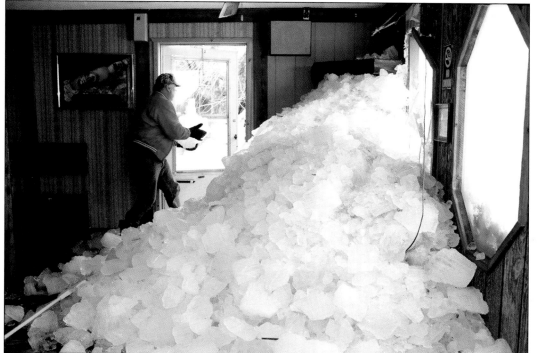

SKIMMING THE SURFACE

It was either love or hate as the newly developed personal watercraft appeared on area lakes in the 1990s. Pete Patnaude of Moorhead zooms around a corner on his craft on July 4, 1991, on Little Detroit Lake at Detroit Lakes, Minn.

THE FORUM / JOE HEINZLE

ON THE ROCKS

Steve Okeson throws a chunk of ice out of Zorbaz, a pizza and Mexican restaurant located on the south shore of Otter Tail Lake east of Fergus Falls, Minn. The ice damaged docks, boat lifts and blocked the lakefront's main road with a six-foot wall of ice April 18, 1995. The wind-driven ice broke two windows in Zorbaz, allowing chunks to spill into the restaurant. Owner Tom Hanson of Fargo said some repairs were needed but for the most part damage was superficial.

THE FORUM / COLBURN HVIDSTON III

DEVIL OF A PROBLEM

The communities of Minnewaukan (above) and Churchs Ferry are being threatened by the rising waters of North Dakota's Devils Lake. Since 1992, the lake has risen 25 feet and tripled in size, forcing the movement of homes, raising of highways and diking of part of the city of Devils Lake itself. Efforts to provide an outlet for the out-of-control lake continue to be discussed as the century winds down.

TOP: THE FORUM / DAVE WALLIS
LEFT: THE FORUM / DAVE WALLIS

DO YOU WANT FRIES WITH THAT?

A trumpeter swan takes a handout while wintering on the Otter Tail River in Fergus Falls, Minn. Release of trumpeter swans in the vicinity of Tamarac National Wildlife Refuge northeast of Detroit Lakes, Minn., was begun in 1987 and continued through 1994. Trumpeter swans, the largest North American waterfowl, once nested in the Detroit Lakes area, but disappeared around the turn of the century. In January 1999, the Minnesota Department of Natural Resources reported the state's flock consists of more than 500 trumpeters. The river stays open in Fergus Falls during the winter because of a power generating plant. A total of 166 swans were tallied in the Fergus Falls area during the winter of 1998-99.

THE FORUM / JOHN LOHMAN

A New Wave

Peter Schickele conducted his own work, "Concerto for Oboe and Orchestra," Nov. 12, 1995, at a Fargo-Moorhead Symphony. Schickele lived in Fargo as a youth and is known to audiences around the world for his satiric P.D.Q. Bach works. He is an author, composer, conductor, humorist and satirist. He lives in New York City.

THE FORUM / FILE PHOTO

Concordia Landmark

Six bronze bells weighing a total of 5,092 pounds ring out from Concordia College's 100-foot tower at the campus' center and crossroads. The cross on the bell tower was positioned Oct. 31, 1990, the 99th birthday of the Lutheran college. The bells and cross were gifts of Lenora and Herman Lee, Borup, Minn.

THE FORUM / DAVE WALLIS

Big Blows

Back-to-back storms July 12 and 13, 1995, caused more than $5 million damage in the region. Part of the roof was ripped from the Fargodome, and planes were turned upside down at the Detroit Lakes, Minn., airport. The region's utilities were hit extremely hard as winds downed power lines and poles and pounded electrical transmission systems. Near Ponsford, Minn., northeast of Detroit Lakes, tents at the Many Point Boy Scout Camp were whipped from their moorings. Four of the 436 Scouts were injured and had to be treated at an area hospital. There also were 126 adult volunteers and 110 staff members at the camp. Left, Todd Foster, a counselor from St. Cloud, Minn., moves his clothes from a collapsed tent at the Scout camp.

THE FORUM / DAVID ARNTSON

THE 'MIND' AT WORK

Minnesota Gov. Jesse Ventura makes a point during an interview with Forum Capitol reporter John Sundvor in his St. Paul office during February 1999. Elected on the Reform Party ticket, the former pro wrestler defeated two long-time Minnesota political stars. Because of his wrestling career and outspoken remarks, Ventura has been a frequent guest on national TV talk shows. As a wrestler, Ventura was known as "The Body." As governor, he prefers to be called "The Mind."

THE FORUM / COLBURN HVIDSTON III

A PLACE FOR HEALING AND COPING

The Roger Maris Cancer Center at MeritCare Hospital in Fargo was dedicated in September 1990. Patricia (Carvell) Maris lent her husband's name to the out-patient facility, and has been involved with various phases of the $6.8 million center. Money for building the center was raised through donations and pledges. Maris, the New York Yankee baseball great, broke Babe Ruth's home run record of 61 runs in 1961. He called Fargo his home and began his baseball career with the Fargo-Moorhead Twins. His wife also grew up in Fargo. Roger Maris died of cancer in 1985. The Roger Maris Celebrity Golf Tournament is held in Fargo in June, with some of the proceeds going to the cancer center.

THE FORUM / FILE PHOTO

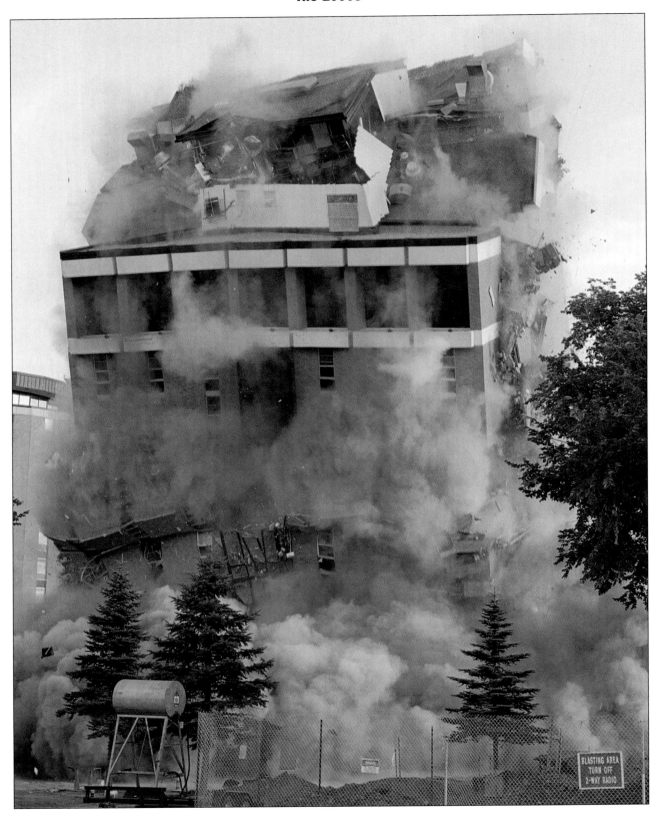

POOF! MSU's NEUMAIER HALL COMES DOWN

It took more than two years to build the 15-story Neumaier Hall on the Moorhead State University campus, but it took less than eight seconds to collapse it into a pile of rubble Aug 8, 1999. The 163-foot-tall dormitory was condemned in January 1999 after it was found that it had sunk 3 to 5 inches since being completed in 1970. The building was condemned and students were ordered to move out. The state of Minnesota hired Controlled Demolition Inc. to implode the building, which was the second tallest in Fargo-Moorhead. A large crowd of onlookers and the news media gathered to observe the successful Sunday morning implosion.

THE FORUM / COILBURN HVIDSTON III